"I hate nothing more than sugary photographs
with tricks, poses and effects.
So allow me to be honest and tell the truth
about our age and its people."

August Sander, Photographer
(1876–1964)

JEW

John Offenbach

JEW

SKIRA

Cover
Patisserie Chef, Tel Aviv, Israel

Art Director
Marcello Francone

Design
Luigi Fiore

Editorial Coordination
Emma Cavazzini

Copy Editor
Maria Conconi

Layout
Evelina Laviano

First published in Italy in 2019 by
Skira editore S.p.A.
Palazzo Casati Stampa
via Torino 61
20123 Milano
Italy
www.skira.net

Printed and bound in Italy. First edition

ISBN: 978-88-572-4059-6

Distributed in USA, Canada, Central
& South America by ARTBOOK |
D.A.P. 75, Broad Street Suite 630,
New York, NY 10004, USA.
Distributed elsewhere in the world by
Thames and Hudson Ltd., 181A High
Holborn, London WC1V 7QX, United
Kingdom.

Contents

Foreword

Devorah Baum

Although an old and familiar term, the word 'Jew' remains strangely unsettled and unsettling, as if it hasn't quite been able to take up its place in ordinary language. Some even think the use of it impolite. An article in *The New York Times* observes how successive American Presidents who've spoken freely of Christians, Hindus and Muslims, have referred to 'Jewish people' instead of 'Jews' lest the noun itself imply something offensive. And though there are, of course, many for whom 'Jew' has only favourable associations, few can be oblivious to the long history of othering that has so often rendered vulnerable those it identifies.

In this extraordinarily beautiful collection of portraits, any offence clinging to the word 'Jew' evaporates as each of the photographed subjects — all of whom have been portrayed with a rare sympathy imbued with grace and dignity — are gathered together under the umbrella of that singular name. Yet in its very singularity, the title of this collection continues to provoke. While the plural 'Jews' might have suggested motley members of a disparate group, the singular 'Jew' plays with the dangerous but always tempting notion of essences. As if these Jews were somehow identical, despite their differences. Or as if any Jew, myself for instance, when facing these particular Jews in all their unmistakeable diversity, would nevertheless, in some mysterious way, be looking at a portrait of themselves.

In seeking out his subjects, John Offenbach travelled from London around the UK, to various places in the US and Israel and to towns, villages and outposts in India, Morocco, Austria, Ethiopia, Barbados, Argentina, China, Ukraine and Azerbaijan. He might have found Jews to photograph in many other places too — and it's possible he still shall — but the present collection is already remarkable for its range and (ironically, in light of certain stereotypes) its internationalism. Indeed, in creating this collection, Offenbach was himself transformed into a sort of wandering Jew: the proverbial stranger in a strange land — including the land of Israel, where, tellingly, he worked, ate and slept not in a permanent settlement, but on an abandoned bus.

Throughout these wanderings, while many of the places he visited felt unfamiliar, the people he met felt anything but — a juxtaposition to put one in mind of Freud's notion of the 'uncanny': the feeling aroused by the sudden recognition that the strange can be familiar and the familiar no less strange. It was uncanny, for instance, when Offenbach visited Bruce Rich, a man convicted of murdering his parents: "I was nervous before meeting him in a Miami prison, expecting to be confronted by a monster. Instead, and perhaps even more disturbing, I met a man who seemed familiar and convivial. He could have been a long-lost friend". A surprise sense of kinship with a convicted parent-murderer would hardly count as surprising for Freud, of course, whose theory of the repressed pertains to pretty much exactly this example. And even for Offenbach, this friendly feeling was perhaps not wholly unpredictable insofar as Rich was the very man he'd set out to meet after hearing about the not

insignificant number of Jews on death row. Why hadn't he heard of those Jews before? Within the relatively limited purview of his own social circles, he realised, he had only really encountered a set of narrow and lazy assumptions about who should be considered a 'normal' Jew. His photographic project was thus born of a wish to capture with his camera a much more fleshed-out picture of reality: a reality that would not only subvert the stereotyping of Jews by often hostile majorities, but would subvert as well the Jewish tendency to create their own internal others. So the intention was to exclude, deny and repress no one, not even those defaced as 'monsters'.

That doesn't mean that there aren't among these portraits some familiar images of Jews. But look at them carefully and you begin to notice how much less of a kind each one appears in the company of the others. The usual suspects, such as the bearded religious Jews with ear locks and black hats, are individuated in a way that art has seldom succeeded in showing us before. The inclusion, for instance, of a portrait of a black religious Jew with a beard and black hat renders every figure in similar garb a little less stereotypical. Indeed, orthodoxy itself looks a lot less orthodox here. So while some wear black hats, others are wearing skullcaps, kaftans or robes, or the white knit coverings favoured by followers of Nachman, an early Hasidic leader. Others still wear shtreimels or sheitels or chic patterned headscarves. Meanwhile, others who dress similarly do so to completely different ends. One man has a beard and black hat, but the title of his portrait tells us he's a 'Rapper'. Another man elegantly profiled with a full beard and a face shrouded by a white hood looks every bit the hipster, though the inscription calls him 'Rabbi'.

There are so many human faces in this collection. Indian Jews, Chinese Jews, Moroccan Jews, mountain Jews, African Jews, European Jews, rich Jews, poor Jews, young Jews, old Jews, transsexual Jews, dancing Jews, clowning Jews, addicted Jews, grieving Jews. There are cops alongside criminals; peers of the realm alongside chancers on the street. And there are residents from many kinds of street, from the 'Wall Street Financier' to the young 'Entrepreneur' selling sweets on a stand in Uman, Ukraine. Through such comparisons, certain of these portraits seem in subtle dialogue with each other — as when an Israeli soldier rubs up against a British soldier and a US marine. Equally suggestive are the contrasts to be discerned by comparing the people portrayed with those who aren't. In Ukraine, for example, amid the tremendous range of faces, largely of pilgrims to Nachman's tomb, not a single woman appears. Yet this very observation in itself contrasts with the portraits of orthodox women we find elsewhere, some of whom are undertaking the kind of public and professional roles we might never have encountered them in before. I was struck in particular by the unusual sight of a female 'Soferet' (Torah scribe). And I was struck as well by something tender yet stoical in the faces of women in other less represented roles, such as the British military 'Medical Officer', the Israeli 'Security Guard', and the Argentinian 'Organic Farmer', a pensive-looking woman with handsomely weathered features and a tough hessian shawl. She, in fact, also presents an interesting comparison to another portrait from Argentina — the man identified as 'Gaucho', whose implicit machismo (cowboy hat, neckerchief) has been softened into fragility by the way his eyes avert, as if shyly, from the grip of our gaze.

As more and more Jews get recognised as normal, the very notion of normal, as well as the hierarchies dictating its terms, begins to lose its power. It's a remarkable achievement of this work that by exhibiting so much diversity and

difference, it simultaneously manages to erase the ways in which differences have been used to rank, grade and pitch people against each other. So while everyone pictured feels distinctive, it's a vision of their fundamental equality that ultimately prevails. A sense of the beauty of each individual is very much at the heart of this photographic vision. Classical beauties such as 'Model' are joined by subjects whose aesthetic features may be less commonly appreciated, but who radiate within this frame. The albino 'Musician', for instance, is a portrait of a man whose head and hair possess the luminosity of classical statues, his whiteness evoking the heroes and gods of antiquity.

So how did the individual portraits get their titles? Not every classical beauty on display, after all — see, for example, the 'Patisserie Chef' — is so-called, no more than 'Tattoo Girl' is the only tattooed girl or 'Transsexual Waitress' the only transsexual. The individual titles are thus in their own way just as enigmatic as the title of the collection overall. *Do not suppose*, they seem to be warning the viewer, *that you are intimate enough with these sitters as to be on first name terms*. Normally, portraits tend to get named after the proper names of their subjects. As the critic Shearer West notes, portraiture's representation of specific people has meant that "its practice tends to flourish in cultures that privilege the notion of the individual over the collective". Over the course of western art history, traditionally posed portraits of sitters surrounded by status symbols gave way to more democratic notions of who should be pictured and how, yet this ideal of the sovereign subject has never ceased to exert a powerful hold over the portraitist's imagination.

There have, however, been challengers to the ethos. One early challenger was the documentary photographer August Sander, whose portraits from Weimar Germany he entitled *People of the 20th Century*. The title alluded to his ambition to attest not so much to his sitters' individuality as to their typicality. Mostly (but not only) of unnamed workers, these pictures tended to exhibit the signs of the social reality each figure inhabits. However, as West remarks, his project wasn't entirely persuasive. Sander's use of real people "enhanced the unique qualities of the sitters, whose individuality undermines the idea that they stand for whole categories of people".

Offenbach's *Jew* acknowledges the influence of Sander through its portrayal, in the historic language of black and white, of individual sitters identified not by name but by profession or other qualifiers. There are even direct parallels between the two oeuvres; for example, Sander's portrait of an earnest-looking blonde and bespectacled man in a suit and tie in 1923, entitled 'Youth Movement', meets its corollary in Offenbach's portrait of a blonde, bespectacled 'Student Union Leader' in a suit and tie in Vienna. But despite such surface similarities, what's arresting is just how differently the characters of these serious-minded youths somehow appear. So is the *unalikeness* of every likeness perhaps the point? Certainly, the curious disparity of Offenbach's titles — some are named after their work, others after the first impression they make, others by the form their suffering takes, others by their enthusiasms, others by their own conception of themselves — attest to the problem with taxonomy, despite purportedly mimicking its logic.

And there's another way in which, for the most part, Offenbach's portraits differ significantly from Sander's. For Sander, real-life backgrounds are often key to the development of his idea that every subject manifests their social type. But here, despite selecting subjects from

across the world, and withal the temptations that such background information can only have presented to the globetrotting photographer, every single portrait is viewed against the blank backdrop of a lit studio, as if everyone we're facing has been shorn of both geographic and temporal considerations. This lack of context is itself the context in which we see 'Jew' — a thought made all the more evocative when one reflects that some of these studios are makeshift roadside tents: booths flimsily structured, like the biblical tabernacles, with three walls and one open side.

Against such a 'background', one of the least usual images of a modern 'Jew' begins to seem unusually representative: 'Homeless' offers a close-up of the face of a man with a bushy beard, wild hair and the frantic eyes of someone who has seen fearful things and has a compelling tale to tell. And yet these remain black and white stills, silent images that cannot yield the history this man seems on the lip of sharing.

There are images in which words do appear, though. One of the faces has a word literally tattooed onto it: 'Fuck'. Seeing this word indelibly marked on the cheek of a young man from Tel Aviv, it would be hard not to read some sort of message into that face. But — in a way that finds its counterpart in so many of these pictures — the portrait won't settle into any stable idea we might wish to project onto its subject. *Fuck*, says the cheek, but the eyes seem cheeky too. They hint at a warmth and sense of mischief that endears us to this Fuck-face character.

Much more unsettling is the portrait of the young woman whose disrobed body tells her life story: a story of parental abuse, rape and self-harm, revealed via her flesh's multiple markings of word and image tattoos and other scars. Yet here, too, the portrait militates against some of its own implications through the sitter's un-

flinching stare out towards us, and the picture's title, which she chose herself: 'Rape Victim, Recovered'.

For Torah Jews bound by the Commandments, such tattooed bodies almost do read as 'Fuck you'. Indeed, it's both a quirk and a crux of this collection that, while everyone featured in it has agreed to be portrayed as a Jew, they wouldn't necessarily view each other that way. Thus, just as the project plays with the logics of typicality by entitling each portrait in a manner undermining any overriding system of classification, it does the same with the idea of 'Jew' itself. Jews here get to be Jews by different sets of rules: some by religious practice, some by conversion, some by matrilineal descent, others by patrilineal descent, others by DNA tests or birth certificates or, in one case in Kaifeng, China, because she saw early on the word 'Jew' marking her state registration booklet. One Jew pictured is a 'Buddhist Nun'.

What the openness of this vision leaves us with is arguably a portrait of the 'Jew' in the image of the photographer, whose unseen backdrop is that of another familiar stereotype: liberal, metropolitan, and so on. But there are always, inevitably, painful discoveries to be made when looking openly in or at one's self-image. The artist Lucian Freud was once asked if he was a good model for himself. "No", he replied. "I don't accept the information that I get when I look at myself, that's where the trouble starts." He had discovered in paint what his grandfather had discovered in words. Much as Offenbach discovered, when seeking out his subjects, even the liberal Jew has his illiberal, orthodox limits — as happened to him in China, where he declined to photograph a particular individual who wanted to belong to his collection, but whose basis for claiming any Jewish identity Offenbach couldn't quite recognise. It was bound to happen at some

point. All categories have their outer edges, and the question of Jewish identity and Jewish belonging has long been a fraught, contentious and, at times, violent one.

Yet one of the wonders of this collection is the way it makes visible the invisible, by allowing us to behold not only lesser seen faces, or more commonly seen faces anew, but because the faces it shows us remind us as well of the faces it doesn't show us. Such as those missing Ukrainian women. Or the 'Hidden Woman' in her full veil. Or those whom we might consider Jews but who do not think of themselves that way. Or those who consider themselves Jews, whom others might not regard as such — including a photographer whose mission it is to recover images of people who ordinarily get excluded.

Then again, doesn't the action of looking at a face — in order to fully behold a face — require us as well to recognise what the face can't and won't show us? This was the opinion of the late Holocaust survivor and philosopher Emmanuel Levinas, according to whom the human face 'overflows images' by rendering visible just how invisible we ultimately are. To *really* see the face of another, therefore, is to recognise that we exist beyond each other's typologies, taxonomies or categories of comprehension. Or, in Levinas's words, "the face resists possession, resists my powers". By thus relinquishing, via the face-to-face, one's own wish for mastery, the door is opened to an ethical philosophy: "In front of the face, I always demand more of myself". It's a curious claim. But in looking at what Offenbach's portraits have to show us, I think we can glimpse what Levinas means. It's the idea that another person's face reveals our own humanity and our own responsibility towards the object of our gaze. And so it is here. Though a sense of harmony and serenity undoubtedly pervades all these beautiful photographs, I feel the rupturing force of that revelation reflected back at me from every single face in the collection, even from the pictures that do not show a face.

Dr. Devorah Baum, associate professor in English literature and critical theory, University of Southampton; author of *Feeling Jewish (A Book for Just About Anyone)* and *The Jewish Joke*.

PORTRAITS

Efraim Halevy was the director of Mossad, the Israeli Secret Service, from 1998 to 2002. He was born in London and emigrated as a boy. When we met, he quizzed me on London postcodes. He was making mistakes. I still don't know if I was being tested.

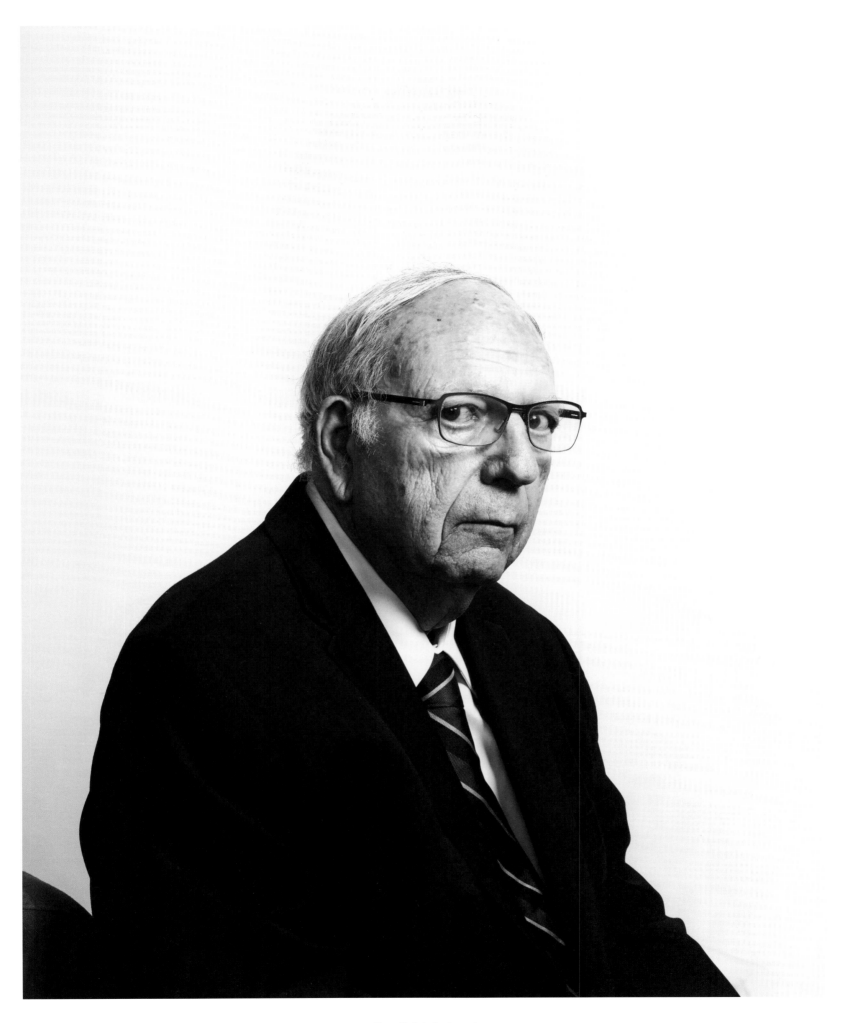

Spy, Tel Aviv, Israel

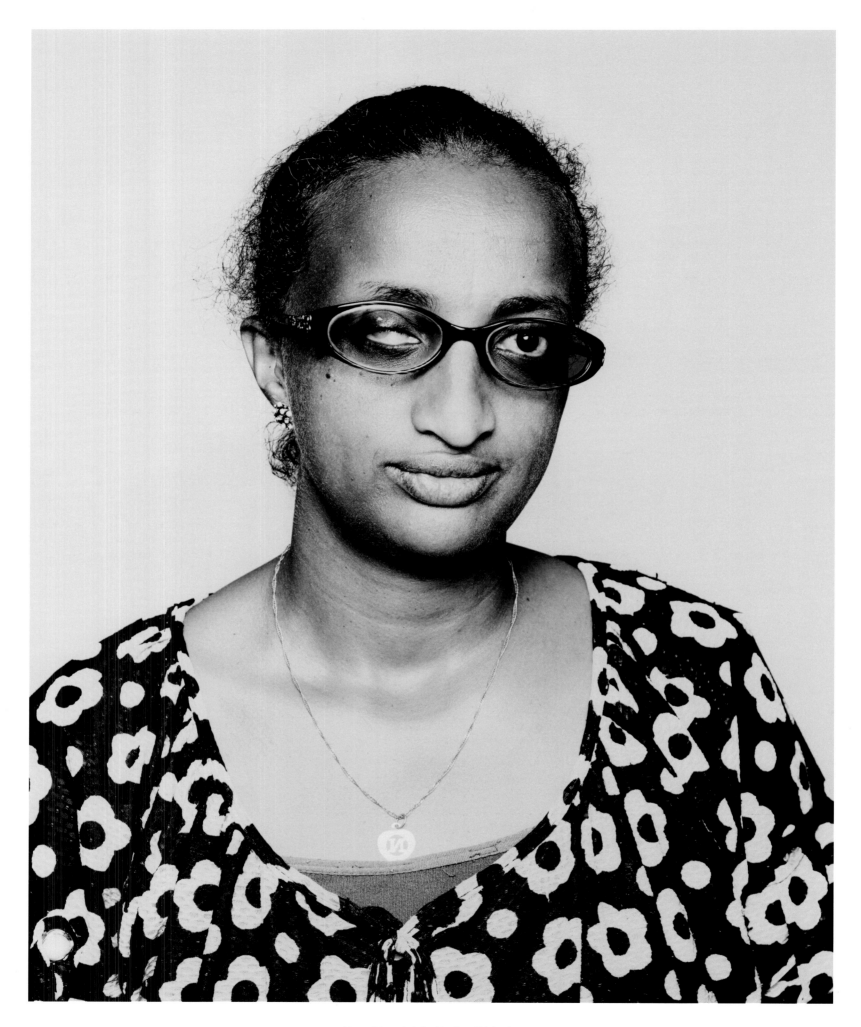

Daughter, Addis Ababa, Ethiopia

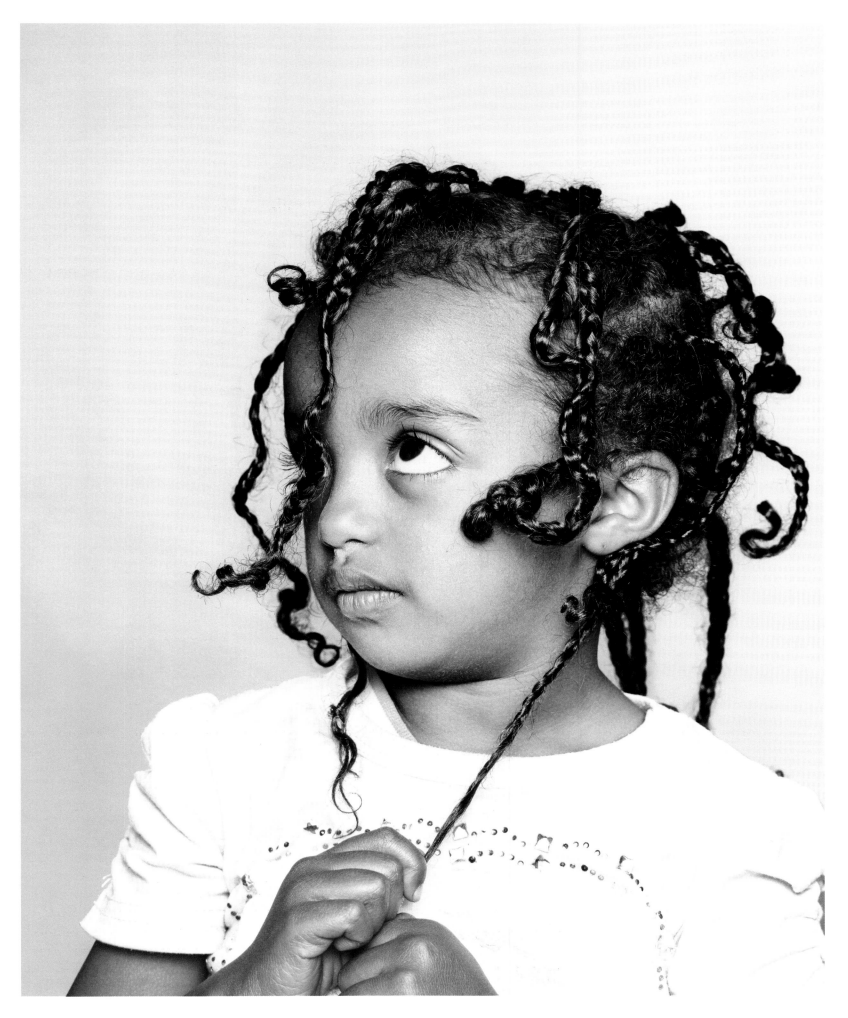

Young Girl with Braids, Addis Ababa, Ethiopia

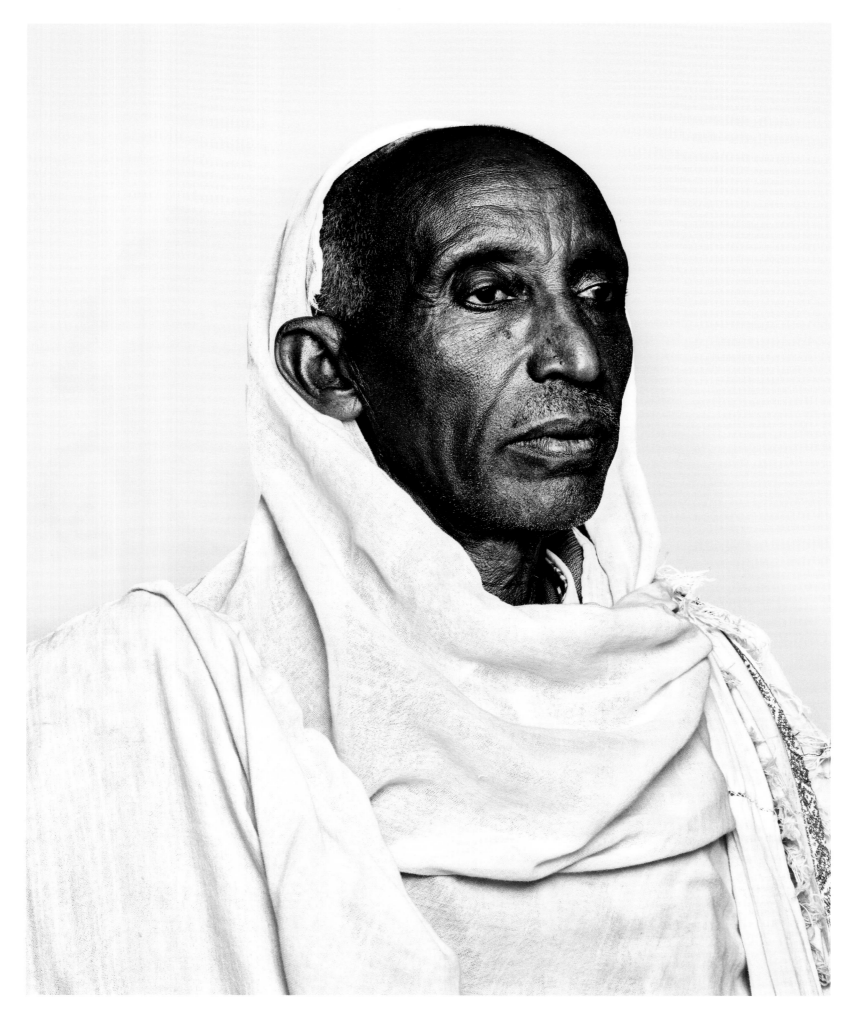

Weaver, Addis Ababa, Ethiopia

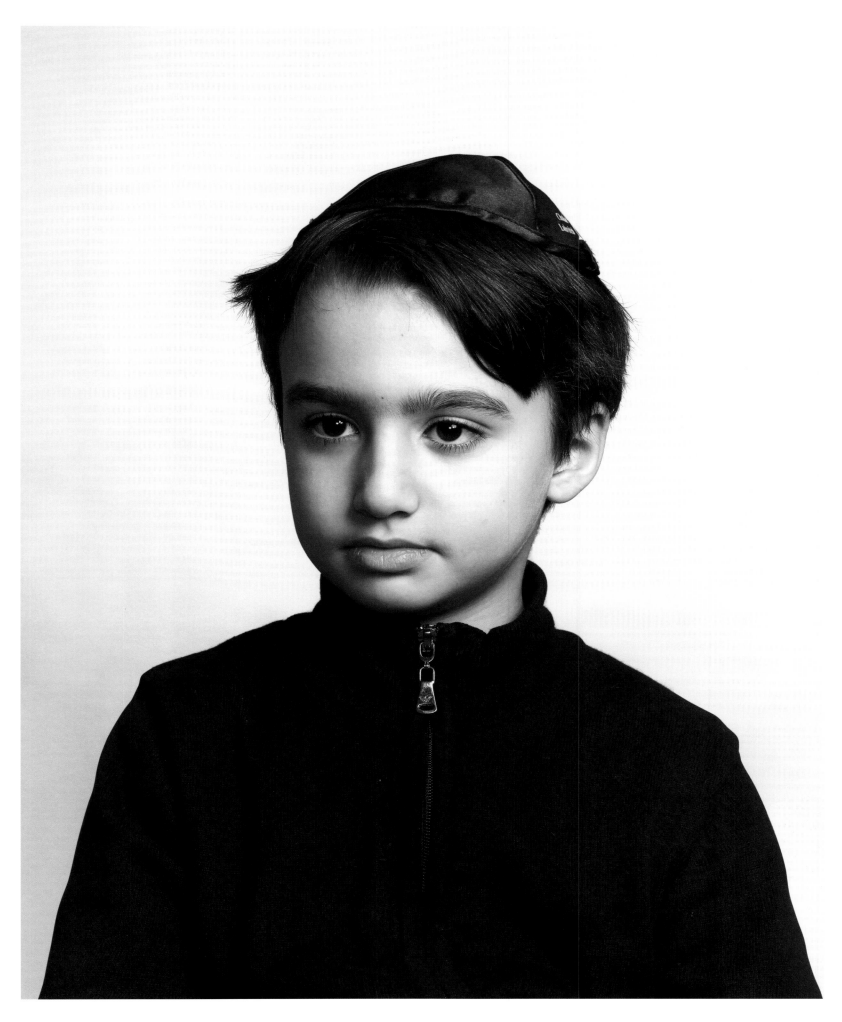

Schoolboy, Baku, Azerbaijan

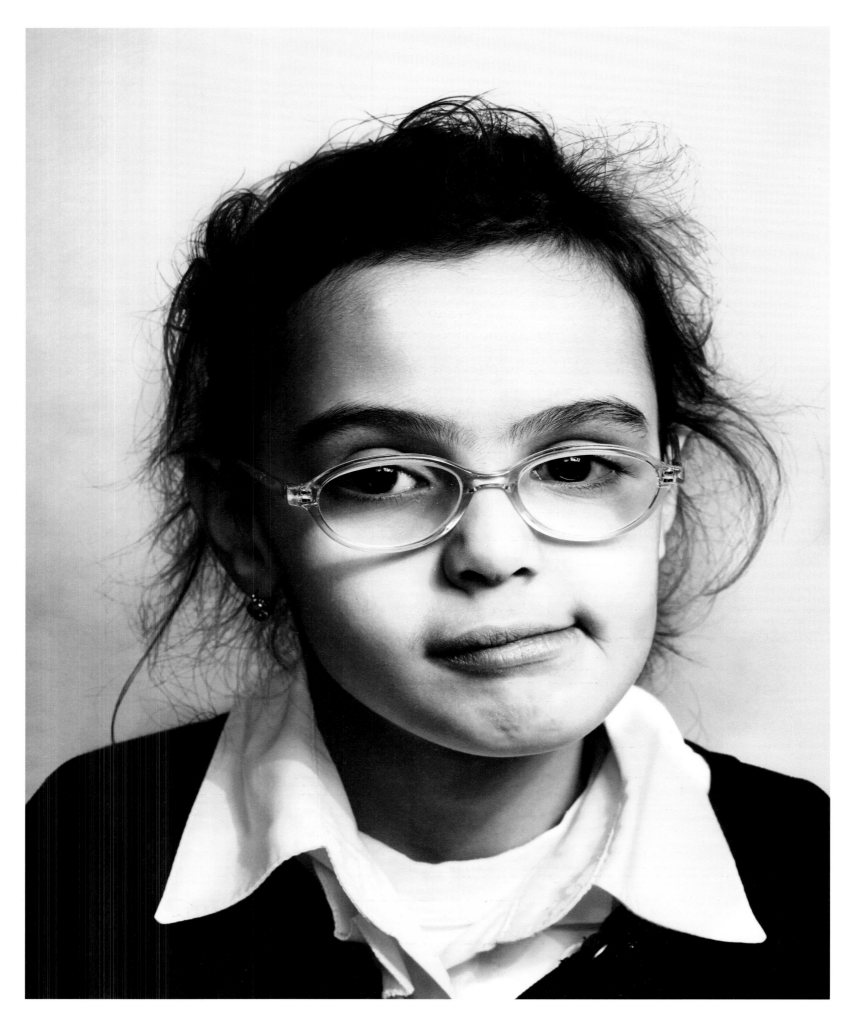

Schoolgirl I, Baku, Azerbaijan

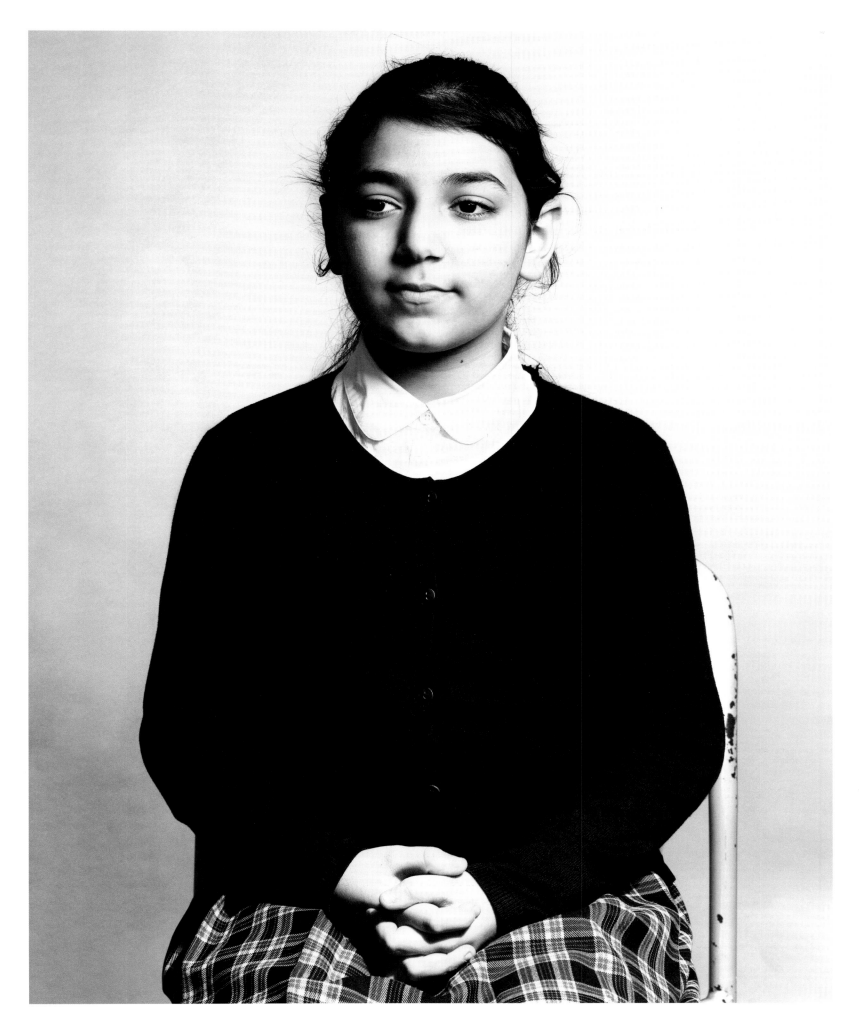

Schoolgirl II, Baku, Azerbaijan

Anita Lasker-Wallfisch is the only surviving member
of the Women's Orchestra in Auschwitz Birkenau.
The orchestra was forced to play by the gates of the camp
as prisoners went about their daily duties, whilst other
arriving prisoners were sent directly to their deaths.

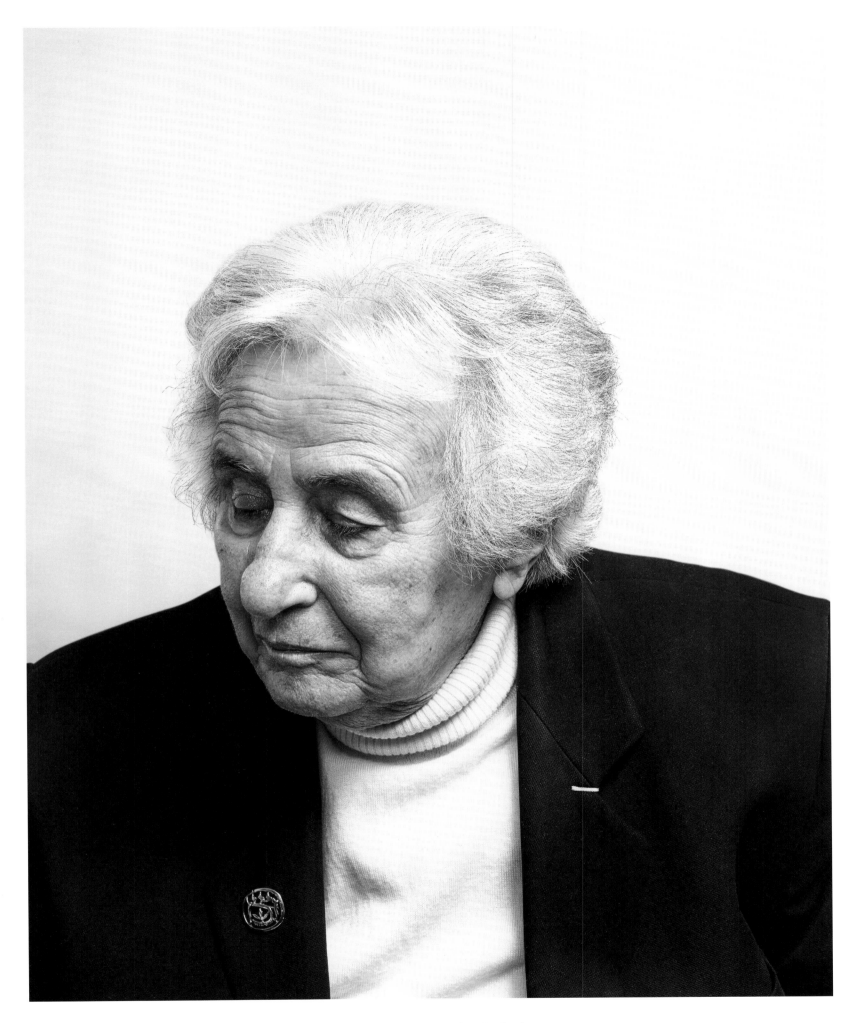

Auschwitz Cellist, London, England

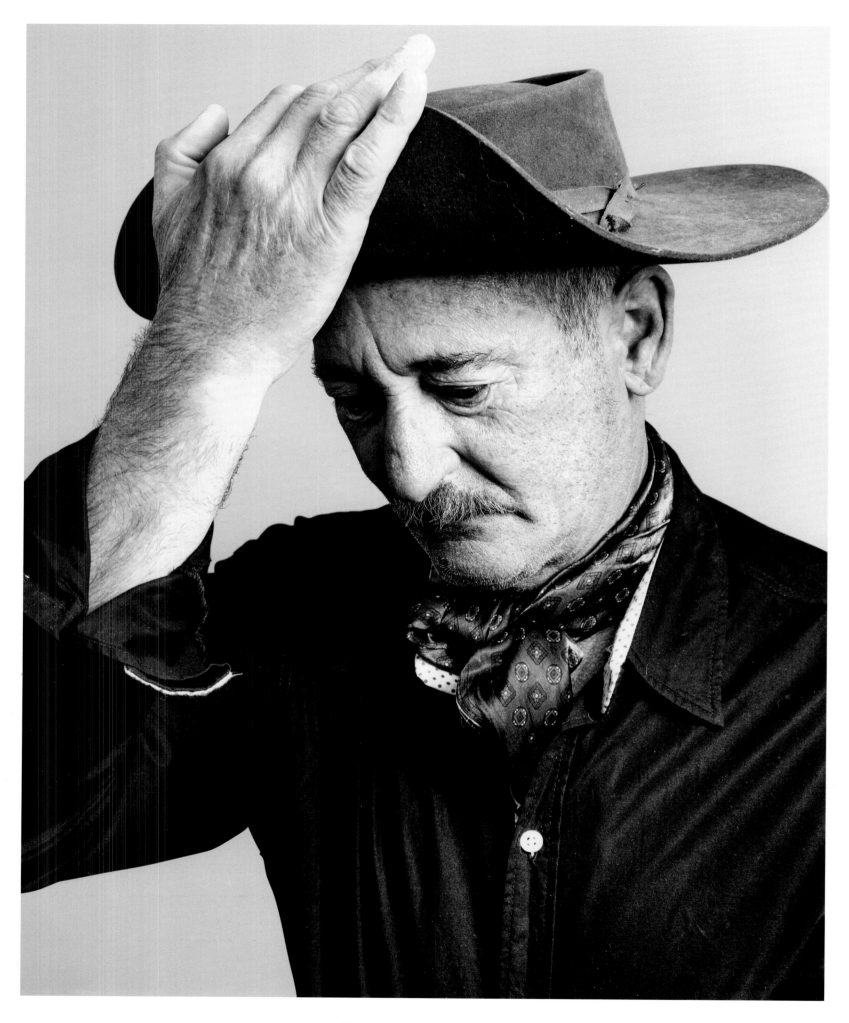

Gaucho, Basavilbaso, Argentina

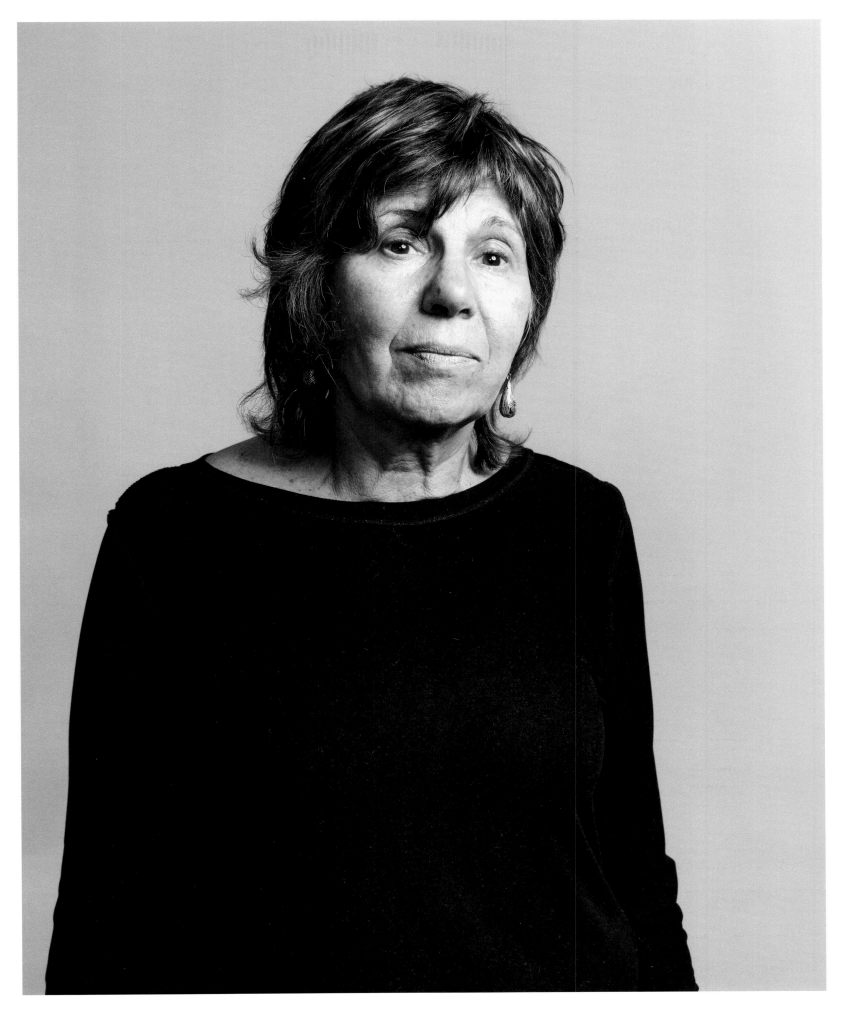

Doctor, Basavilbaso, Argentina

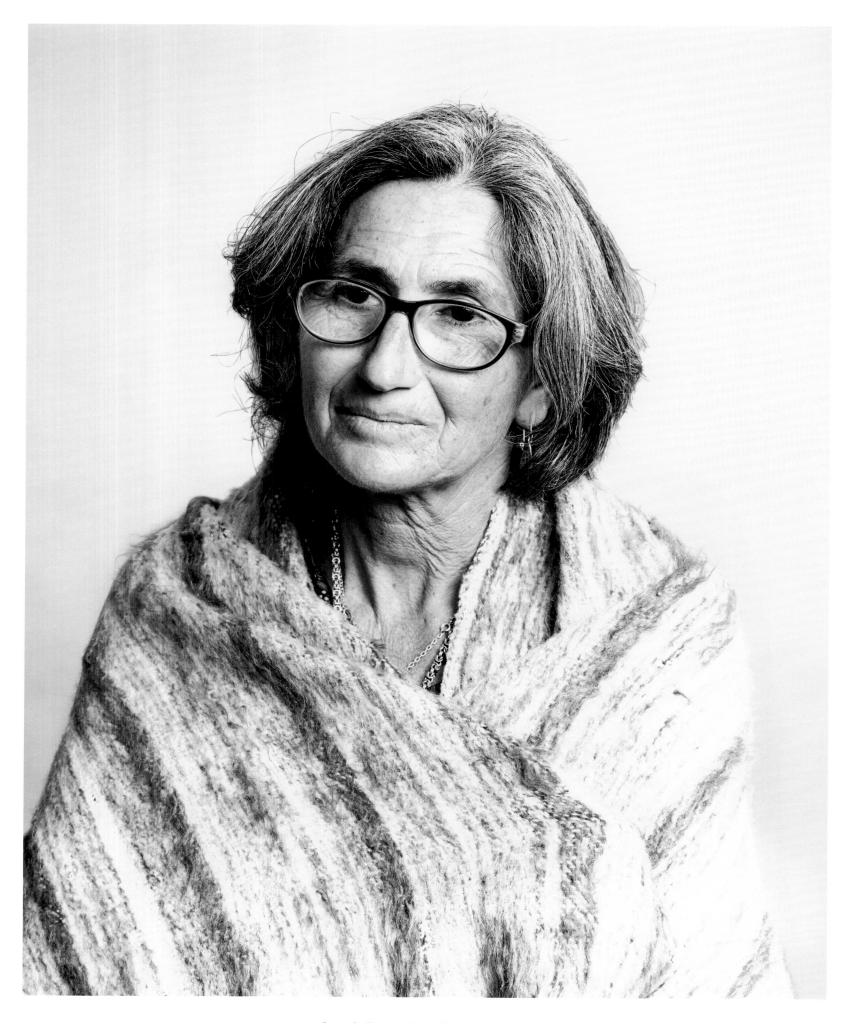

Organic Farmer, Basavilbaso, Argentina

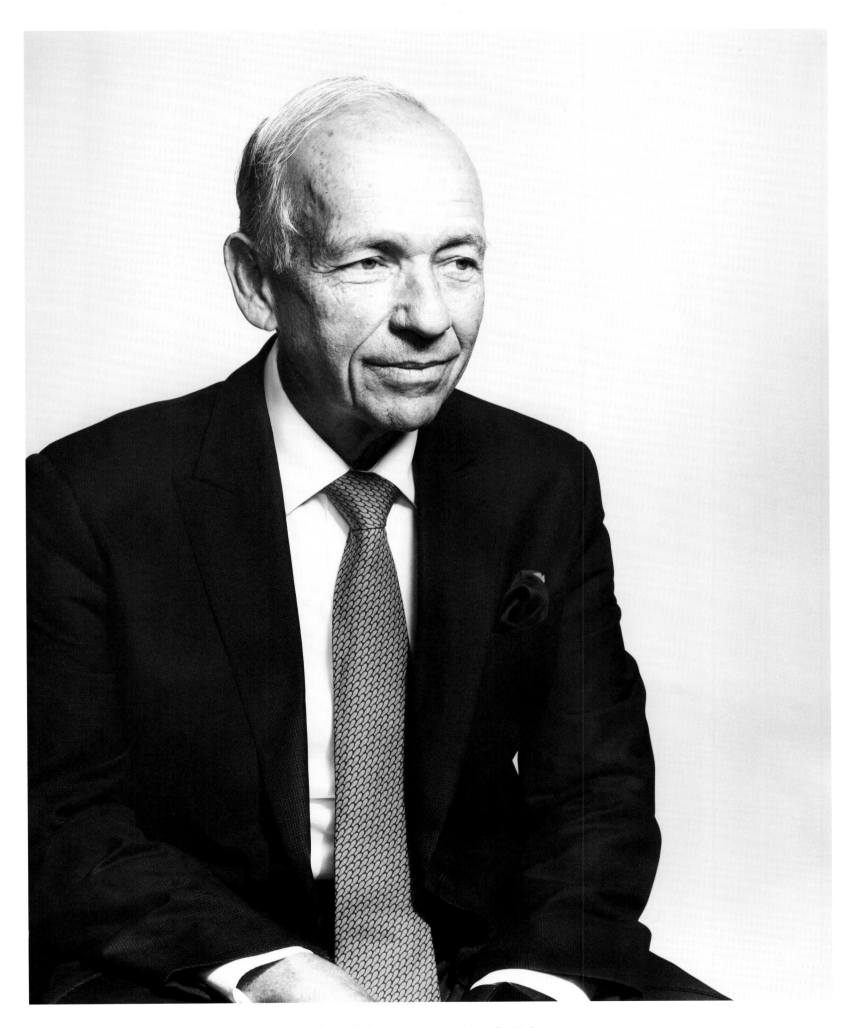

Property Developer, Bridgetown, Barbados

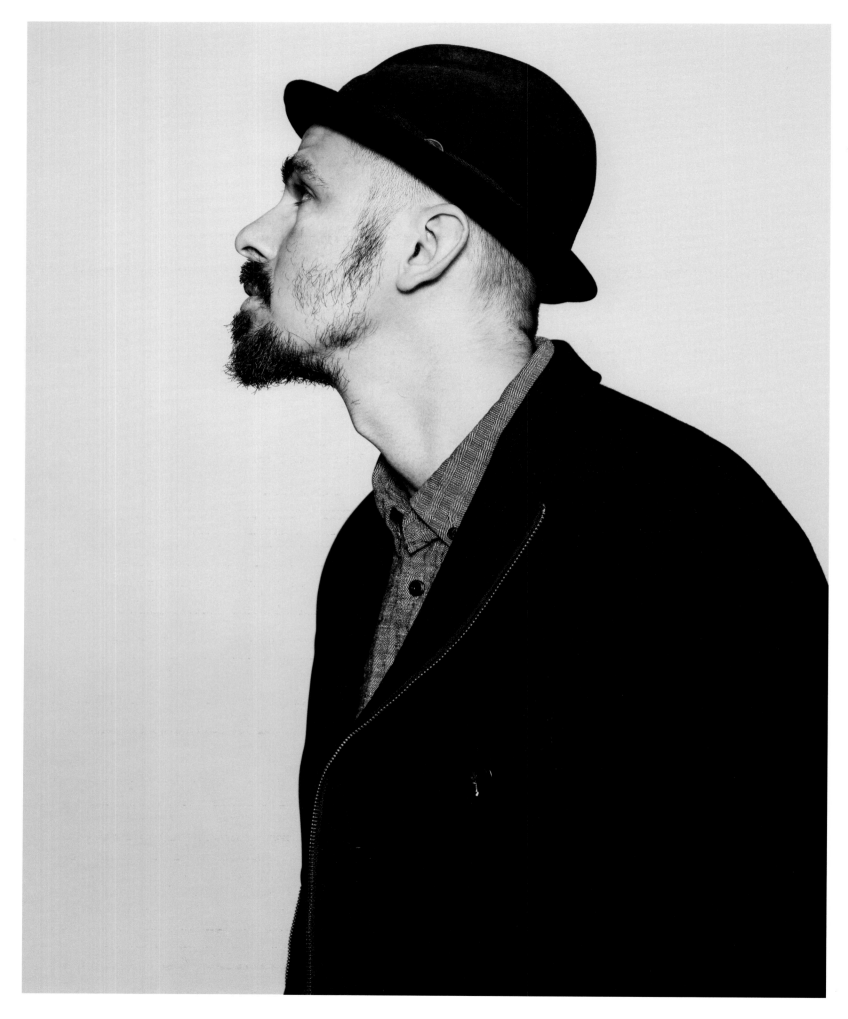

Rapper, Brooklyn, USA

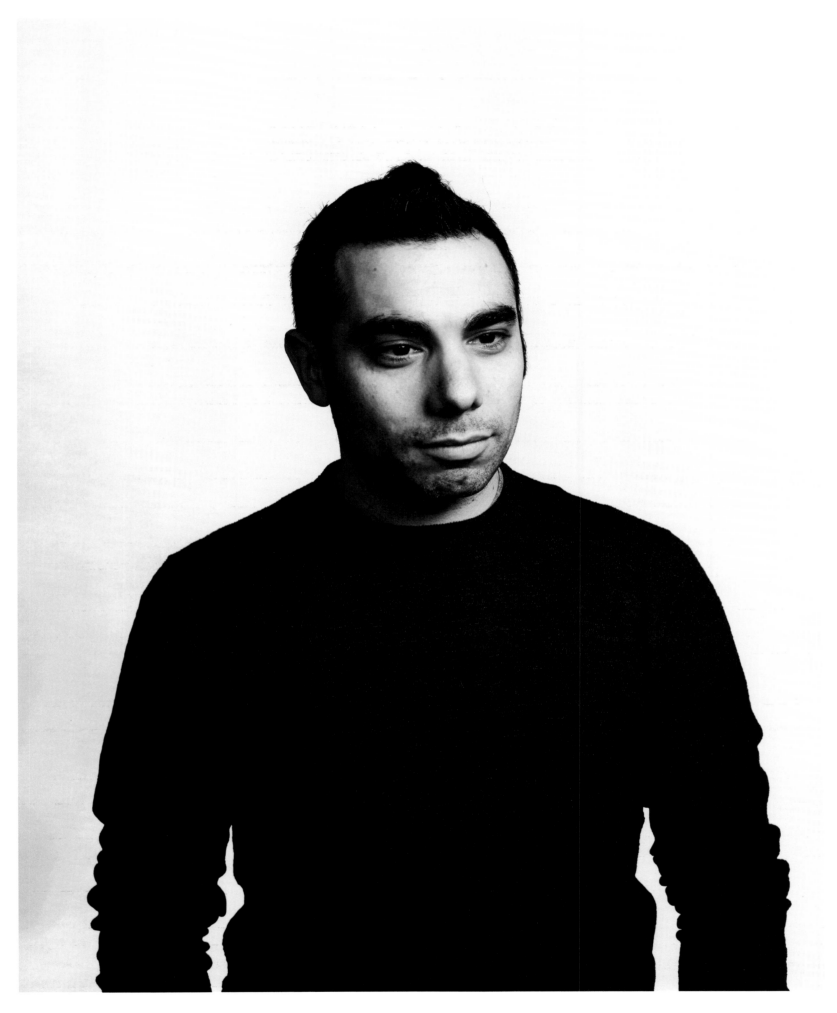

Filmmaker, Brooklyn, USA

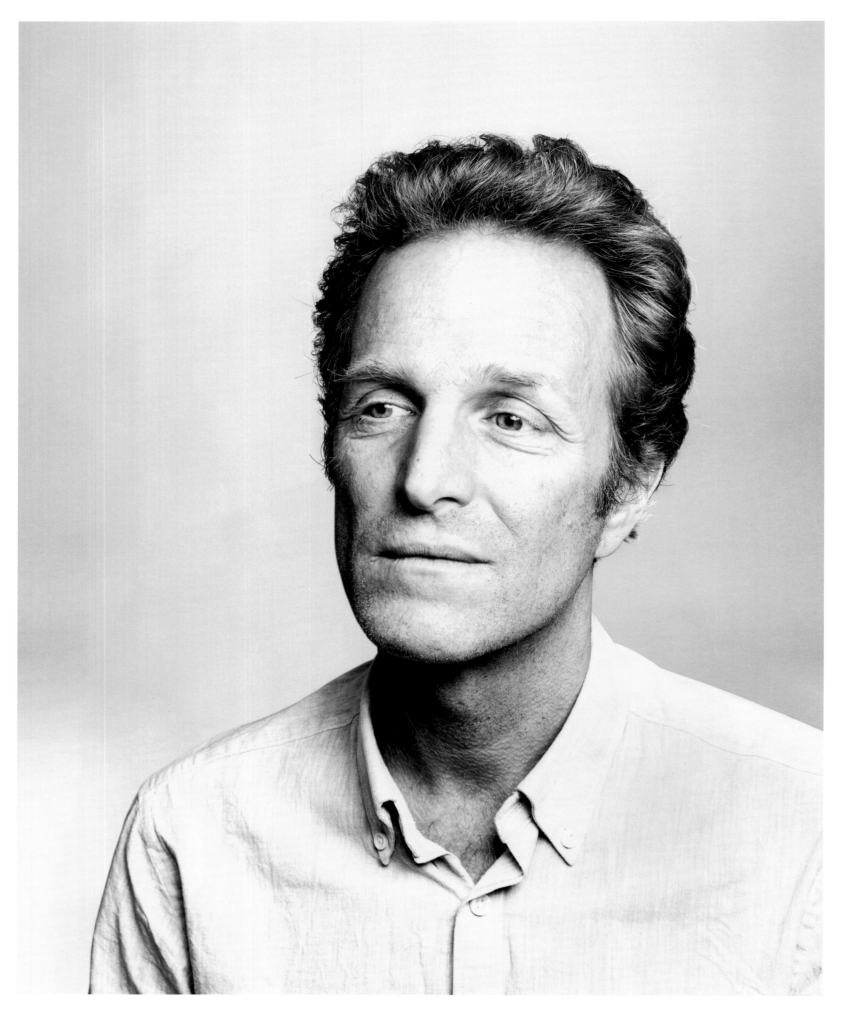

Librarian, Brooklyn, USA

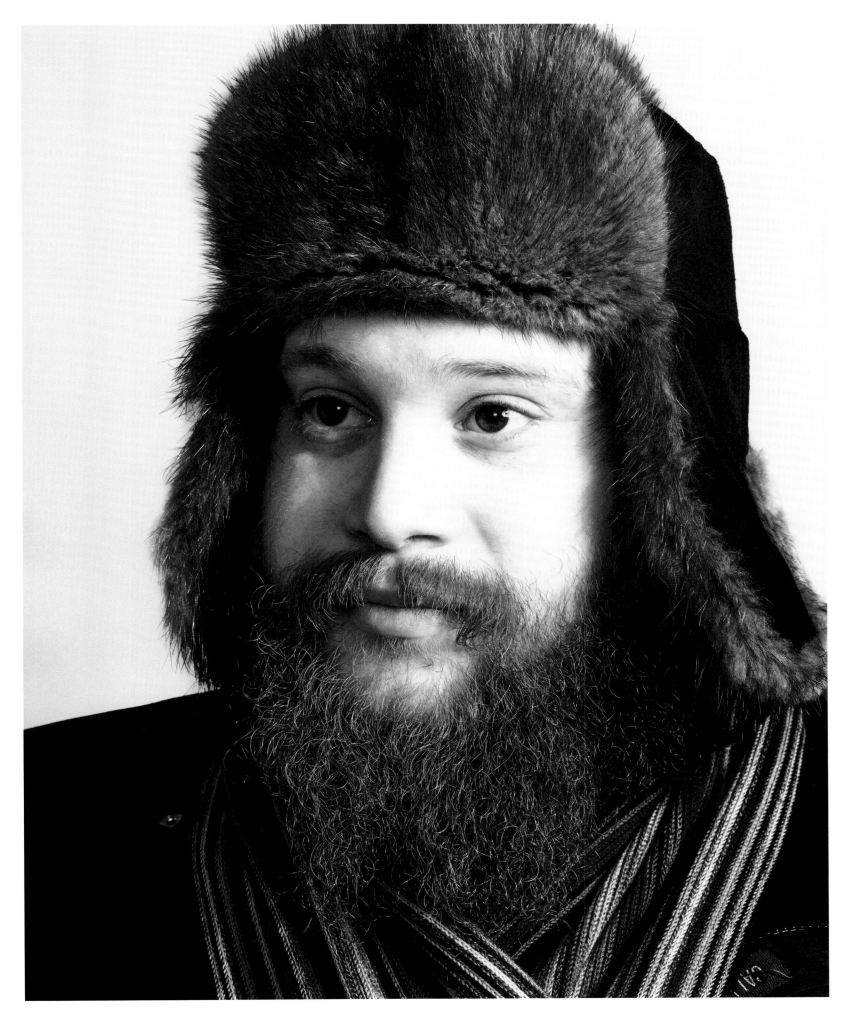

Man in a Fur Hat, Brooklyn, USA

Bruce Rich was convicted of shooting his parents. I was nervous before meeting him in a Miami prison, expecting to be confronted by a monster. Instead, and perhaps even more disturbing, I met a man who seemed familiar and convivial. He could have been a long lost friend. On leaving the meeting room, I misplaced my security pass. There was a moment of prison humour as Bruce was being strip searched for it. I was apologising to him through the door, but he said not to worry, "it's a part of the daily life here".

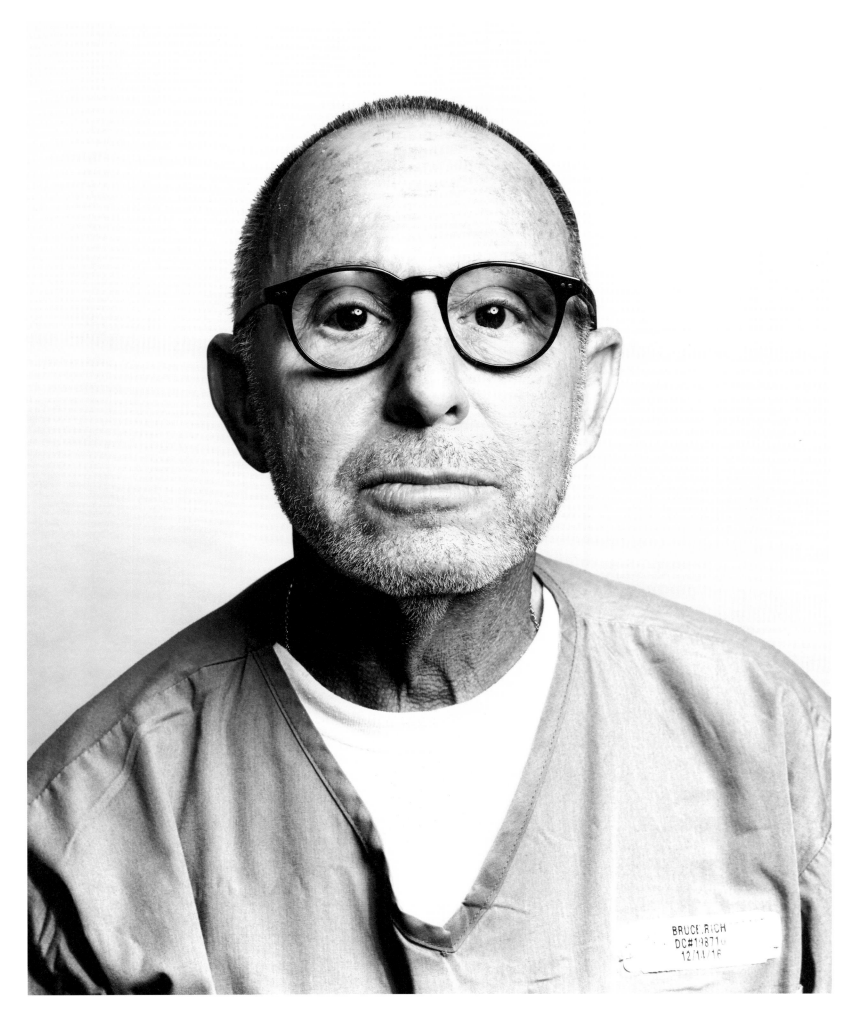

Murder Convict, Miami, USA

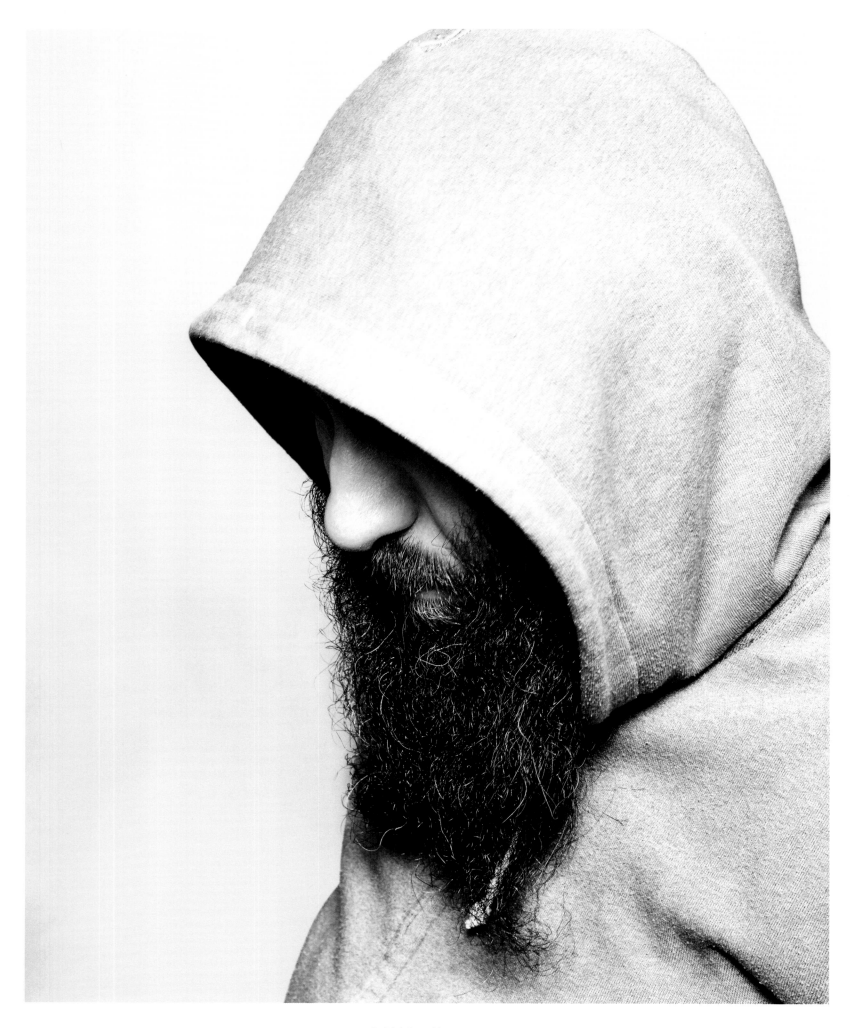

Rabbi, Brooklyn, USA

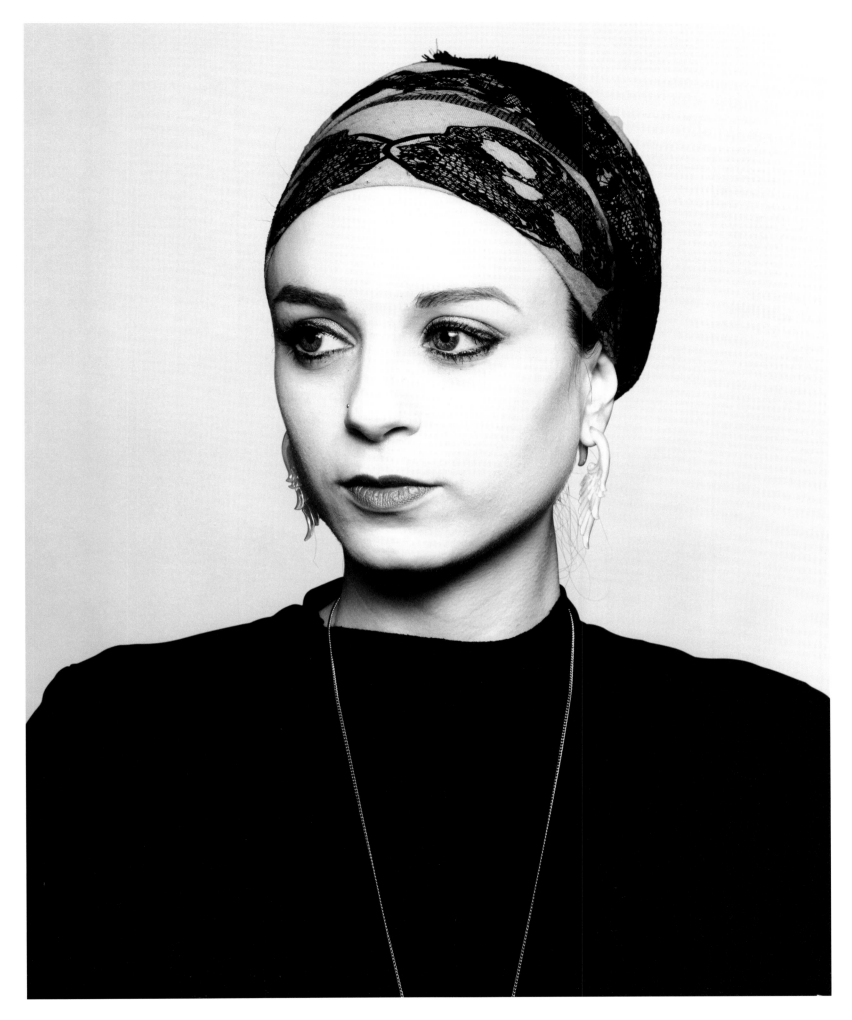

Illustrator, Brooklyn, USA

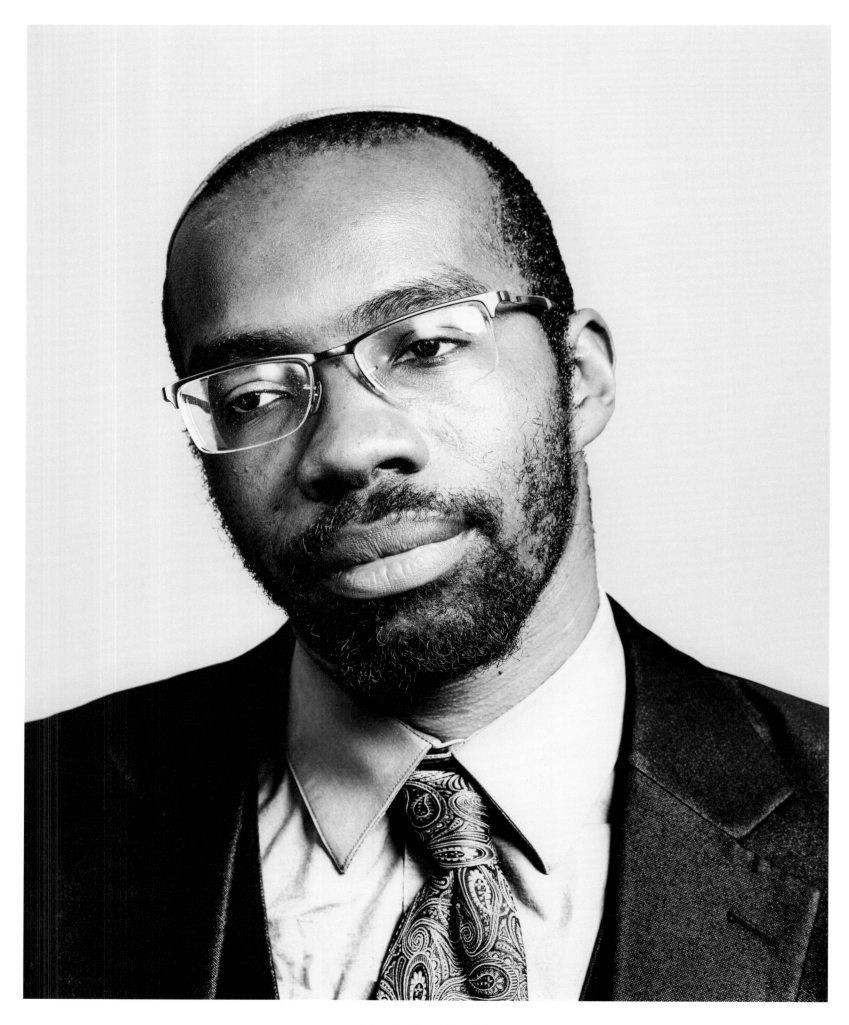

Igbo Jew, Brooklyn, USA

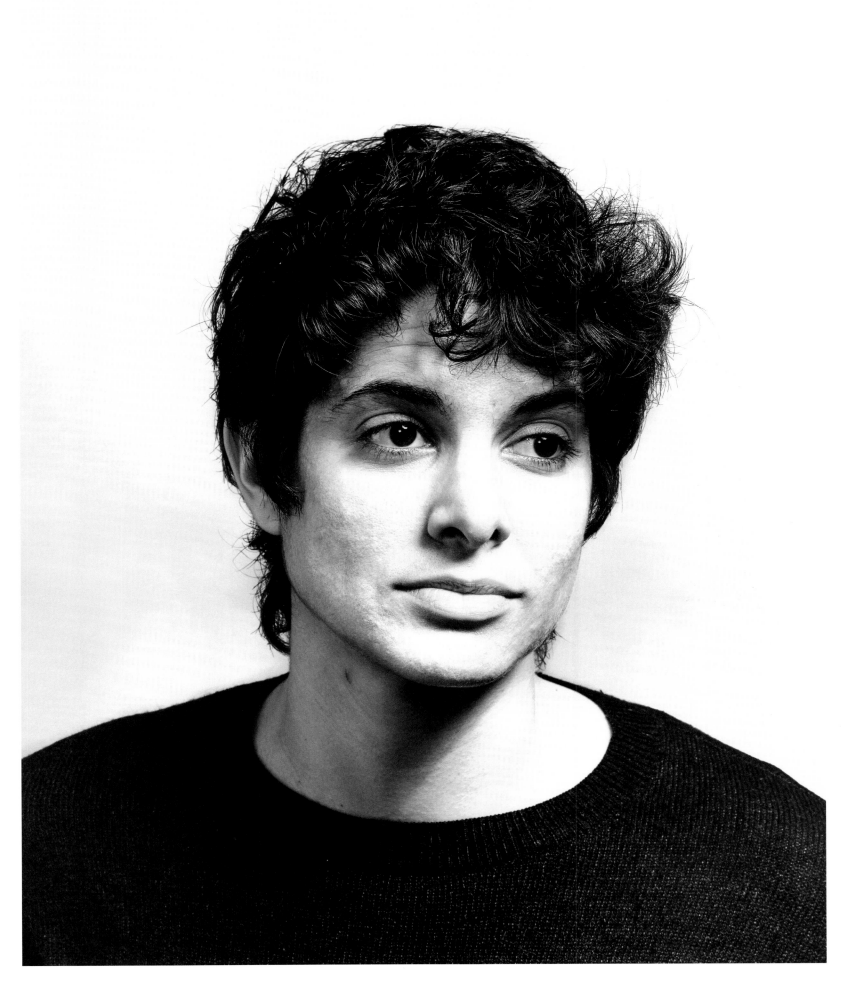

Gefilte Fish Maker, Brooklyn, USA

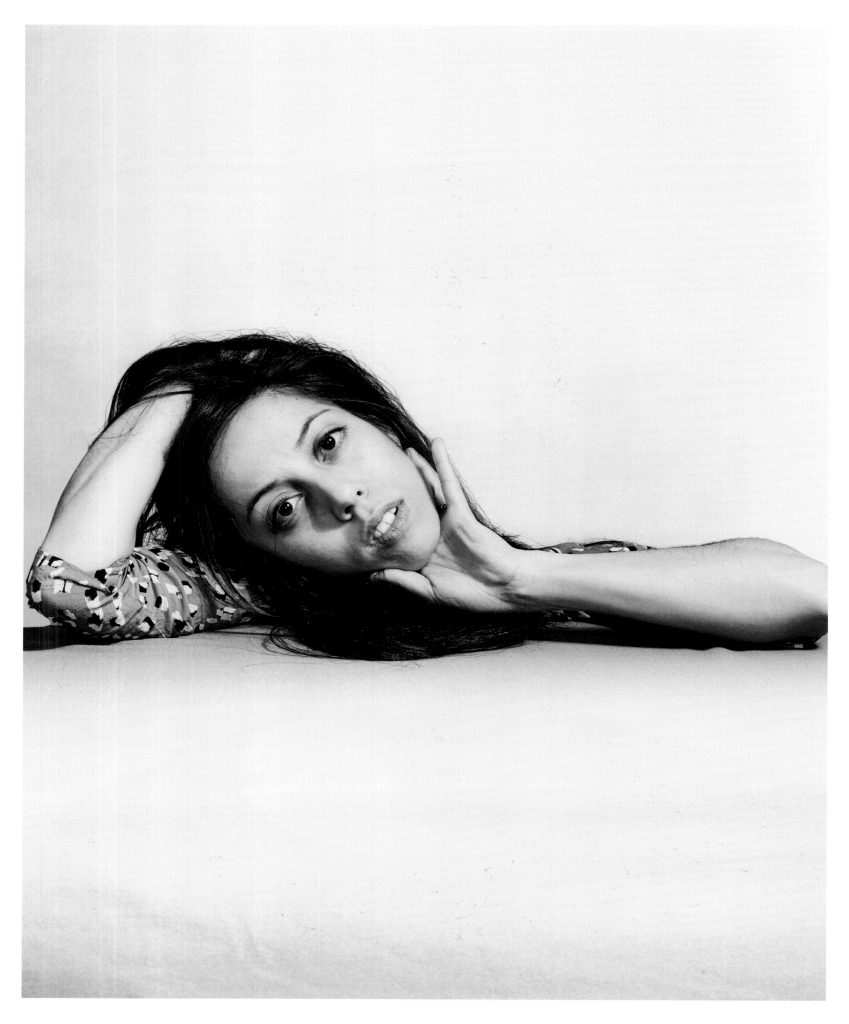

Dancer, Brooklyn, USA

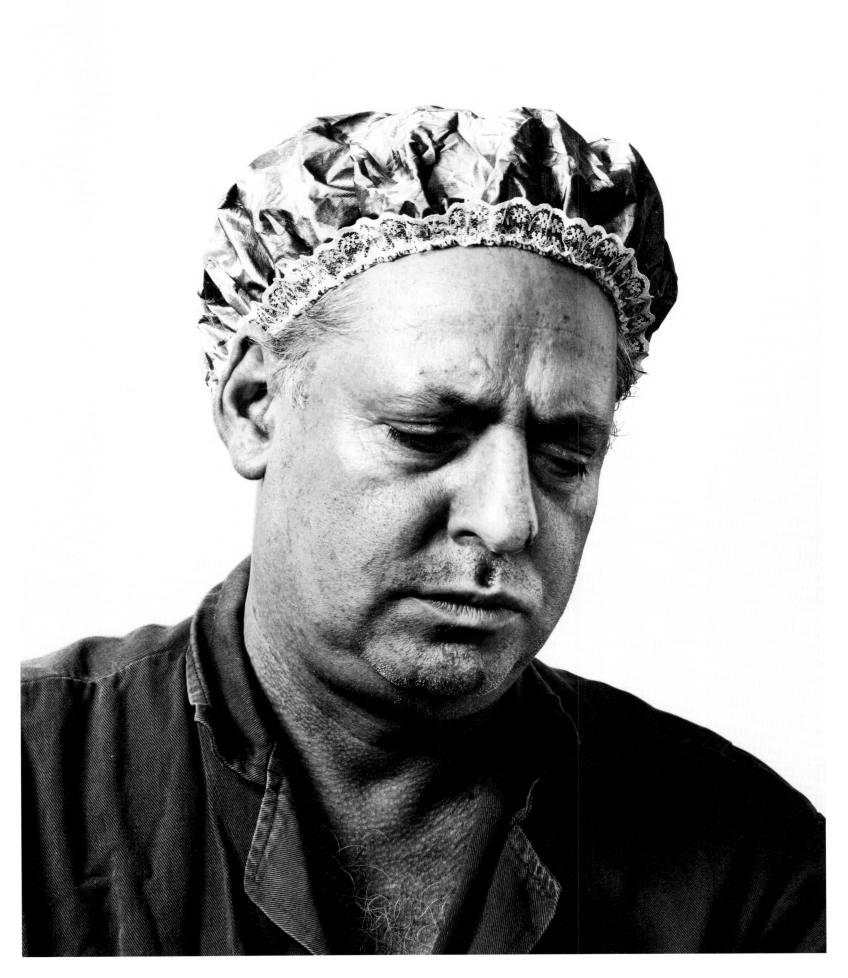

Bio Artist, Brooklyn, USA

Aluf Benn is editor-in-chief of *Haaretz* newspaper in Israel. He told me he is frequently mistaken for the actor Patrick Stewart, but is unaware whether Patrick Stewart is ever mistaken for him.

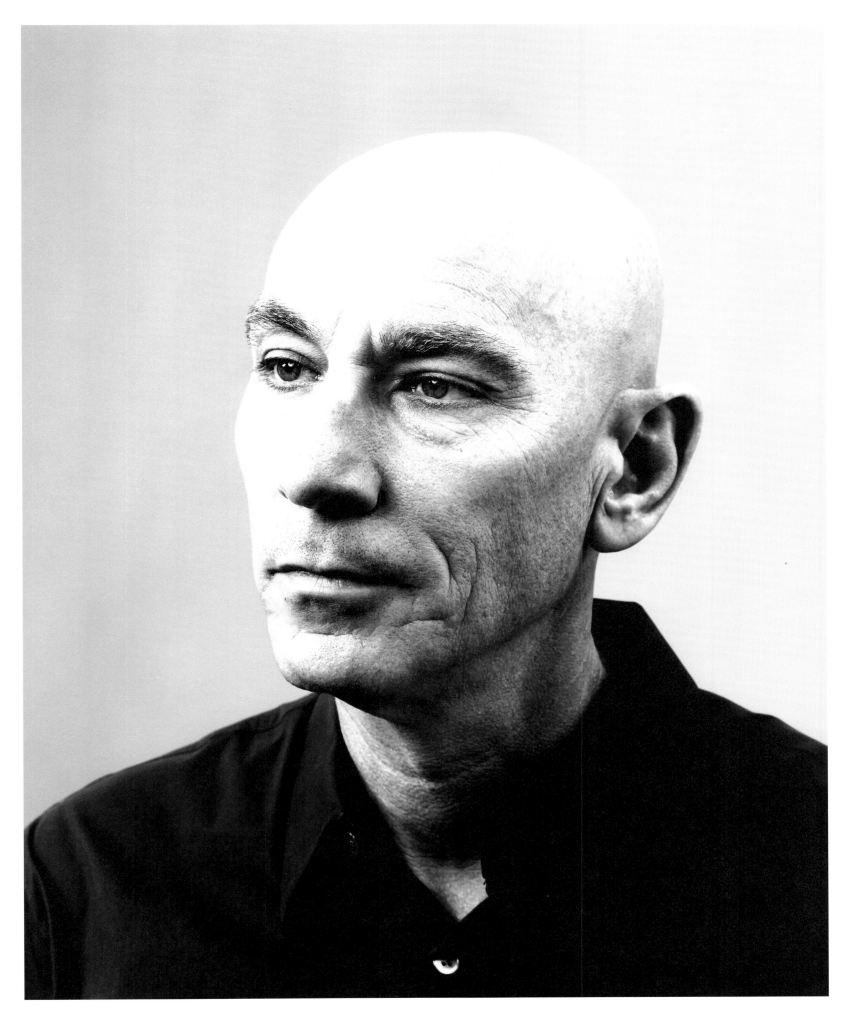

Newspaper Editor, Tel Aviv, Israel

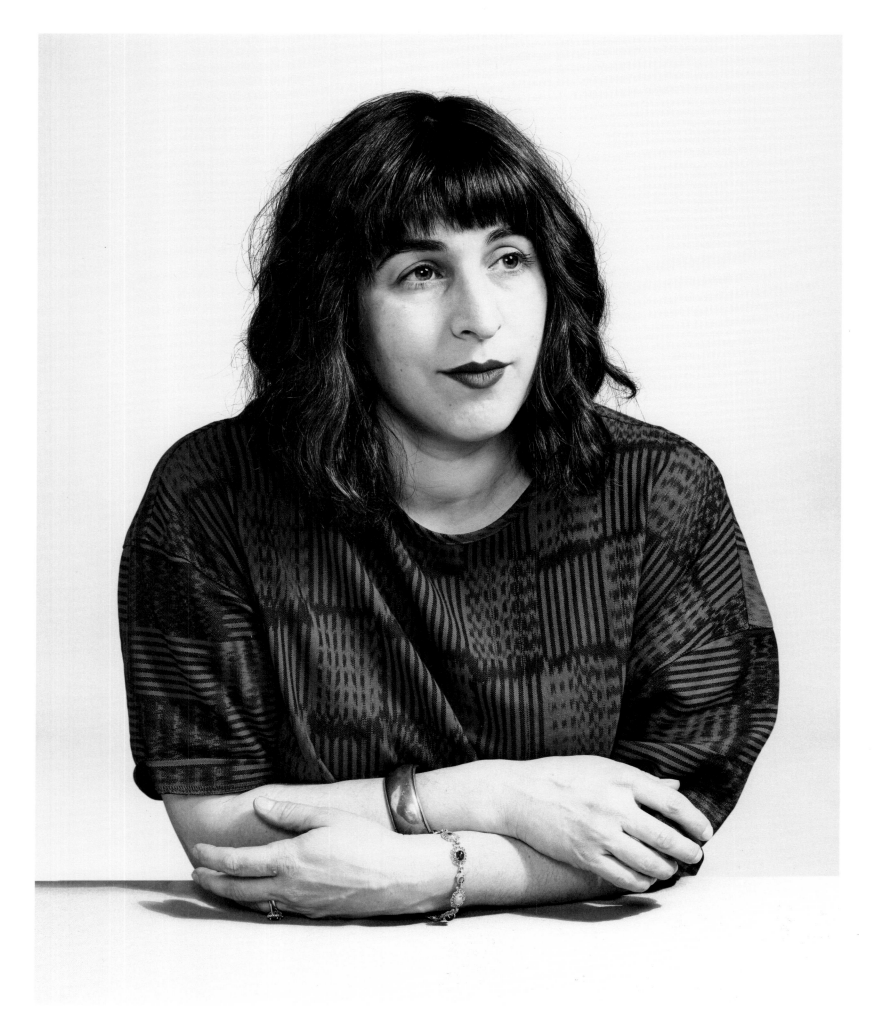

Woman with a Sheitel, Brooklyn, USA

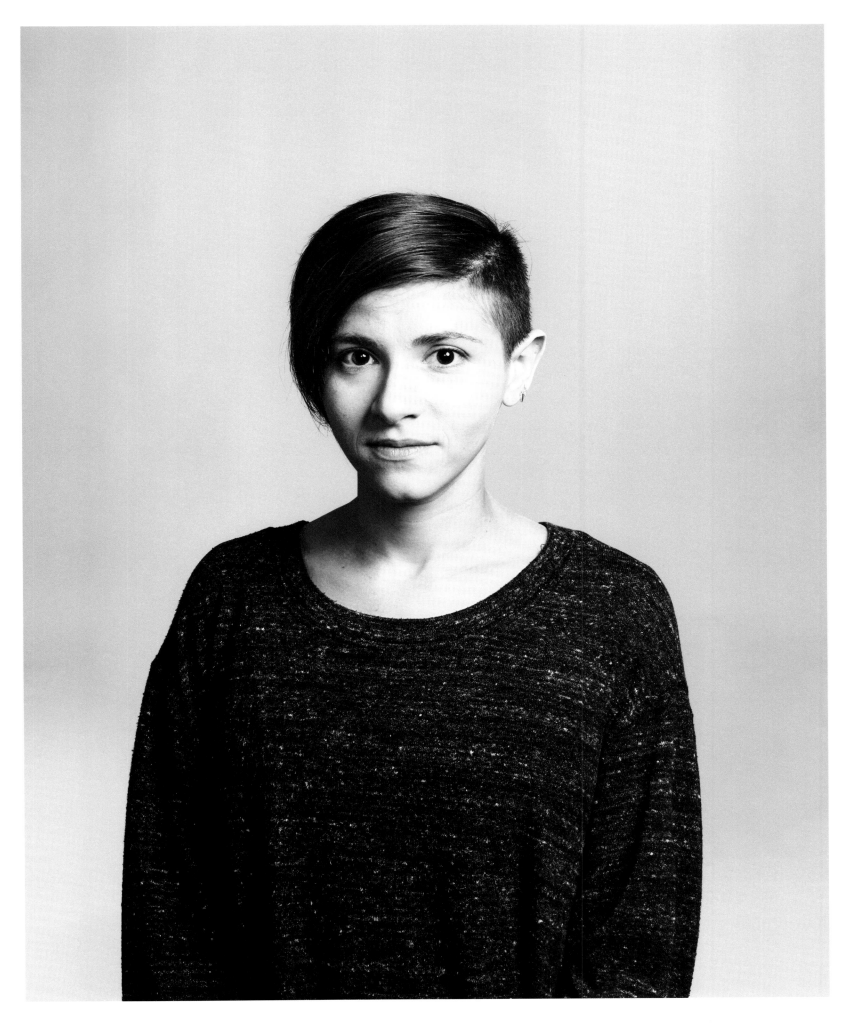

Actor, Brooklyn, USA

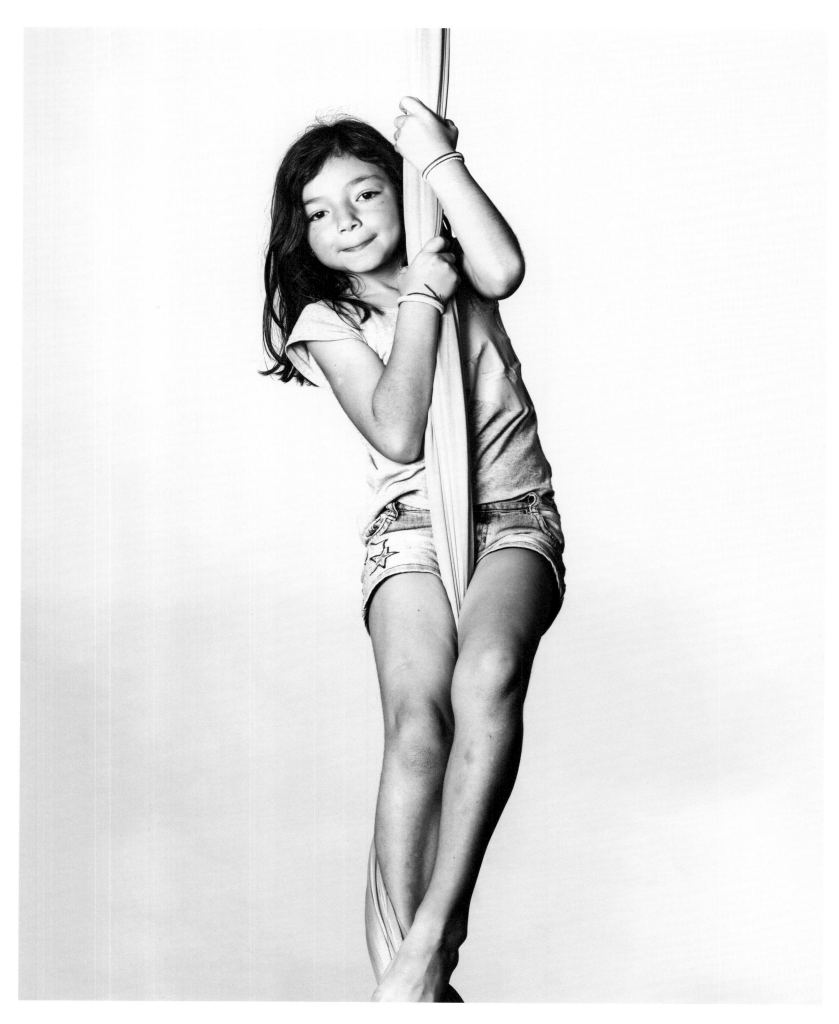

Young Gymnast, Buenos Aires, Argentina

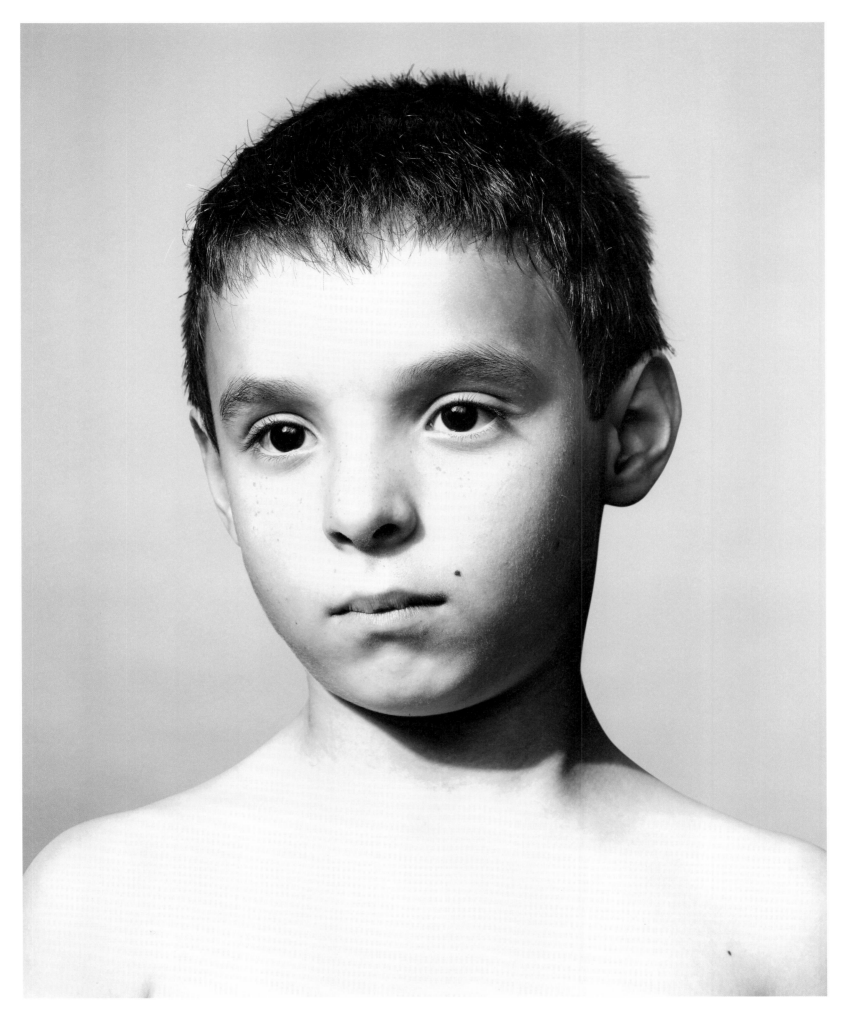

Young Boy, Buenos Aires, Argentina

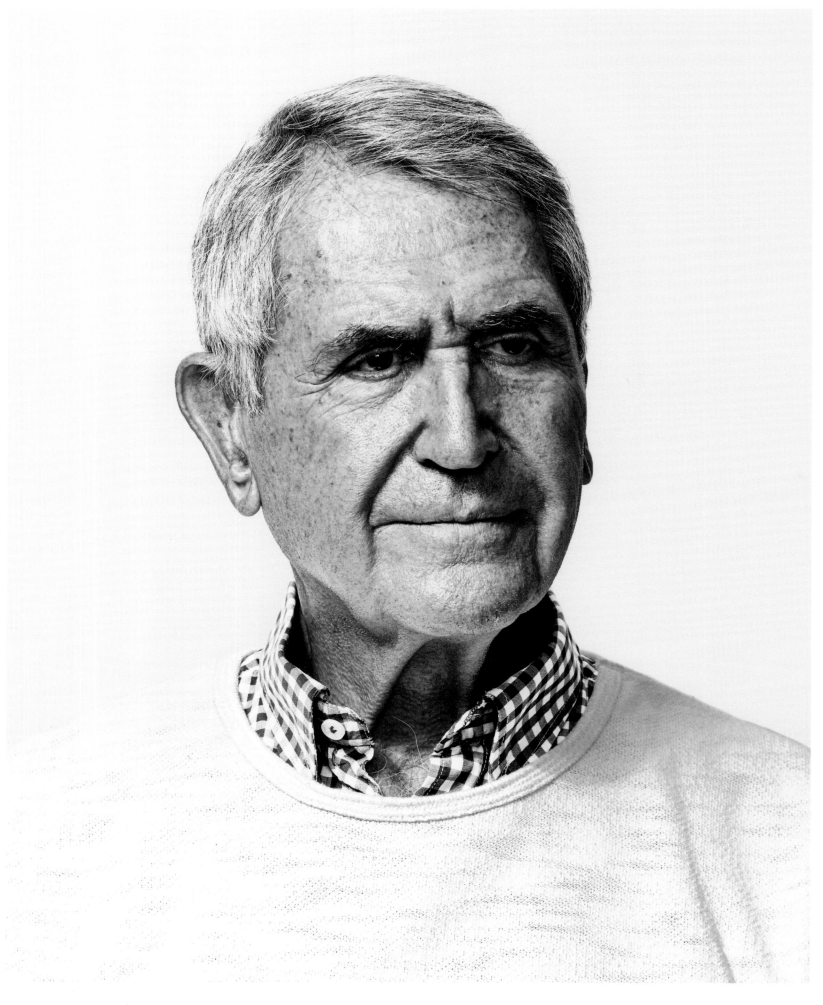

Guide, Buenos Aires, Argentina

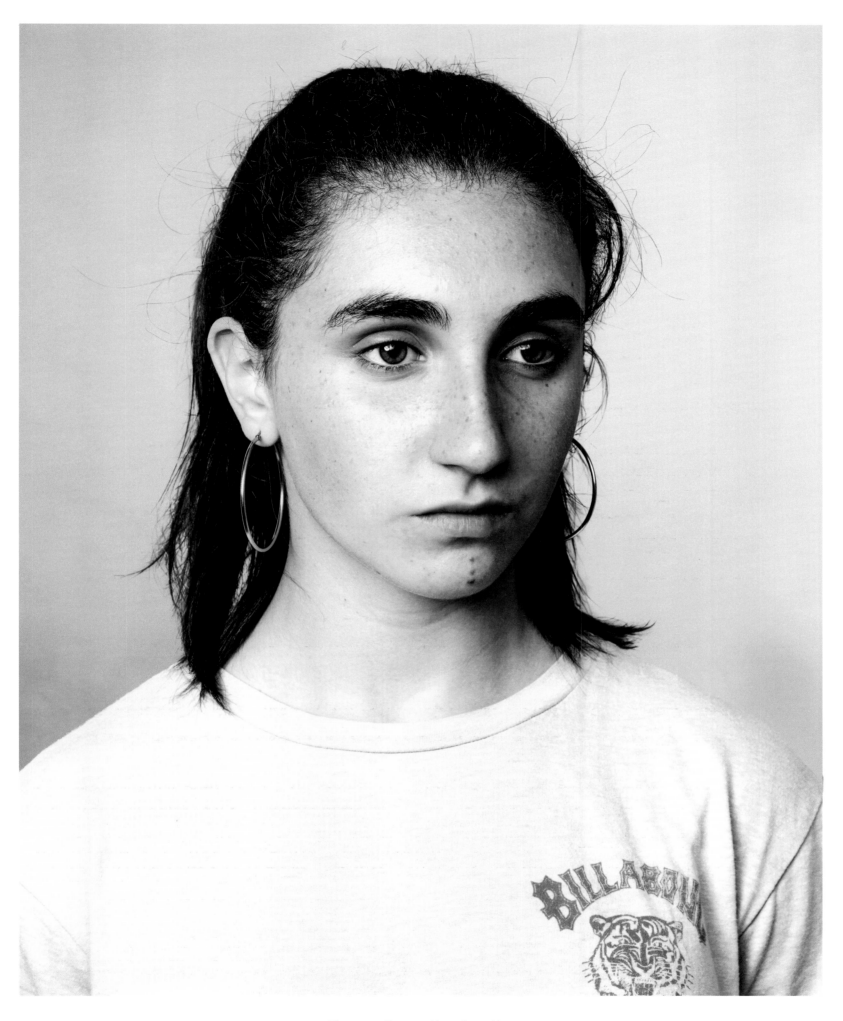

Teenager, Buenos Aires, Argentina

I asked Ani Zamba if she had any reservations about being included in a book of Jews. "No", she said. "I was born a Jew. Buddhism for me is a way of life."

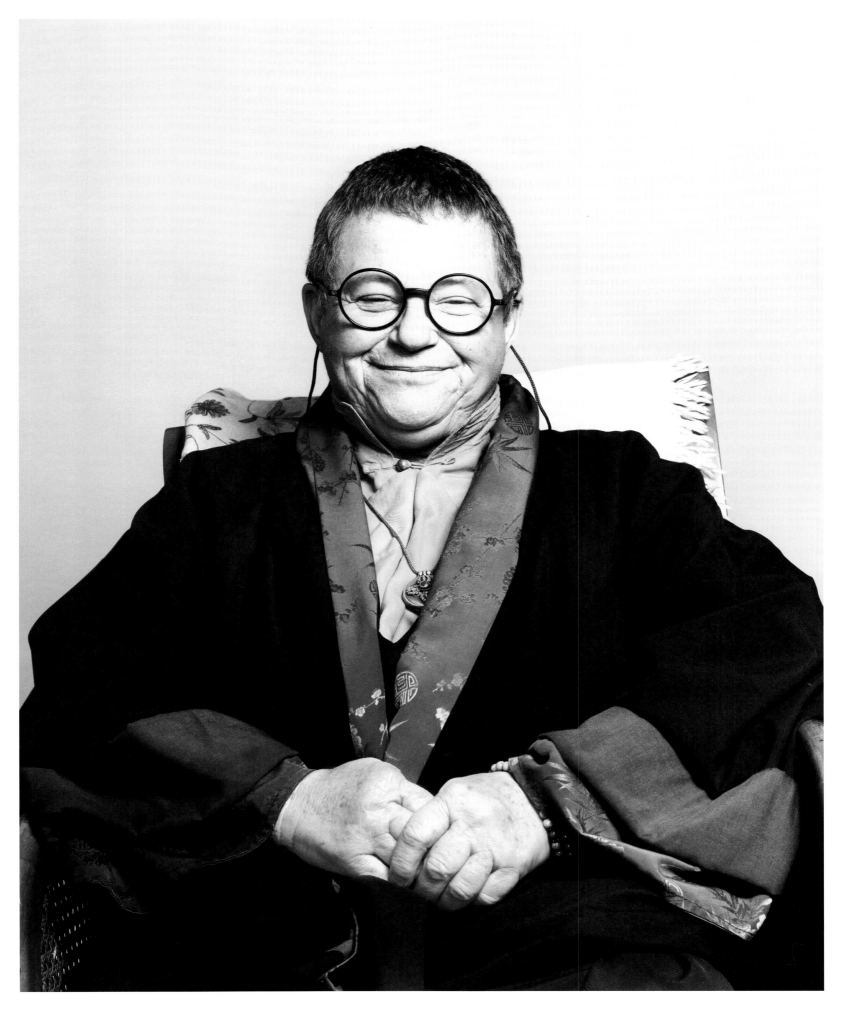

Buddhist Nun, Oxford, England

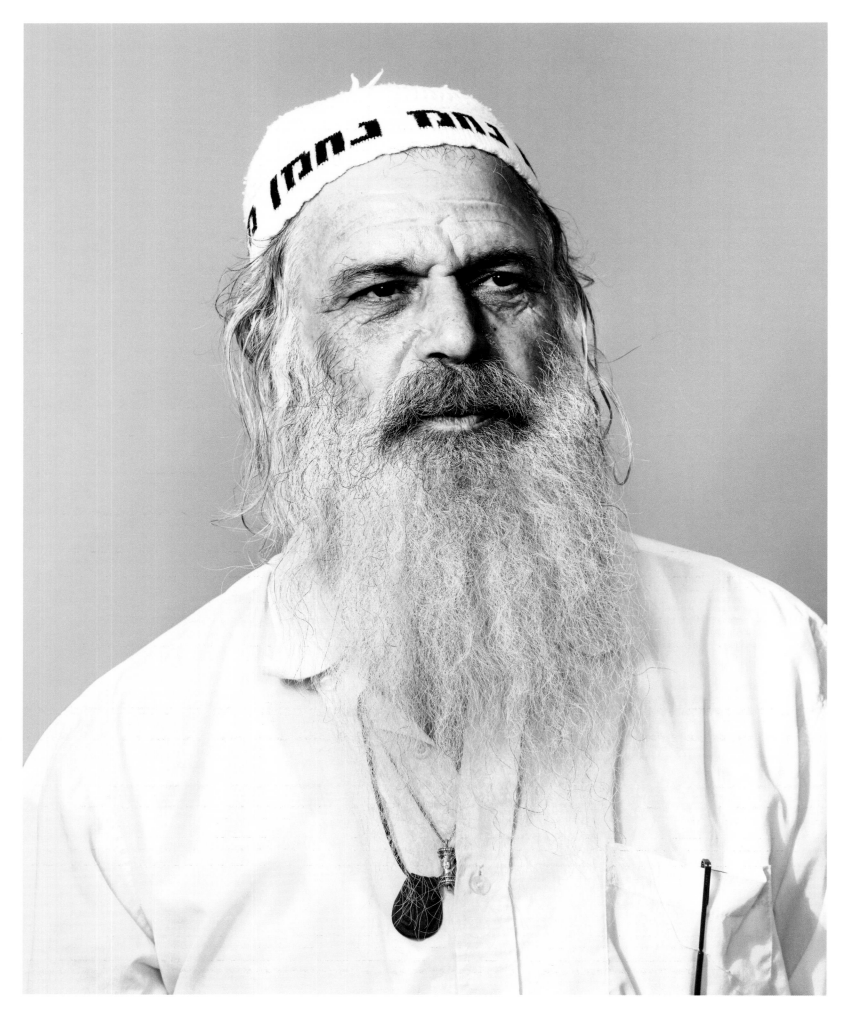

Follower of Rabbi Nachman I, Harish, Israel

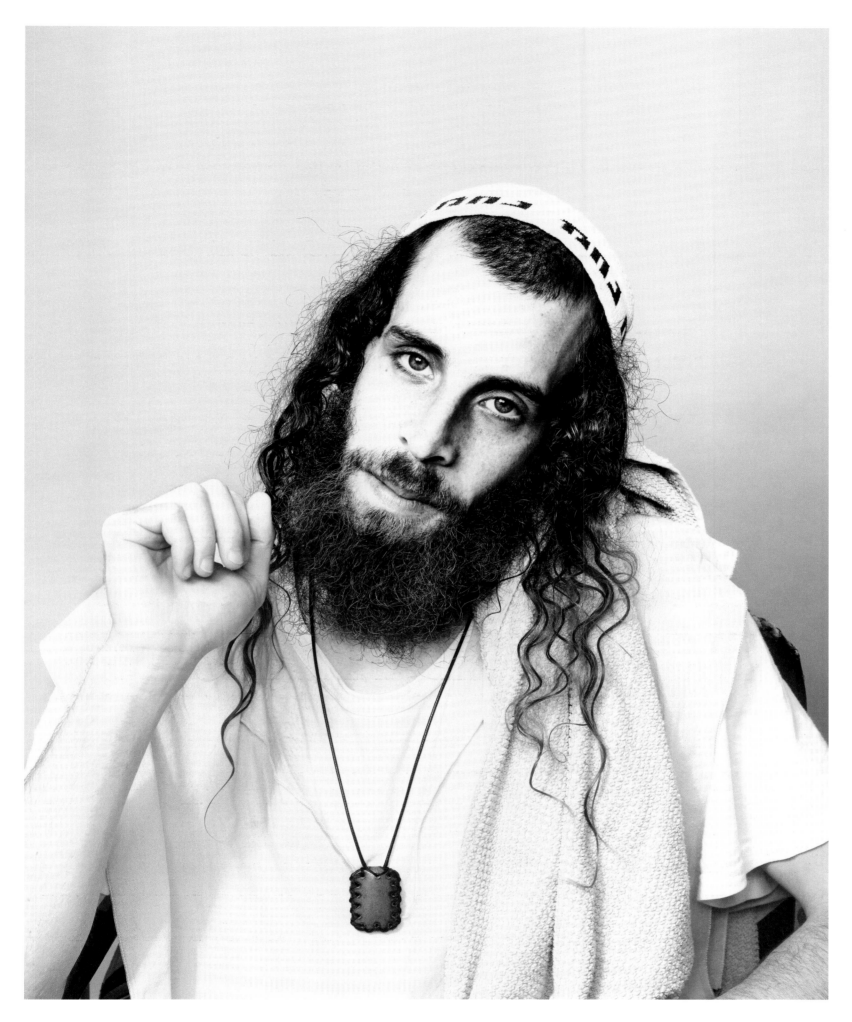

Follower of Rabbi Nachman II, Harish, Israel

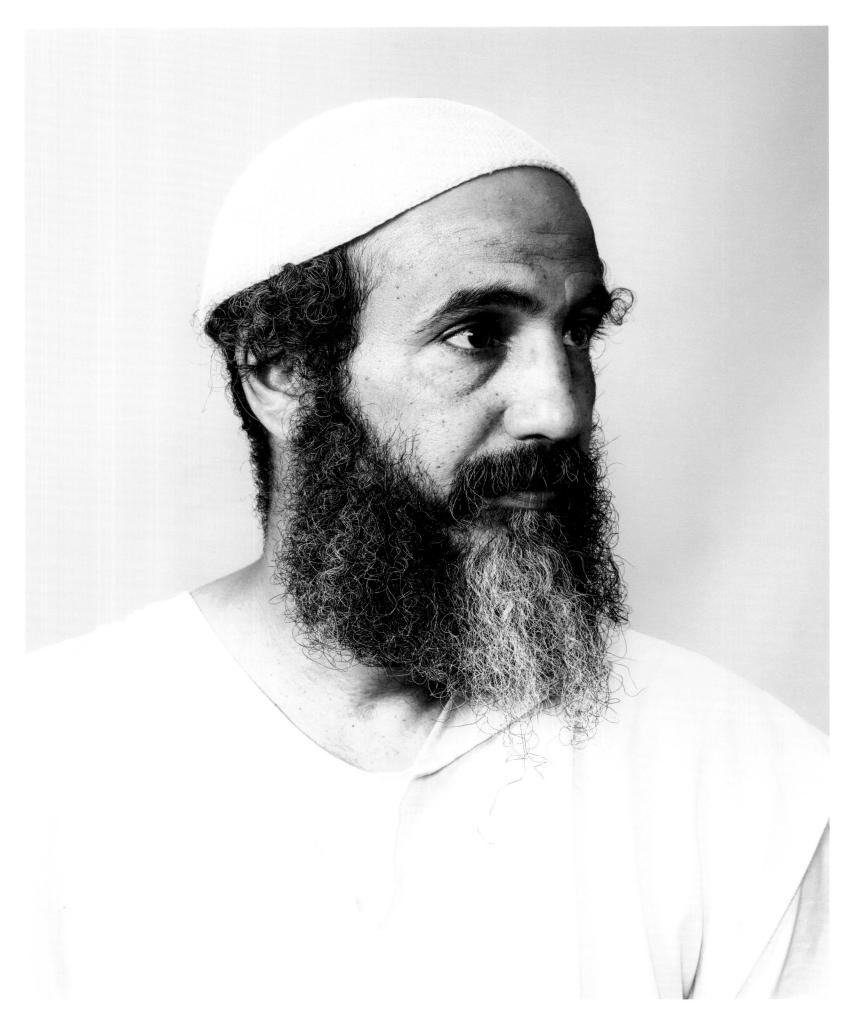

Community Leader, Harish, Israel

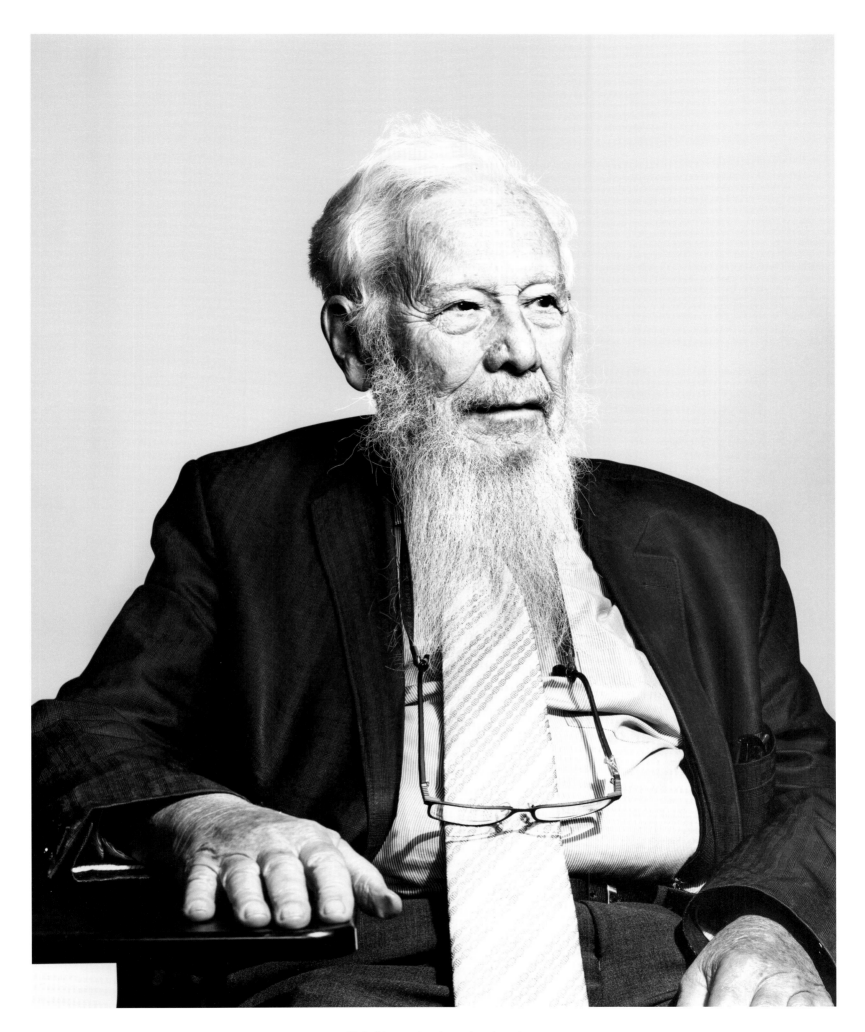

Nobel Laureate, Jerusalem, Israel

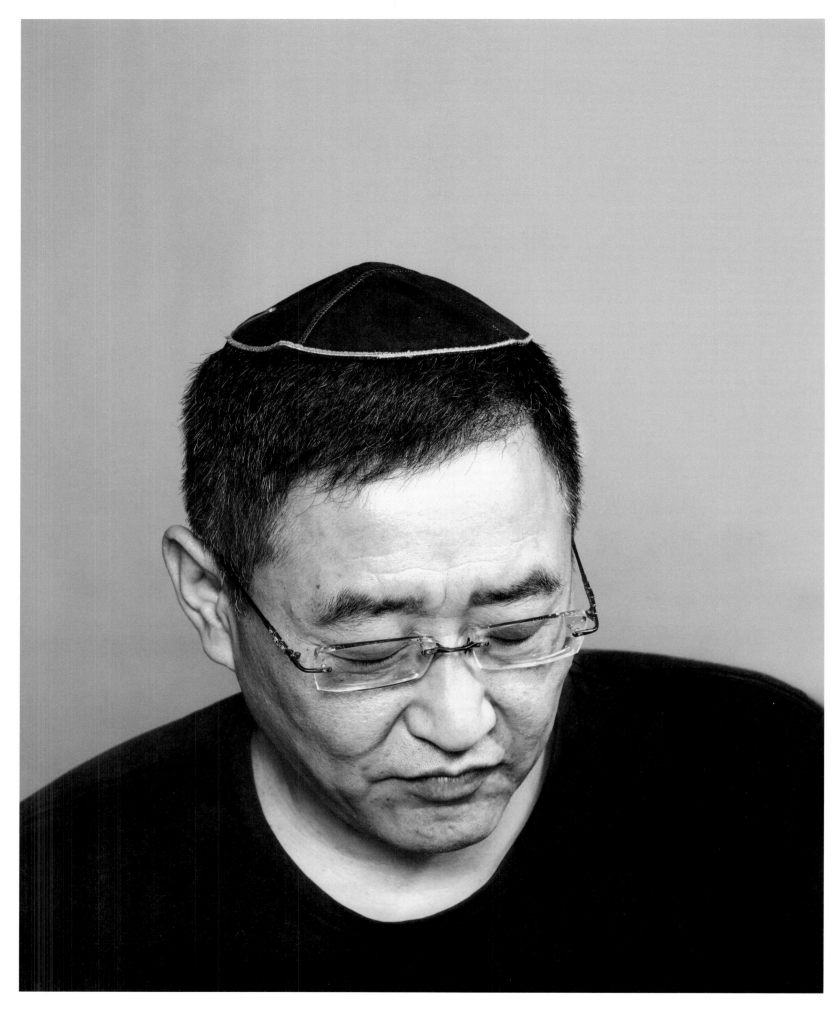

Kaifeng Jew I, Kaifeng, China

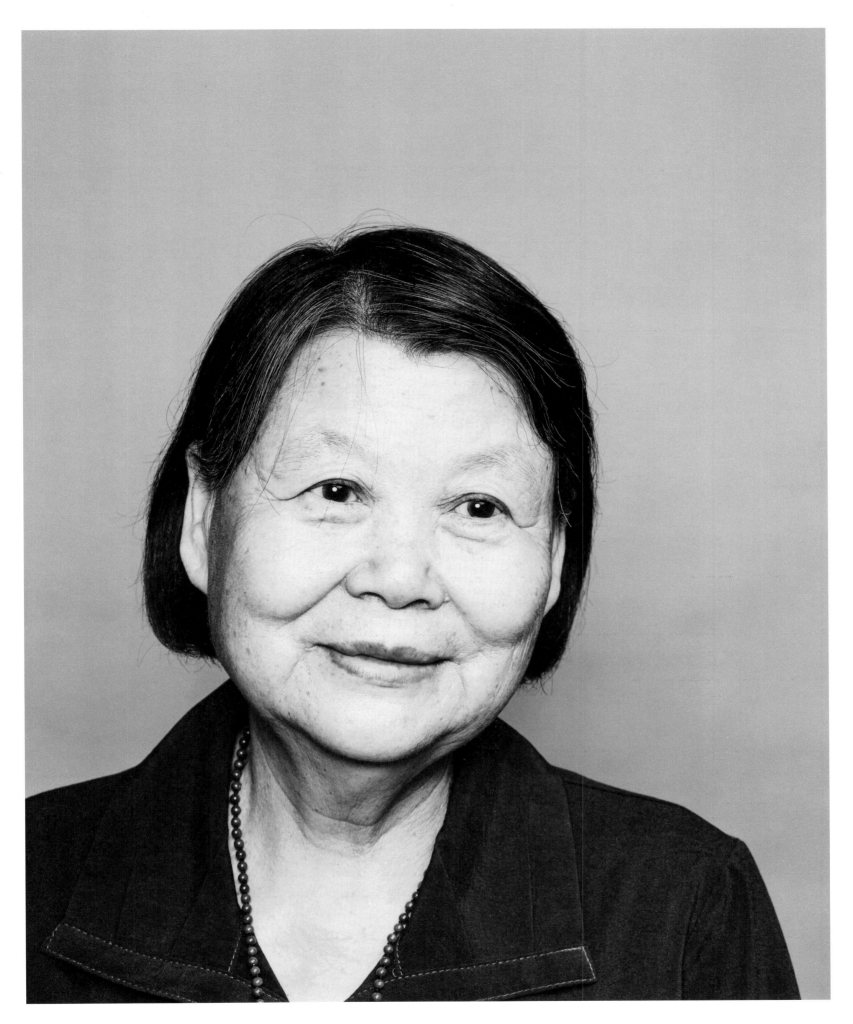

Kaifeng Jew II, Kaifeng, China

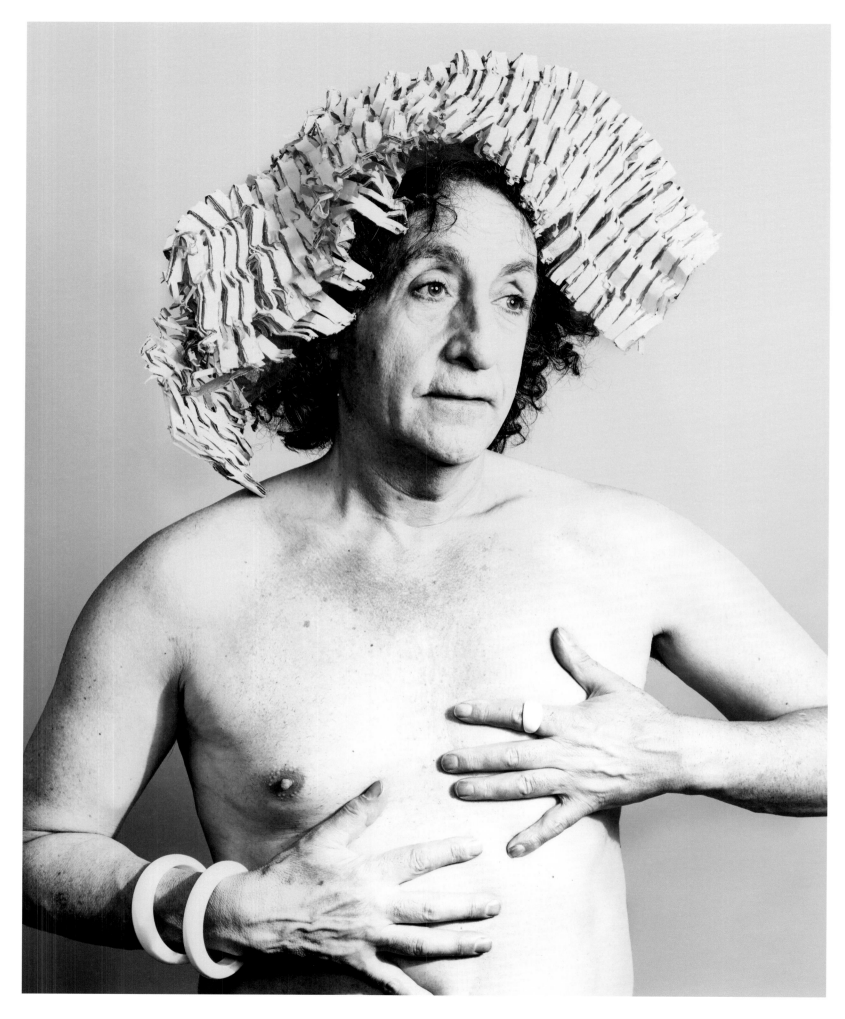

Socialite, London, England

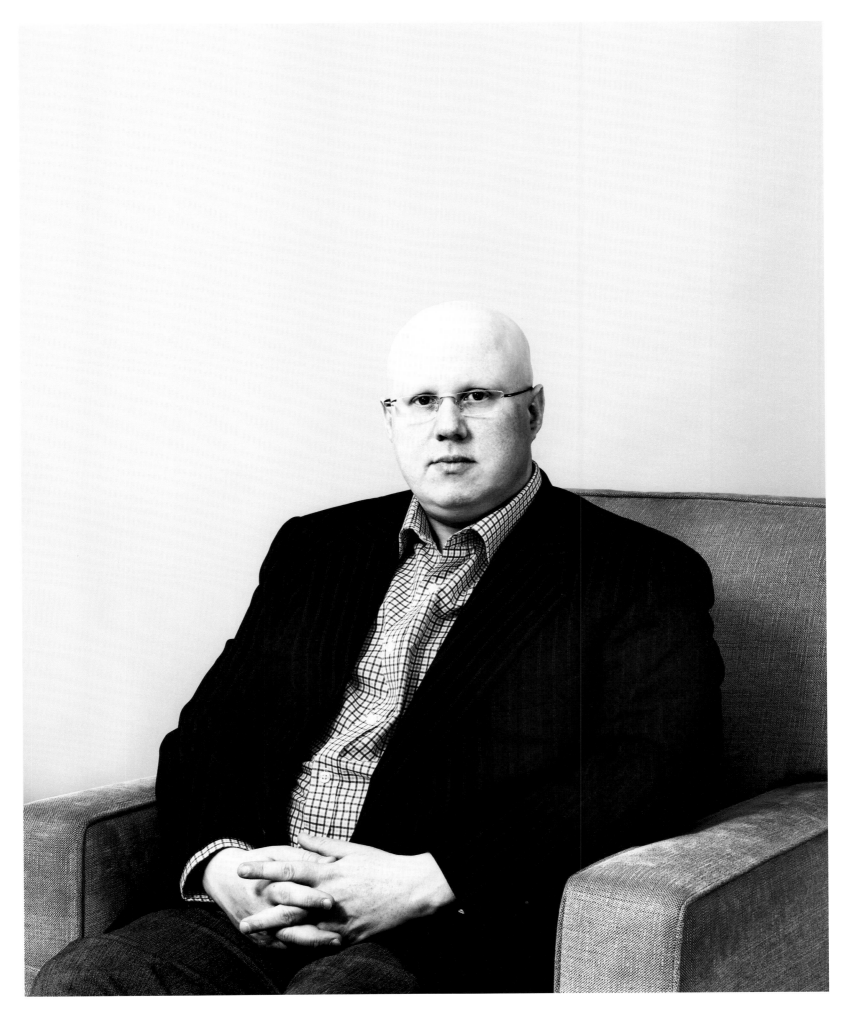

Comedian, London, England

I had the honour of a traditional coffee ceremony in the tiny house in Addis Ababa where I shot this portrait. We did it twice, the first time the pot exploded and coffee flew everywhere. The second attempt was more successful, and delicious. I'm convinced the best coffee comes from Ethiopia.

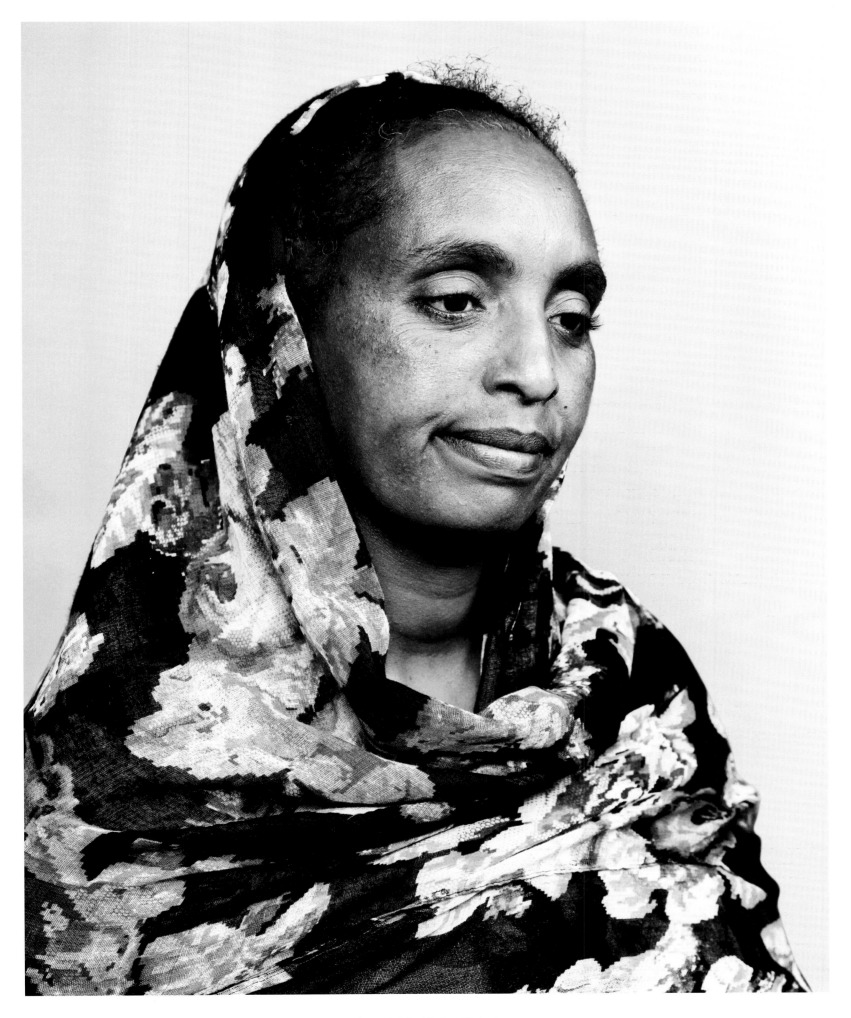

Sister, Addis Ababa, Ethiopia

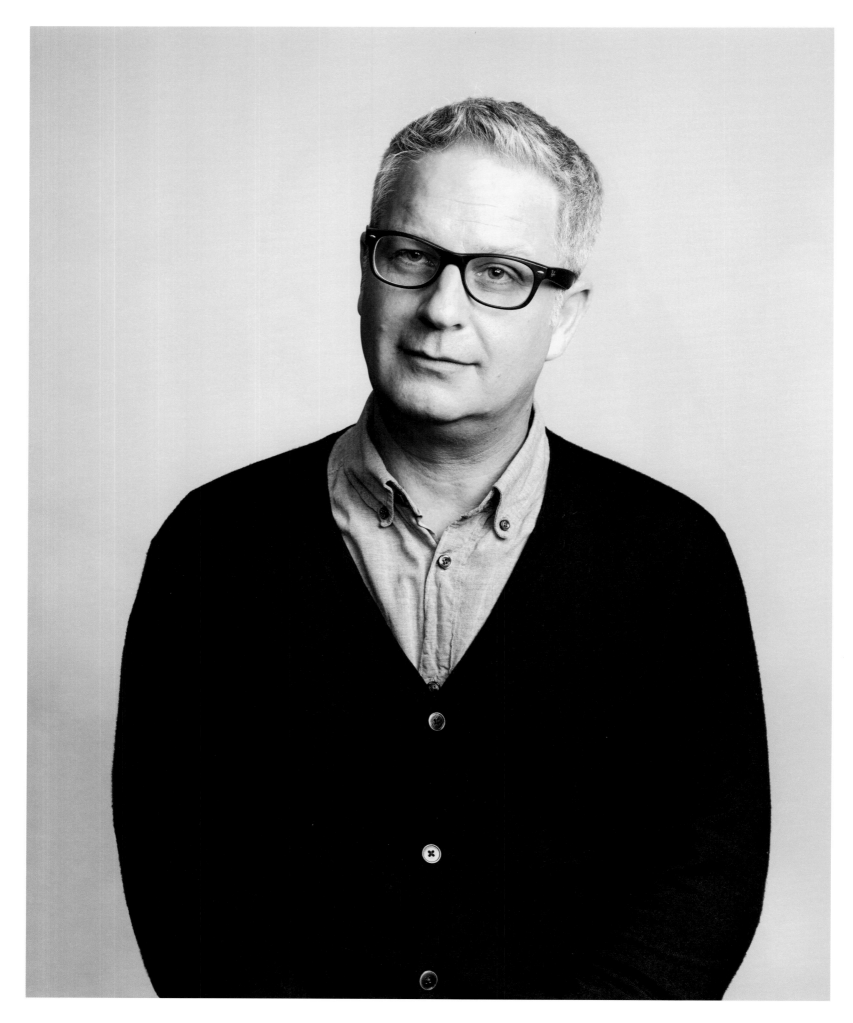

Professor, London, England

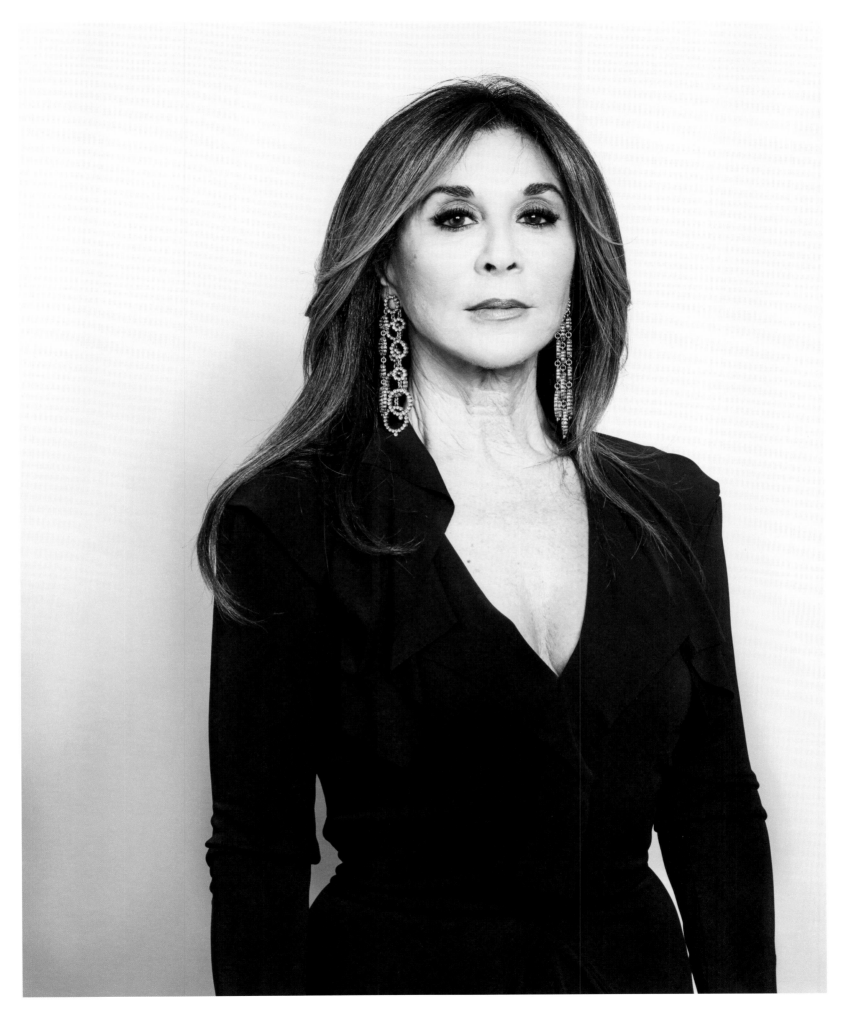

Glamorous Woman, London, England

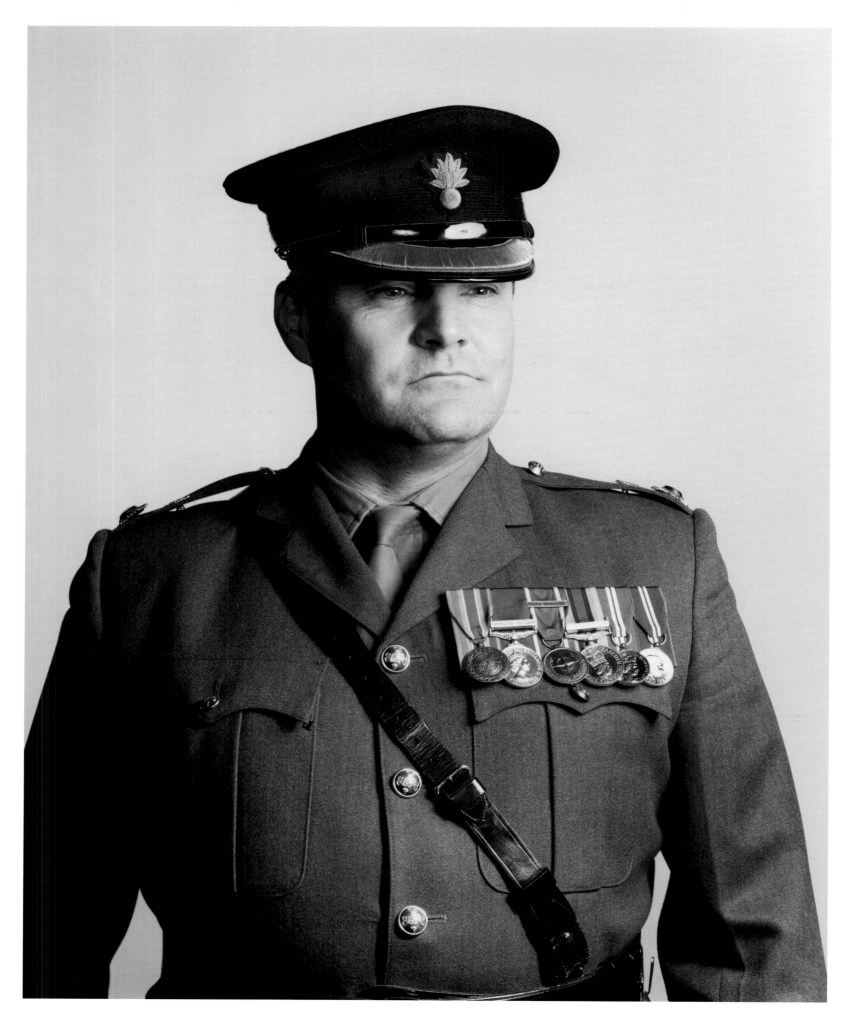

British Army Officer, London, England

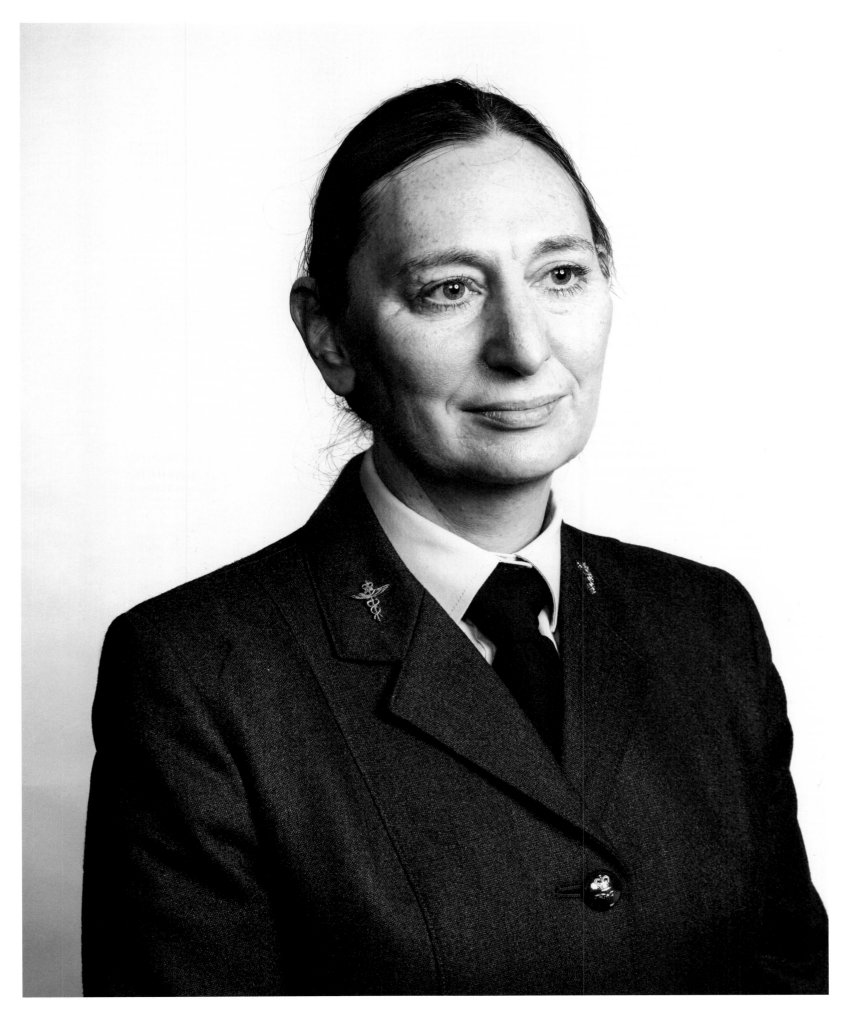

Medical Officer, London, England

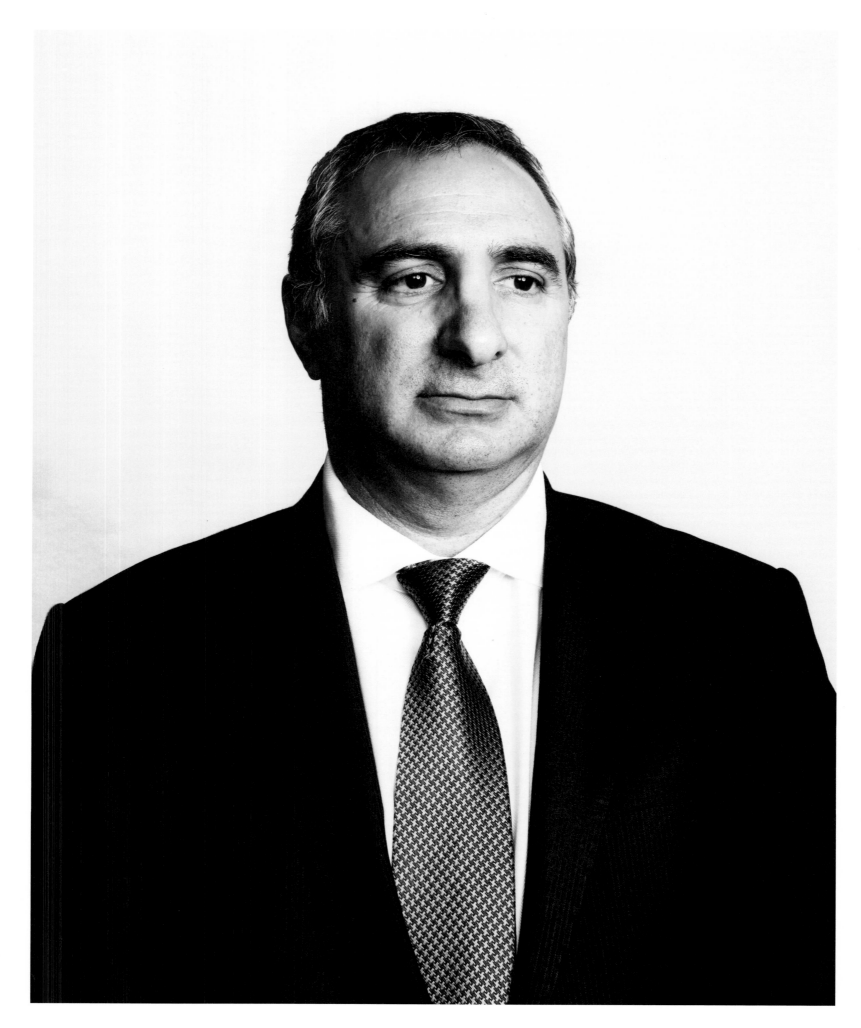

Ambassador, London, England

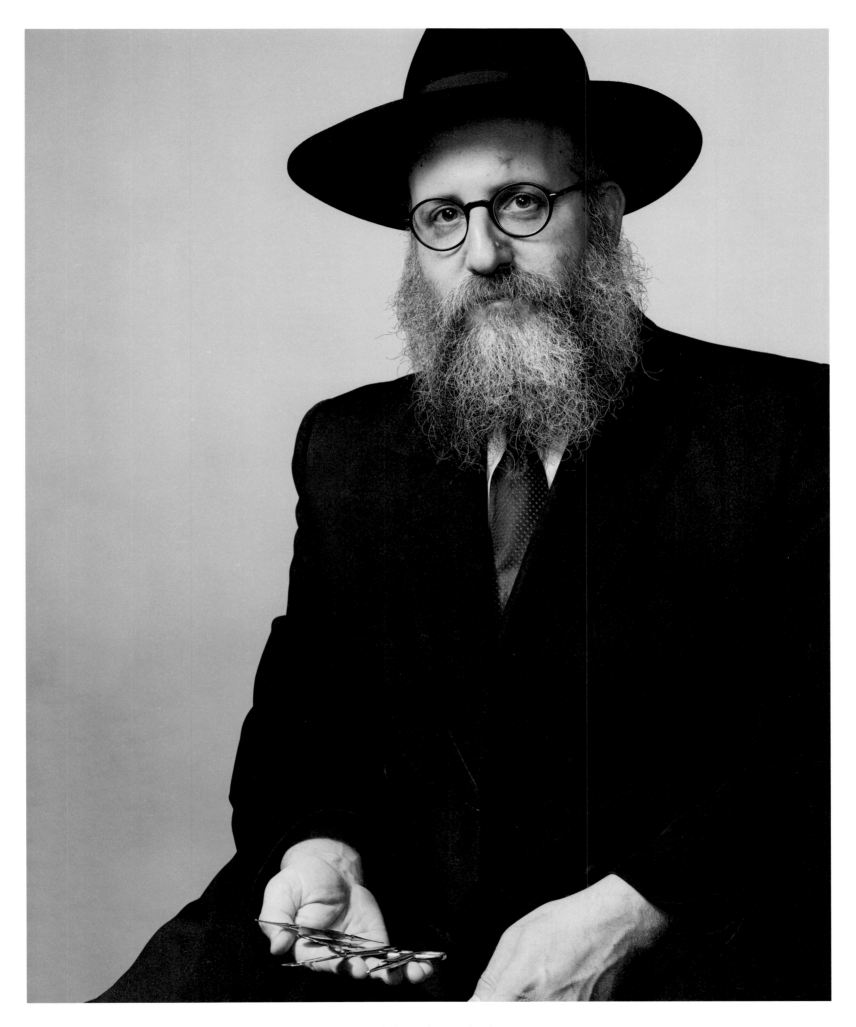

Mohel, London, England

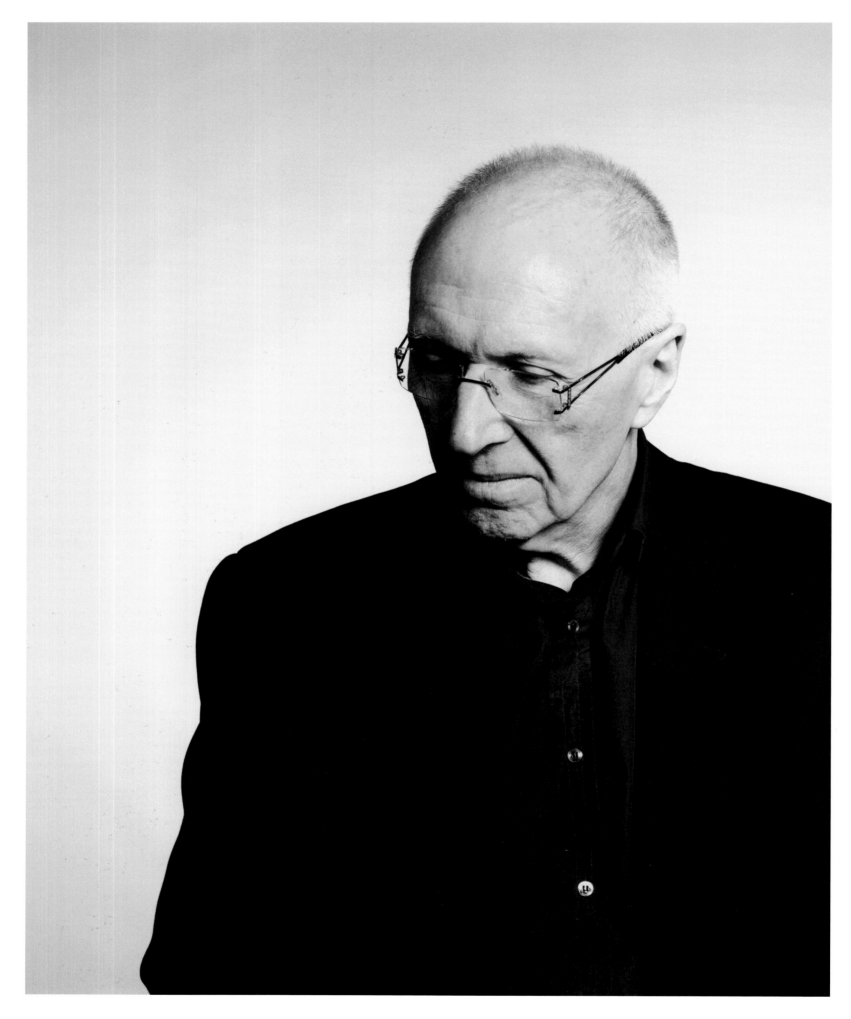

Scientist, London, England

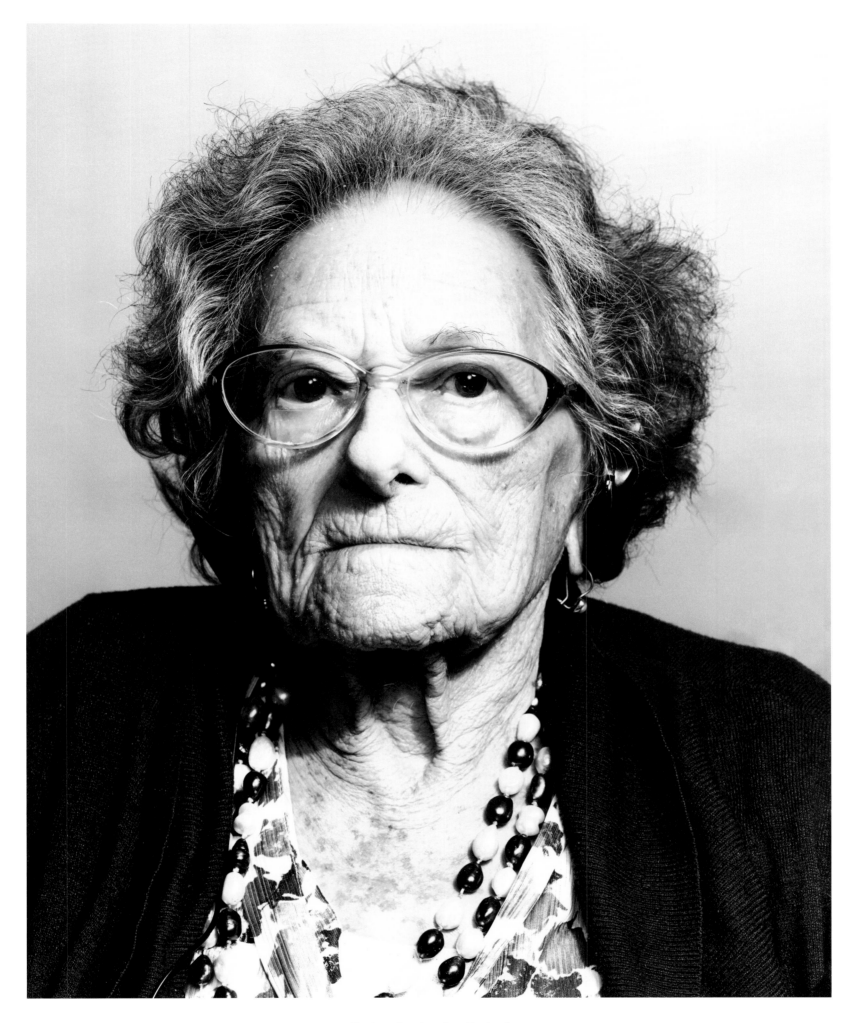

Centenarian, London, England

I photographed Lloyd Kaufman, head of Troma
Entertainment and creator of the Toxic Avenger, at his
Long Island studio. He couldn't have been more hospitable.
After the shoot I asked if I should title his portrait
'Schlock Horror Producer'. I immediately knew I said
the wrong thing. He glowered at me. "My movies
take years and millions of dollars to make; I gave Kevin
Costner his first acting break." My apologies Lloyd.

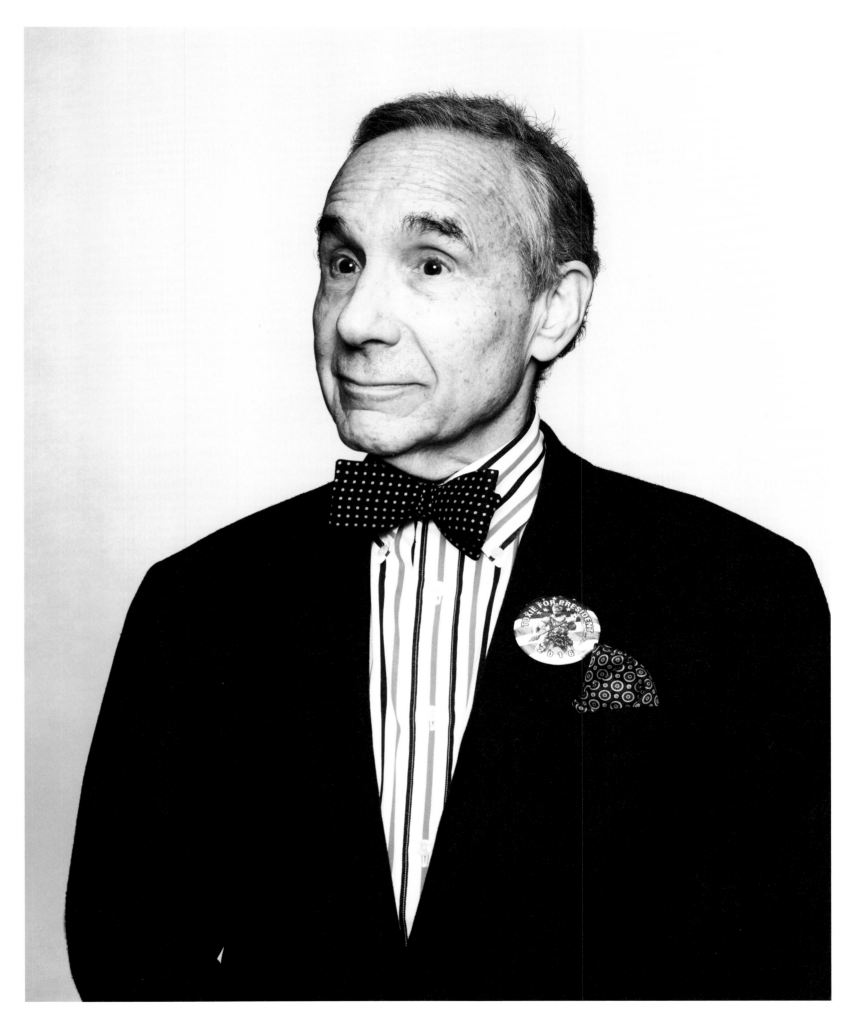

Teen Horror Producer, Long Island City, USA

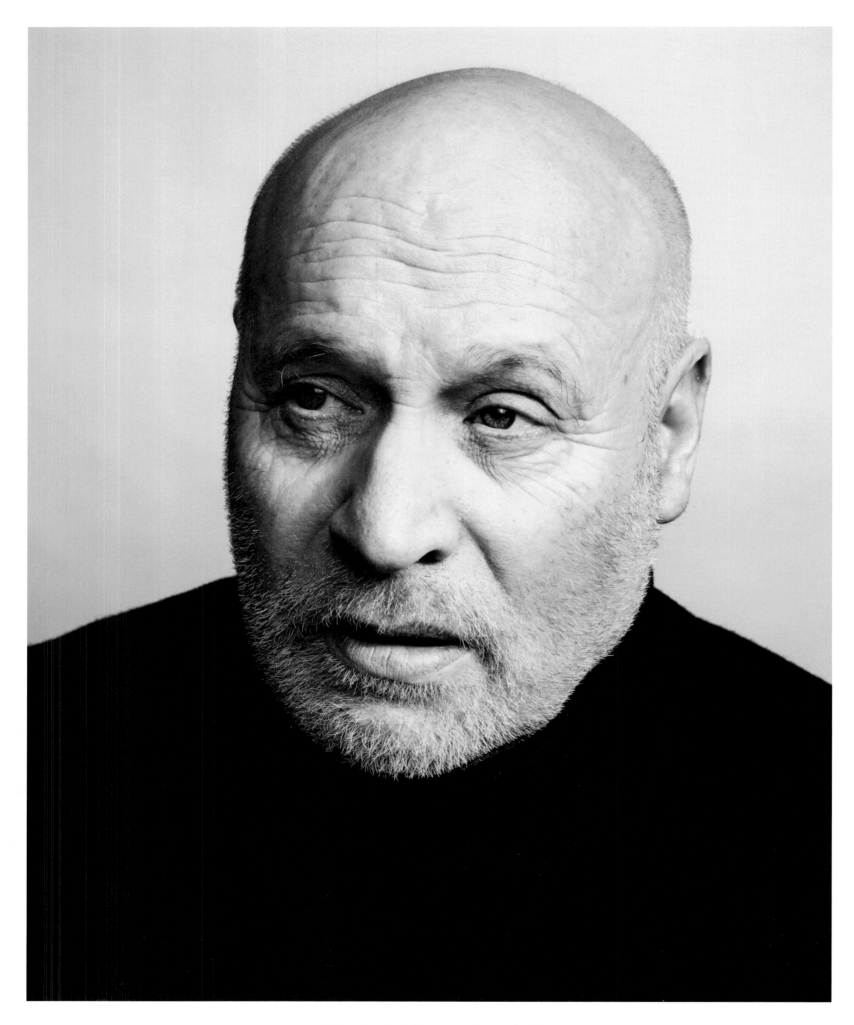

Schizophrenia Sufferer, London, England

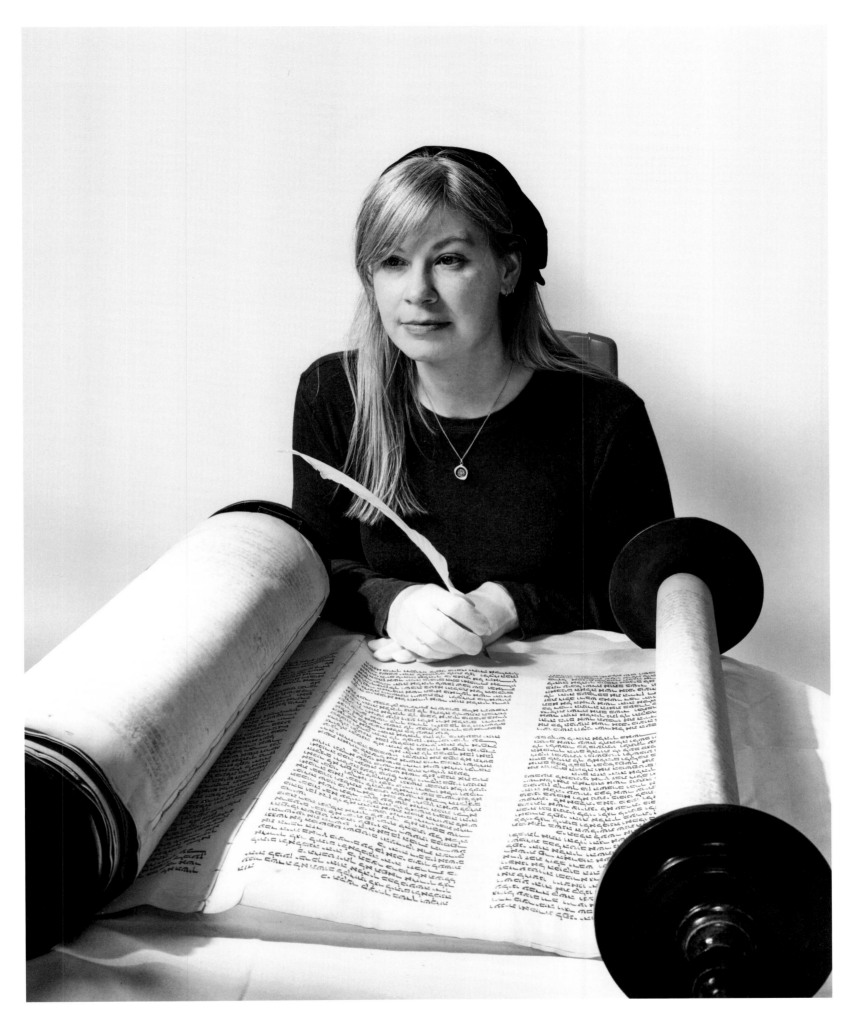

Soferet, London, England

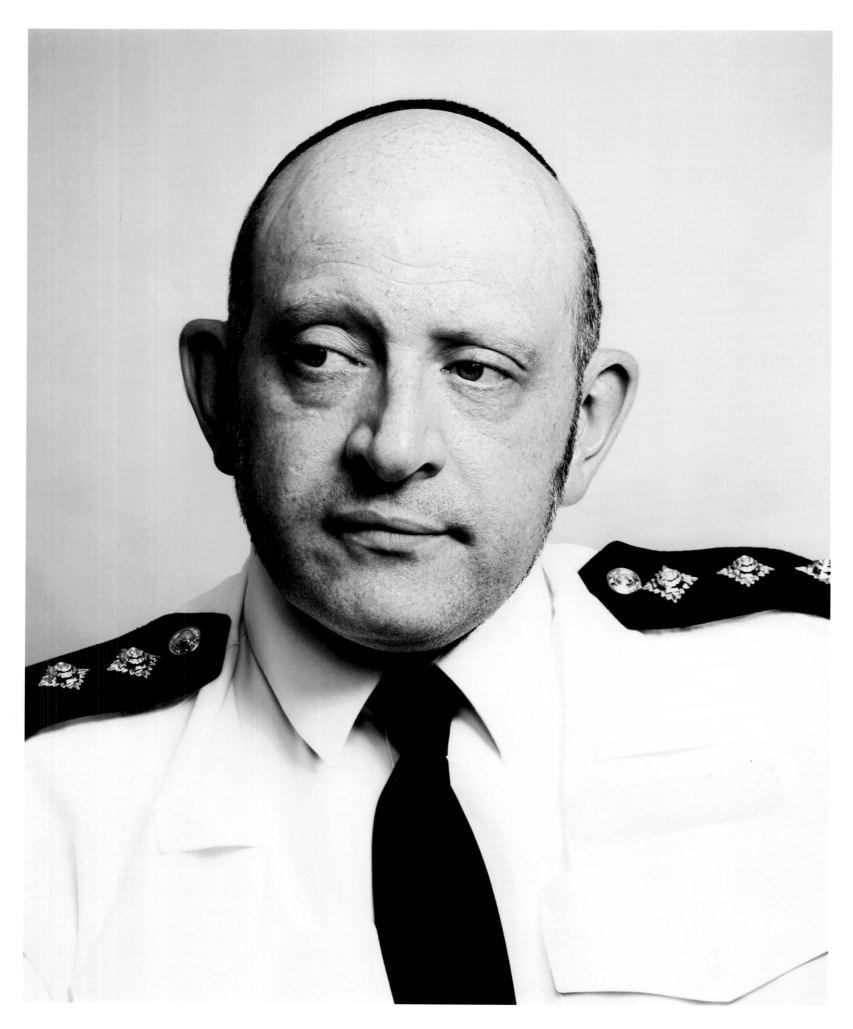

Policeman, London, England

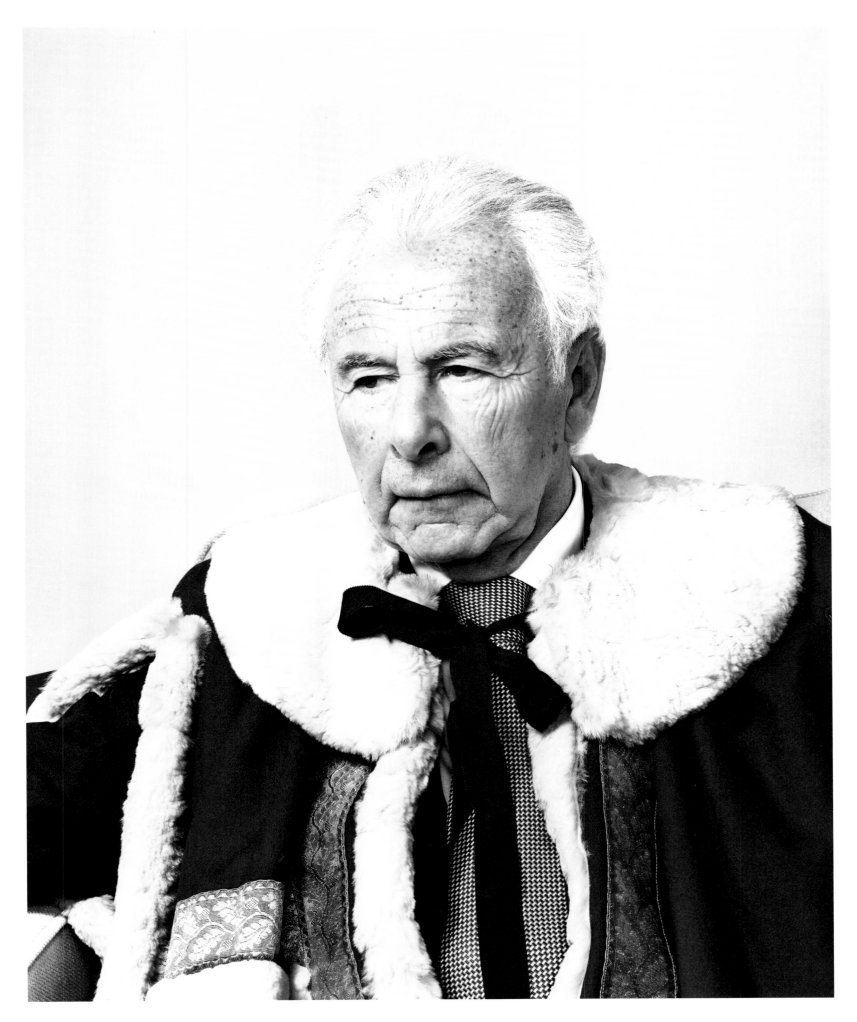

Member of the House of Lords, London, England

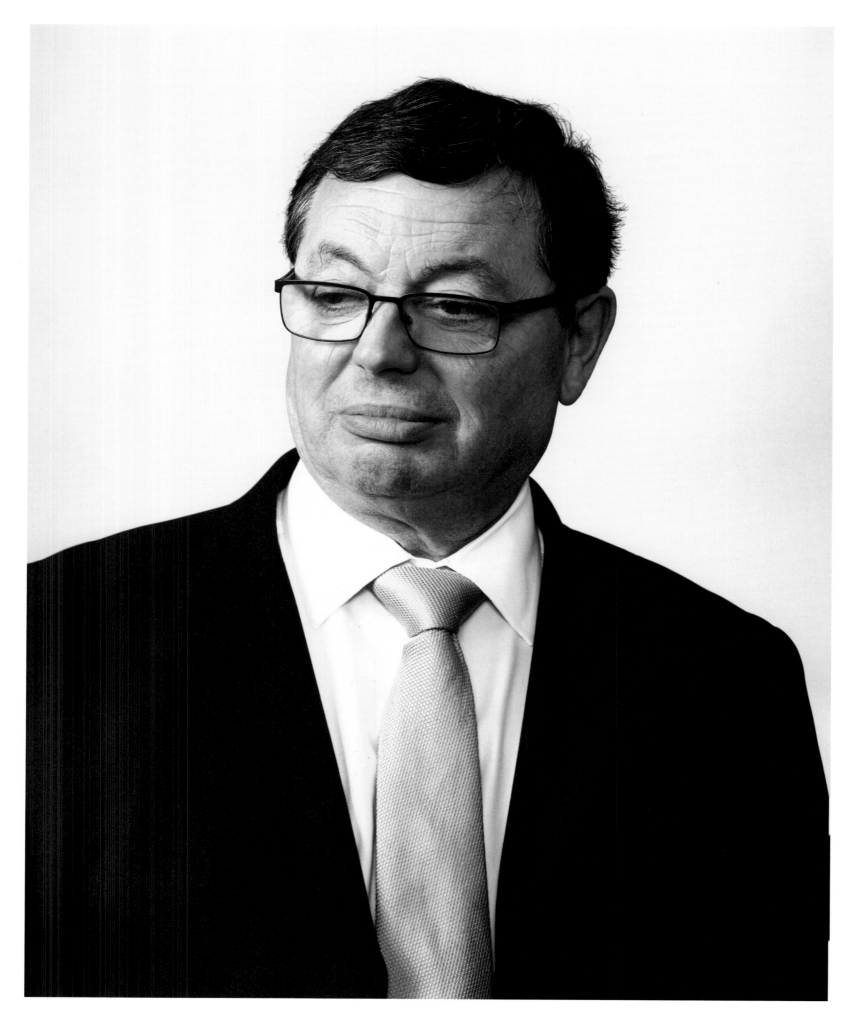

Judge, London, England

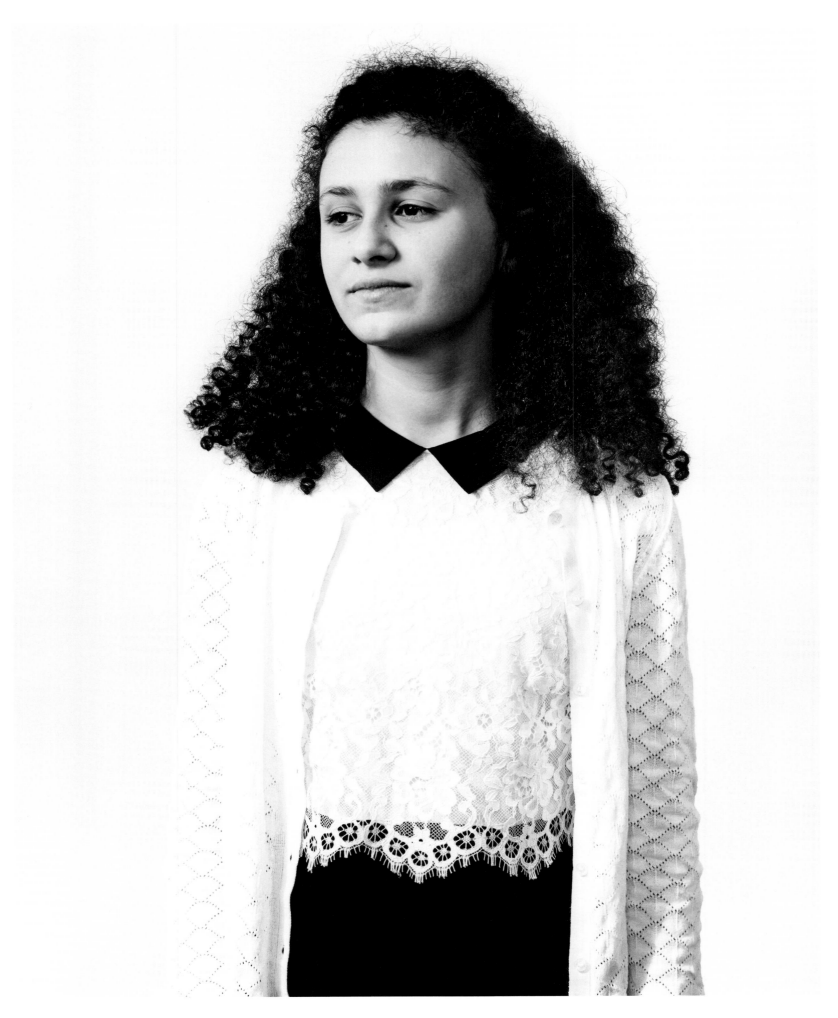

Bat Mitzvah, London, England

I spent a day attempting to photograph a woman wearing
a veil. I knew it was an important part of the story I had
to tell, but I got nowhere. Even a local photographer who
was helping me, abandoned the quest. After a while I got a
call from a friend who seemed to know all about it. "Well
it's a small community, you know?" He told me his mother
makes veils, that his wife wears one and I could photograph
her later that evening. I waited. I ate a lot of pastries,
and eventually went to his house close to midnight for
the portrait.

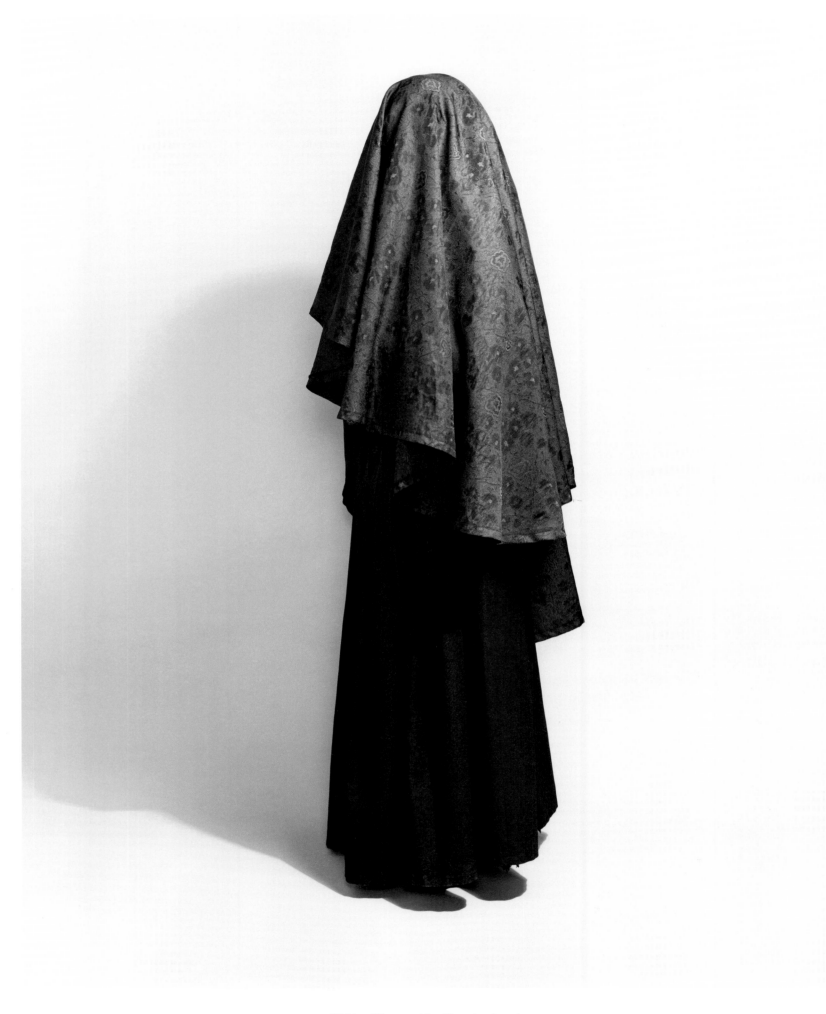

Hidden Woman, Mea Shearim, Israel

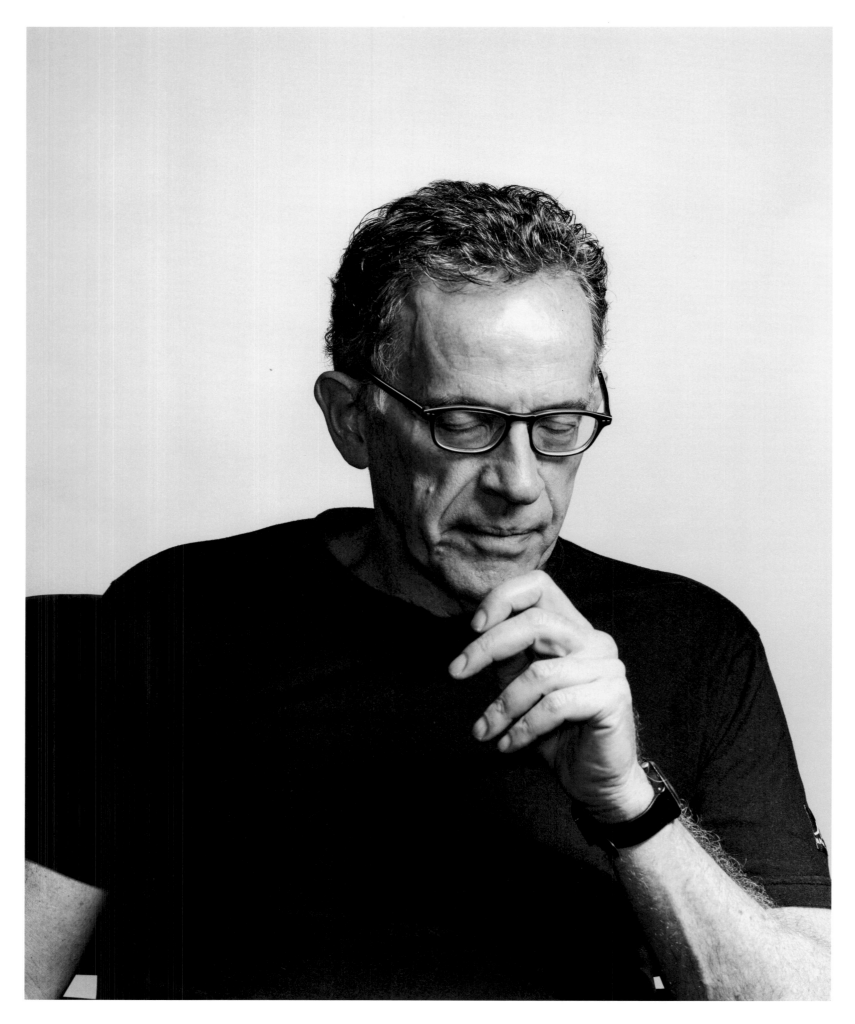

Psychiatrist, London, England

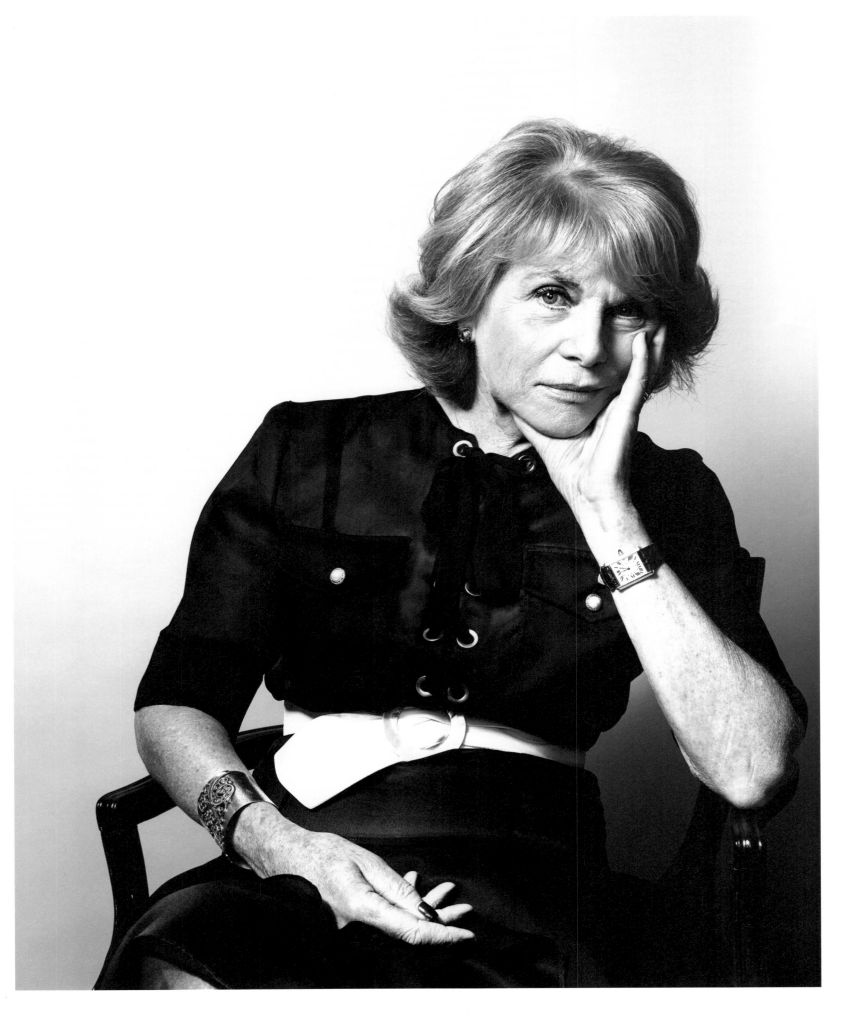

Historian, London, England

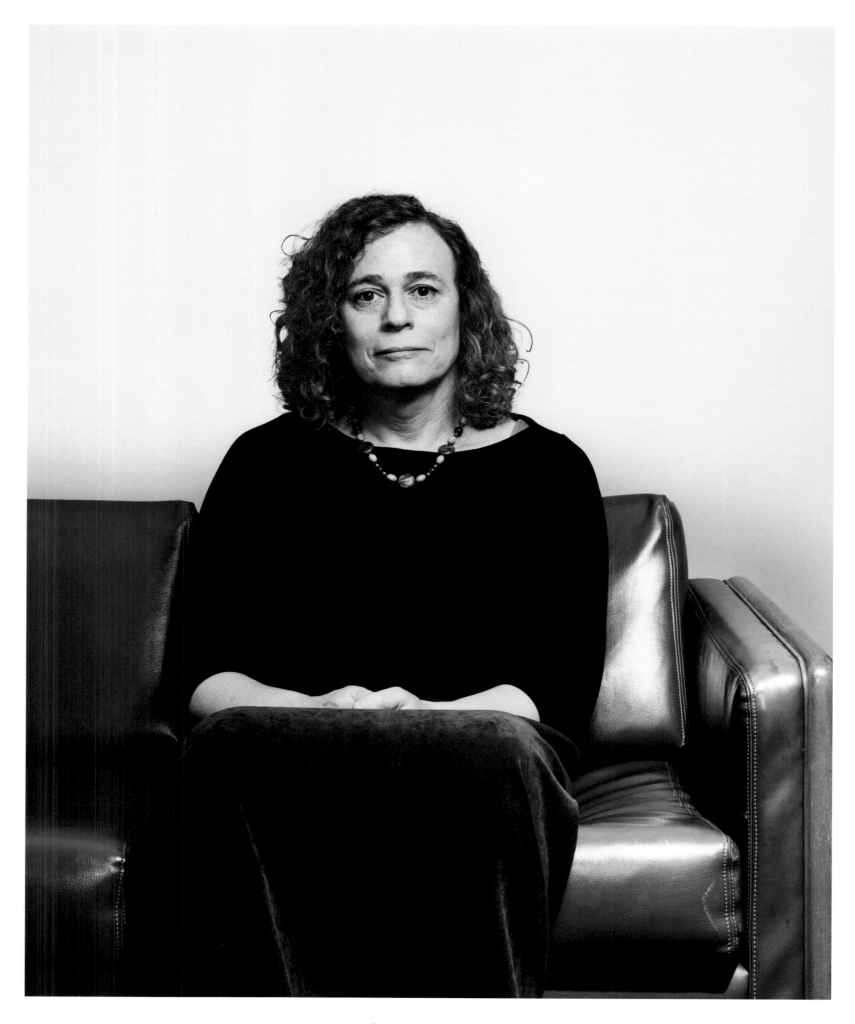

Poet, Manhattan, USA

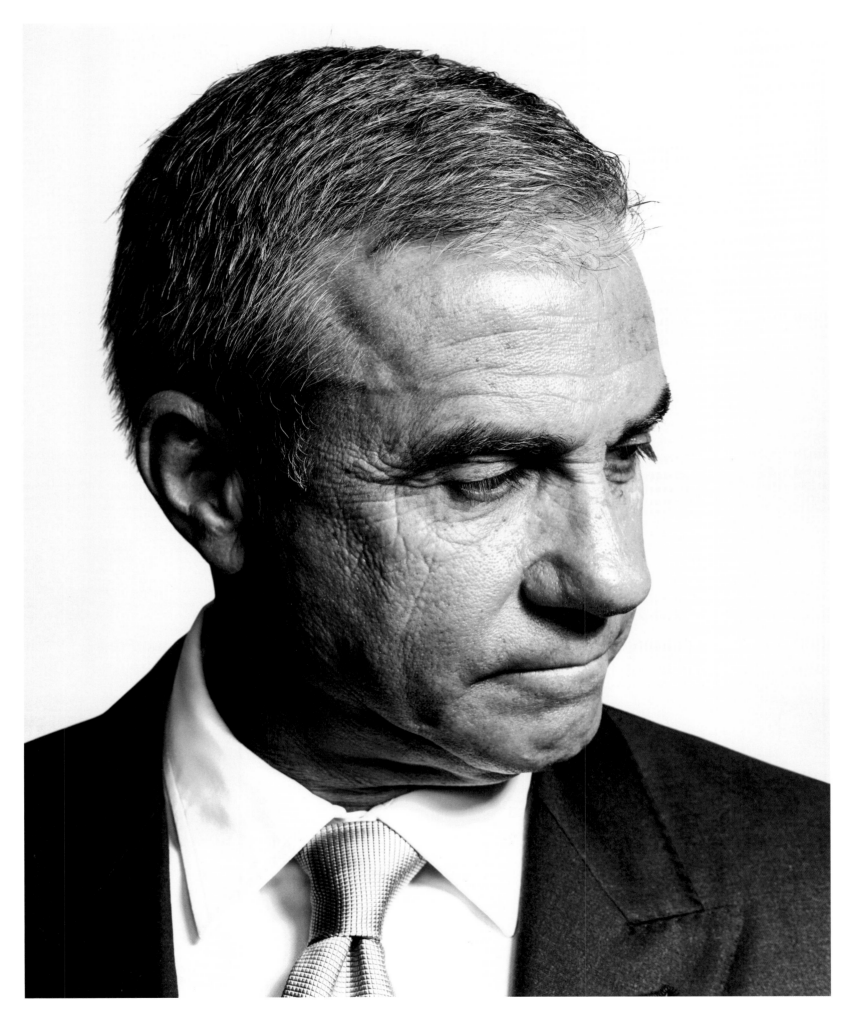

Wall Street Financier, Manhattan, USA

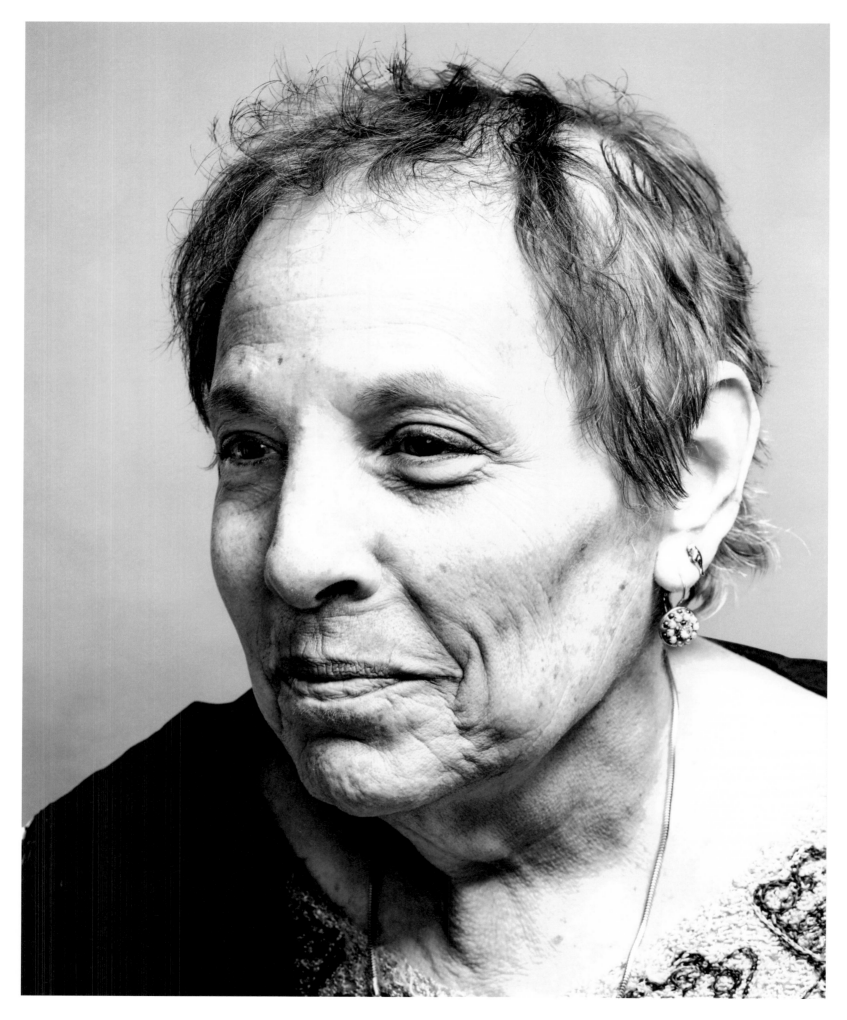

Cancer Survivor, Marco Island, USA

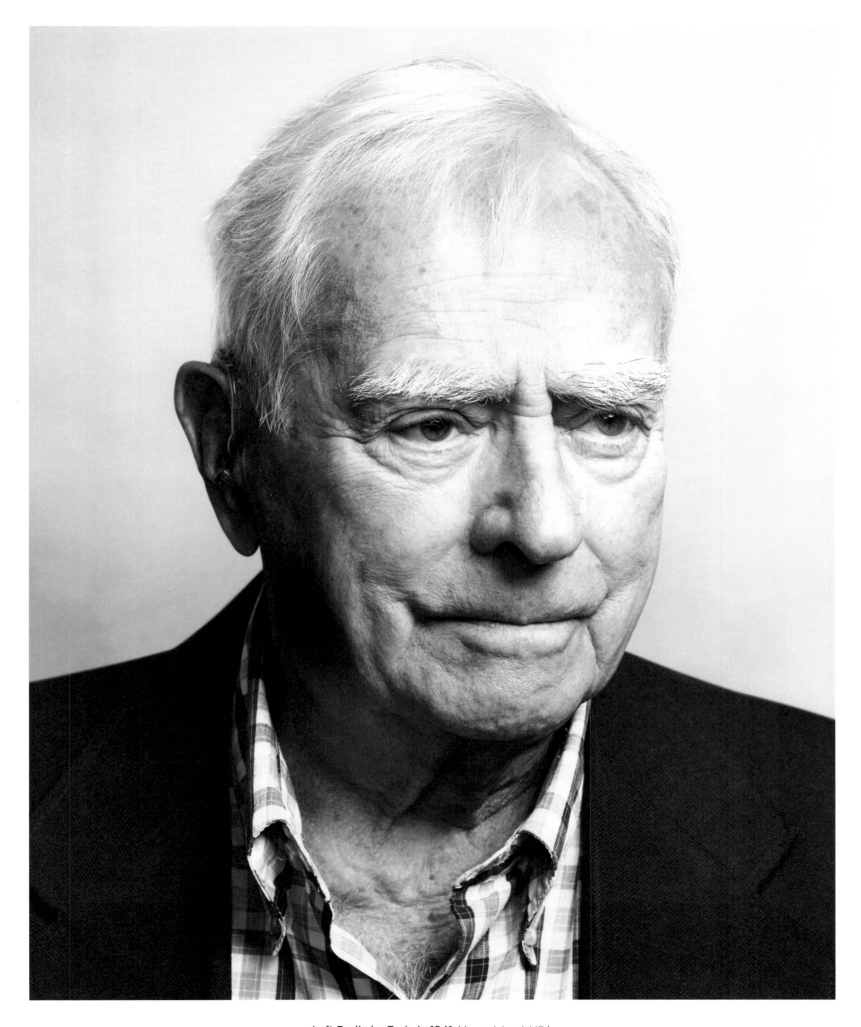

Left Berlin by Train in 1941, Marco Island, USA

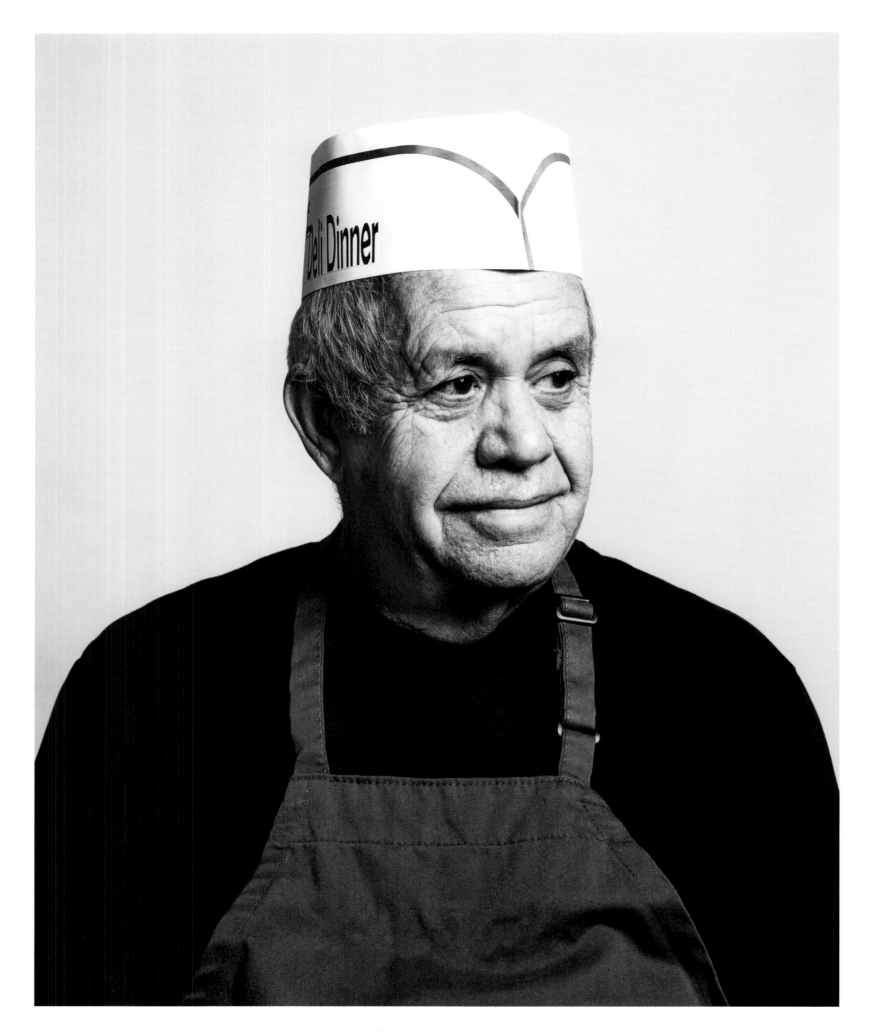

Deli Chef, Marco Island, USA

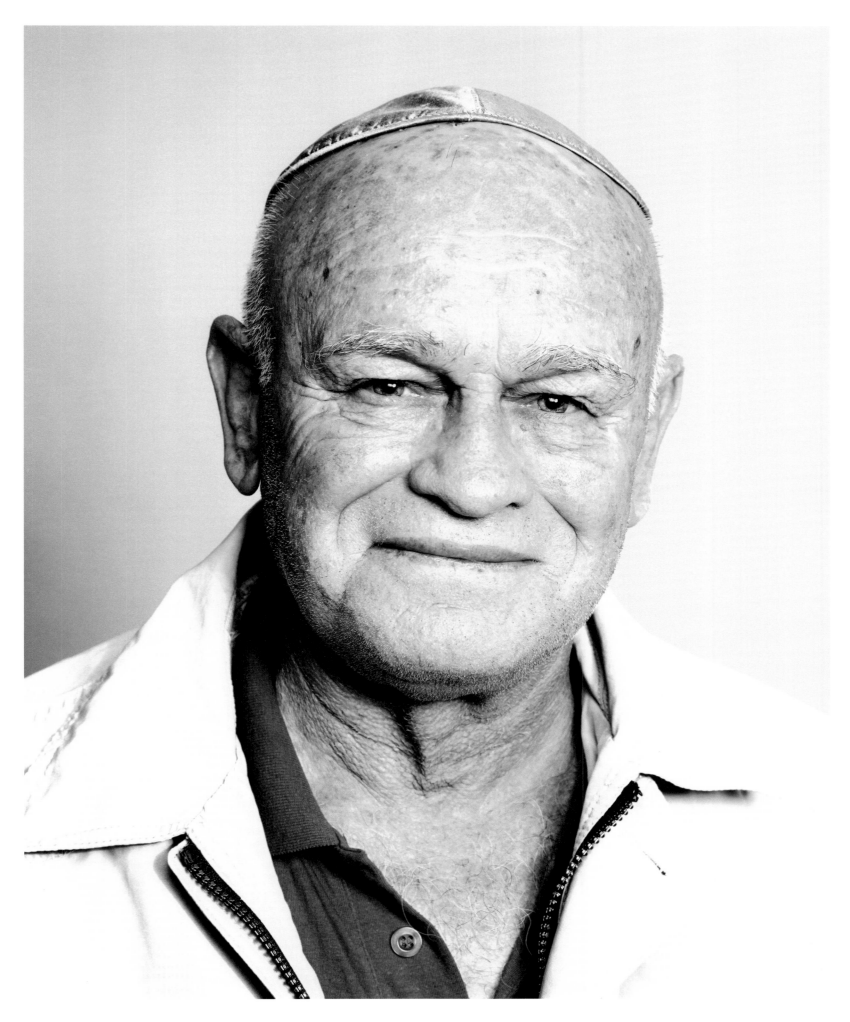

Engineer, Marrakech, Morocco

In December 2014, Chen Reiss sang Midnight Mass in the
Vatican at the request of Pope Francis. I photographed
her in a large rehearsal room along the infinite corridors and
staircases backstage at the Vienna Opera House.

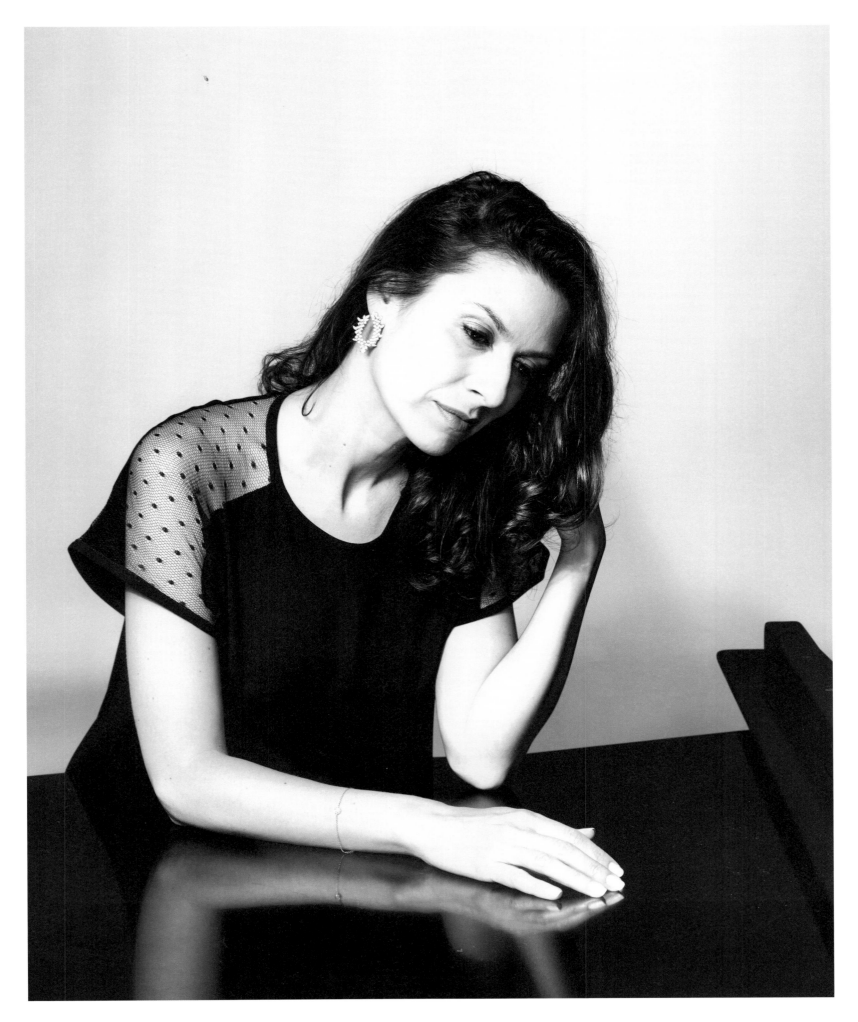

Opera Singer, Vienna, Austria

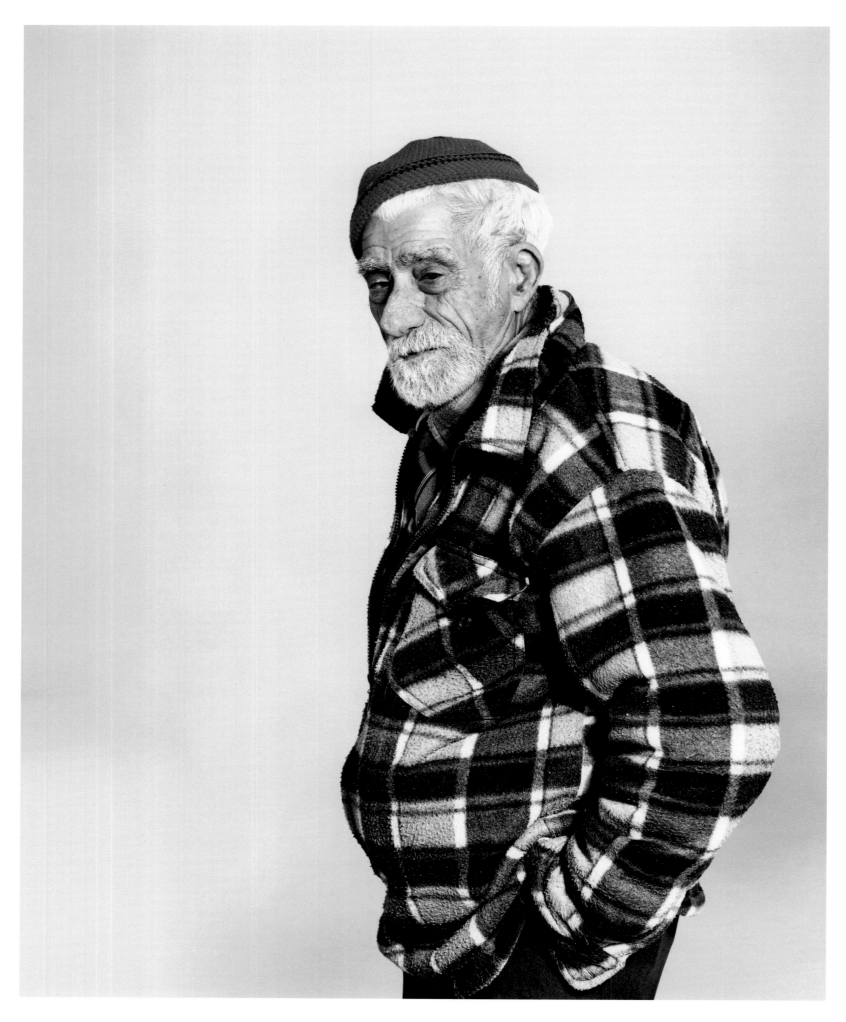

Carpenter, Marrakech, Morocco

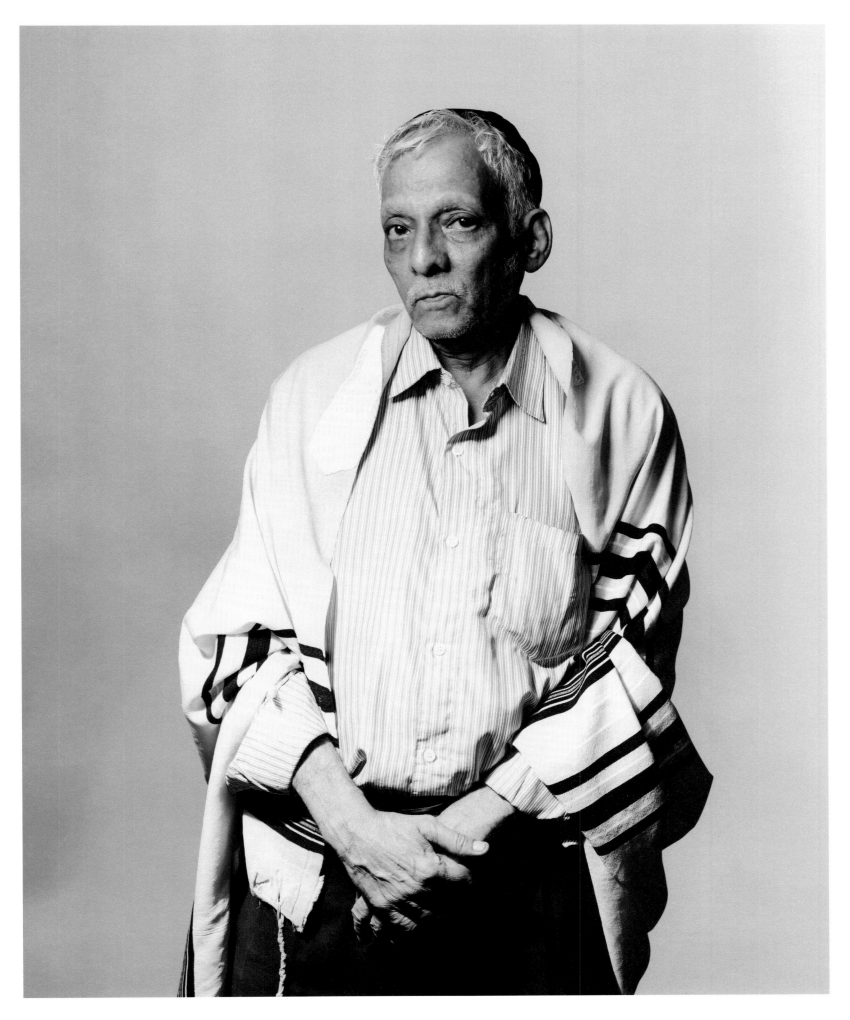

Worshipper Wearing Tallit, Mumbai, India

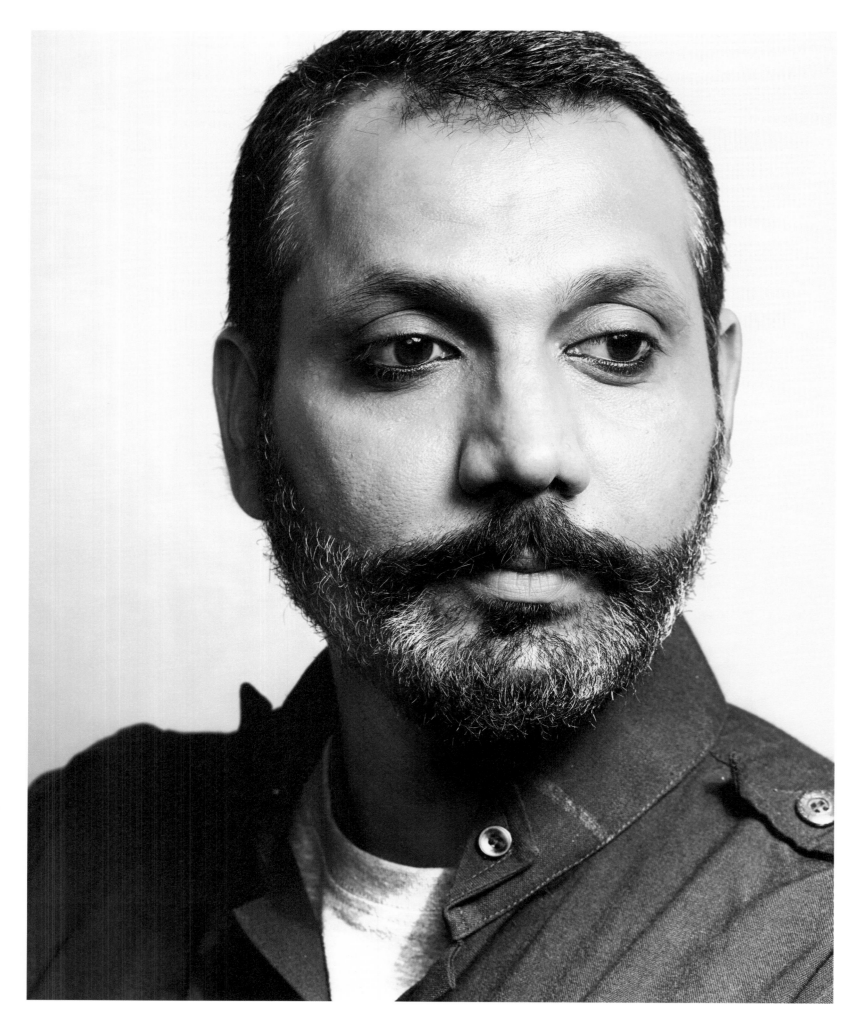

Sculptor, Mumbai, India

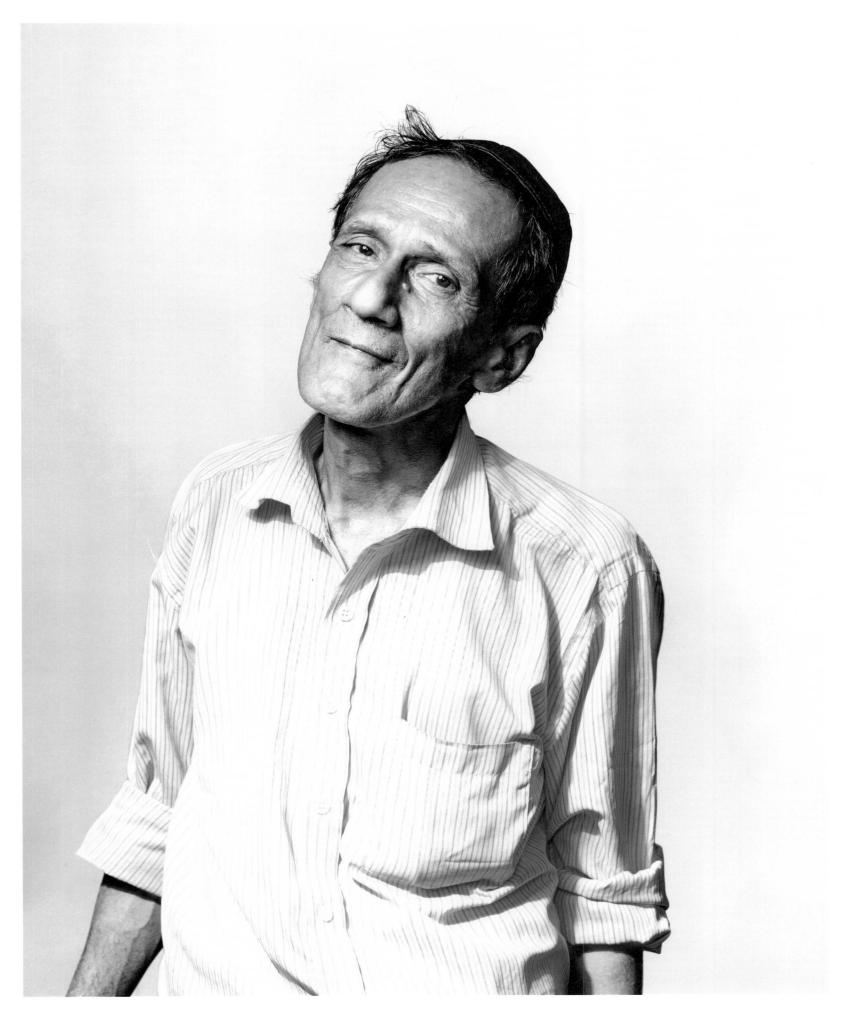

Worshipper II, Mumbai, India

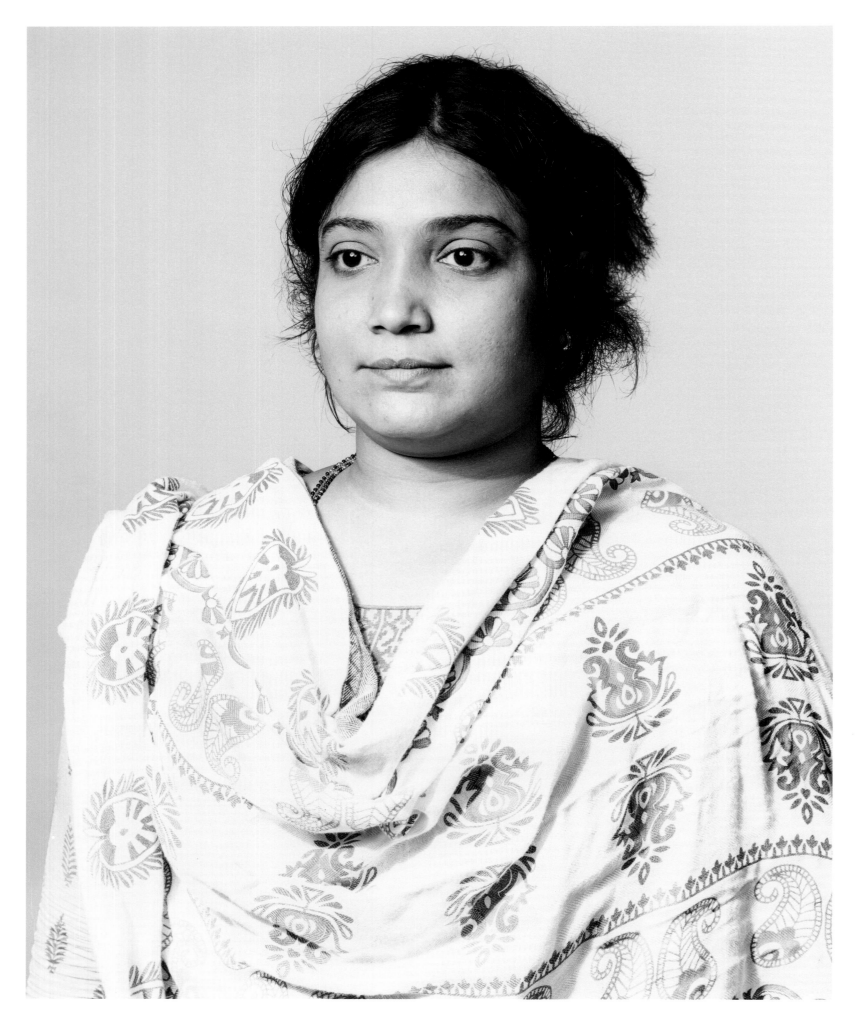

School Teacher, Mumbai, India

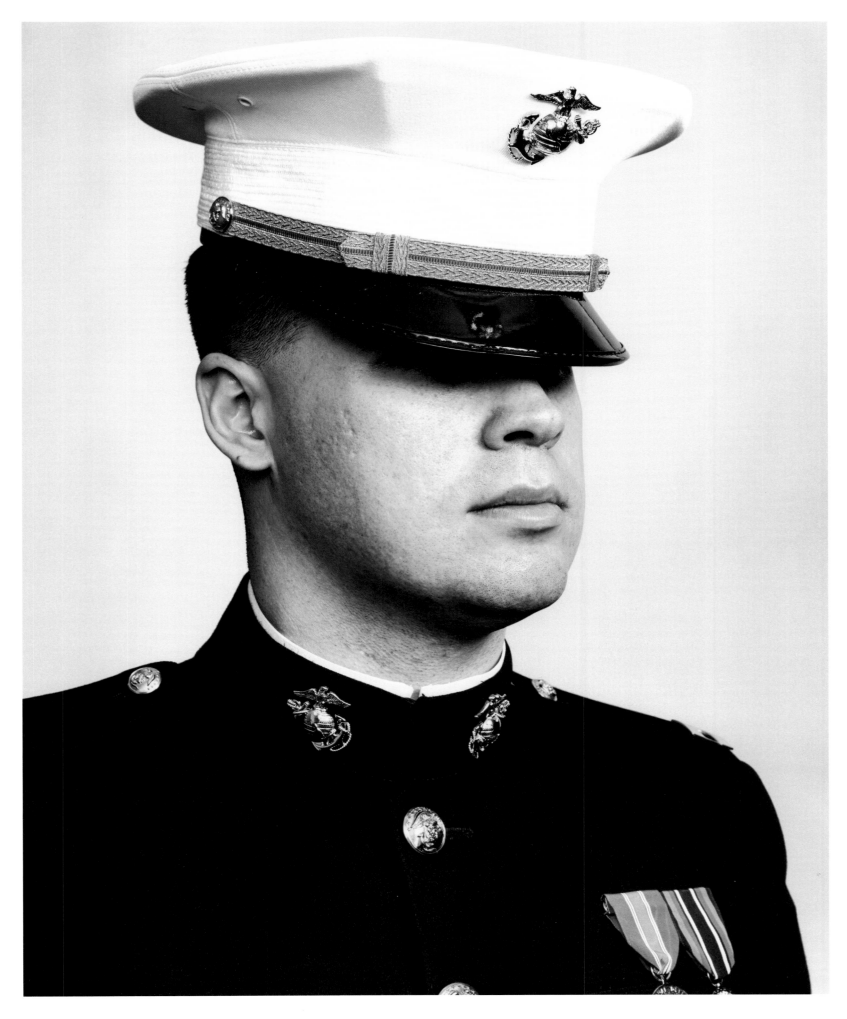

Marine, Parris Island, USA

Knowing I would not be granted approval to photograph inside an abattoir, I asked Rachamim Goodman to make the portrait as authentic as possible. "I understand", he said. Later, when I arrived at his house, he pulled his work clothes from a black plastic bag, the blood dripping on his living room floor. No one, including his family, seemed to think this was strange.

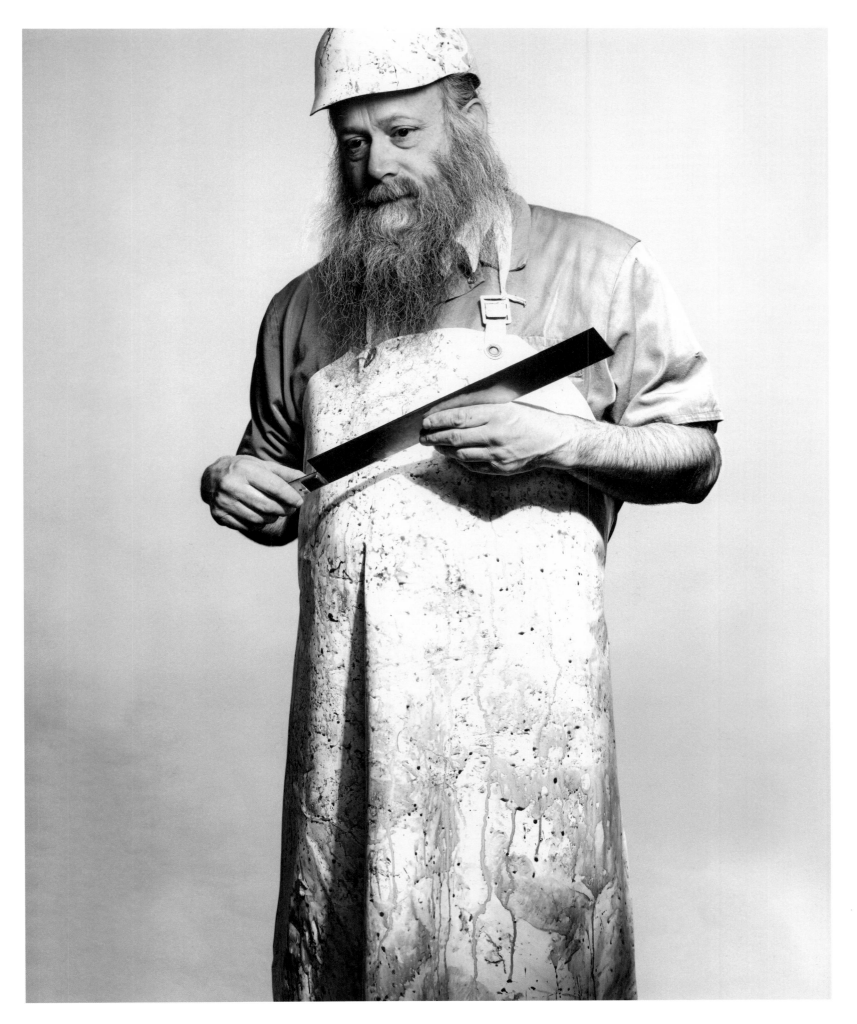

Shochet, Manchester, England

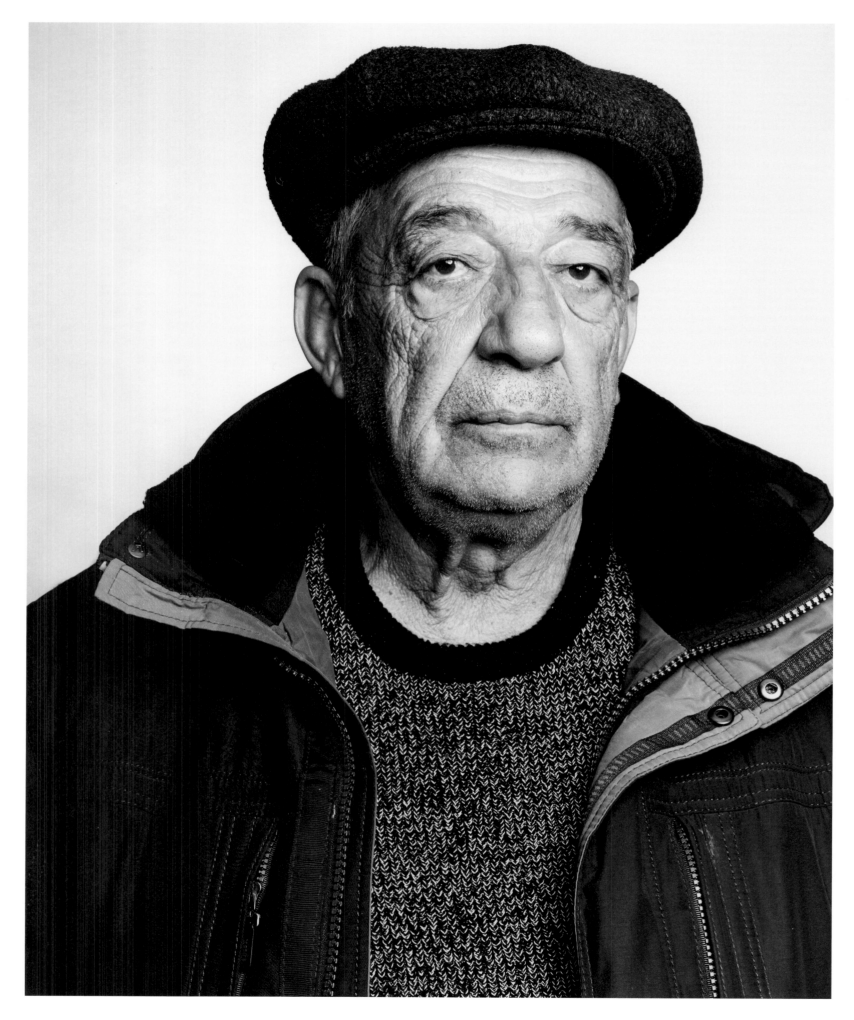

Mountain Jew, Quba, Azerbaijan

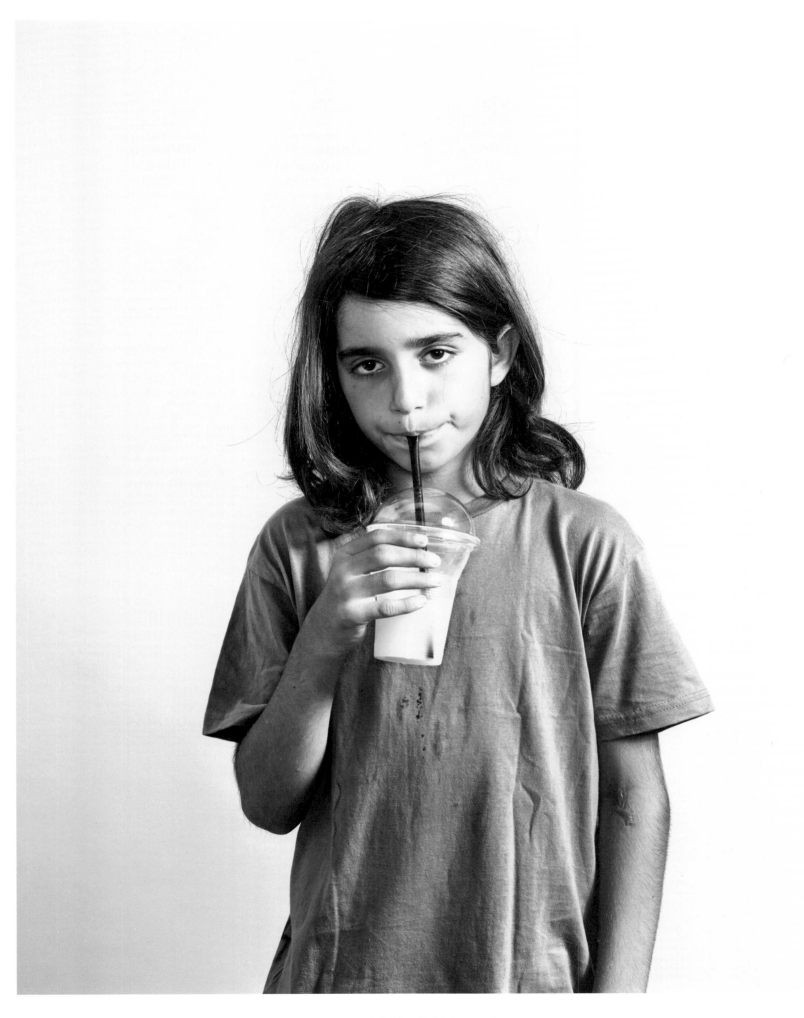

Boy Drinking, Tel Aviv, Israel

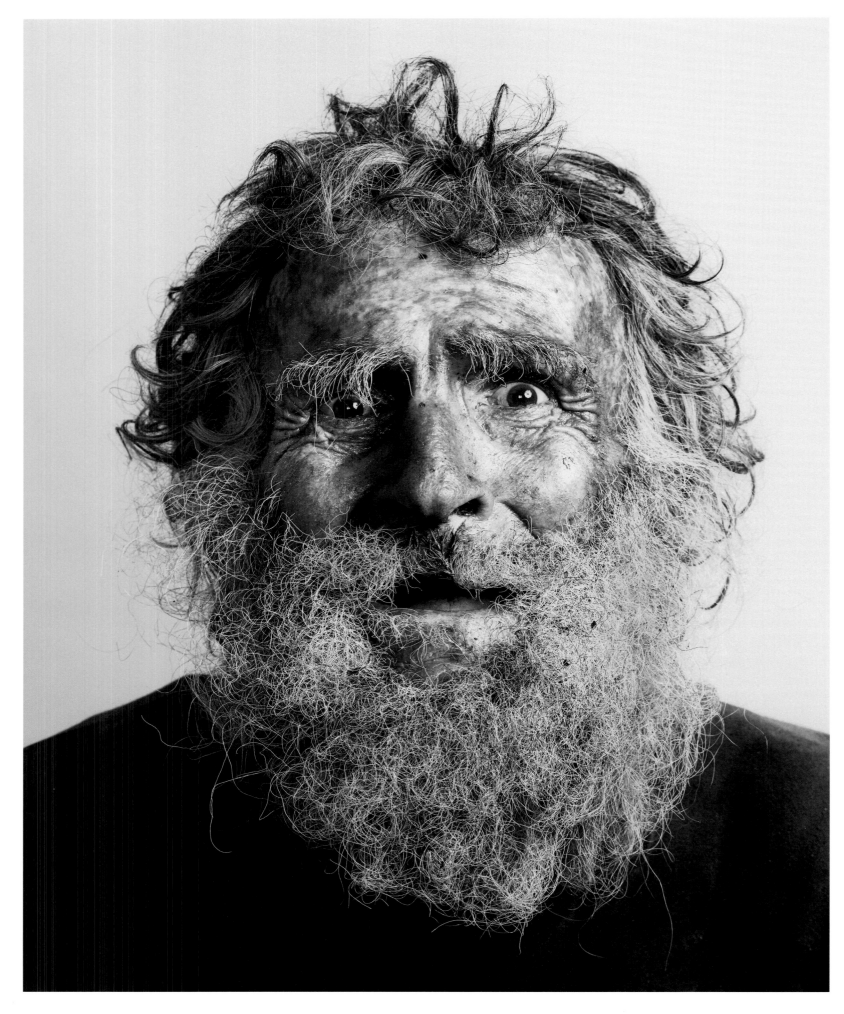

Homeless, Tel Aviv, Israel

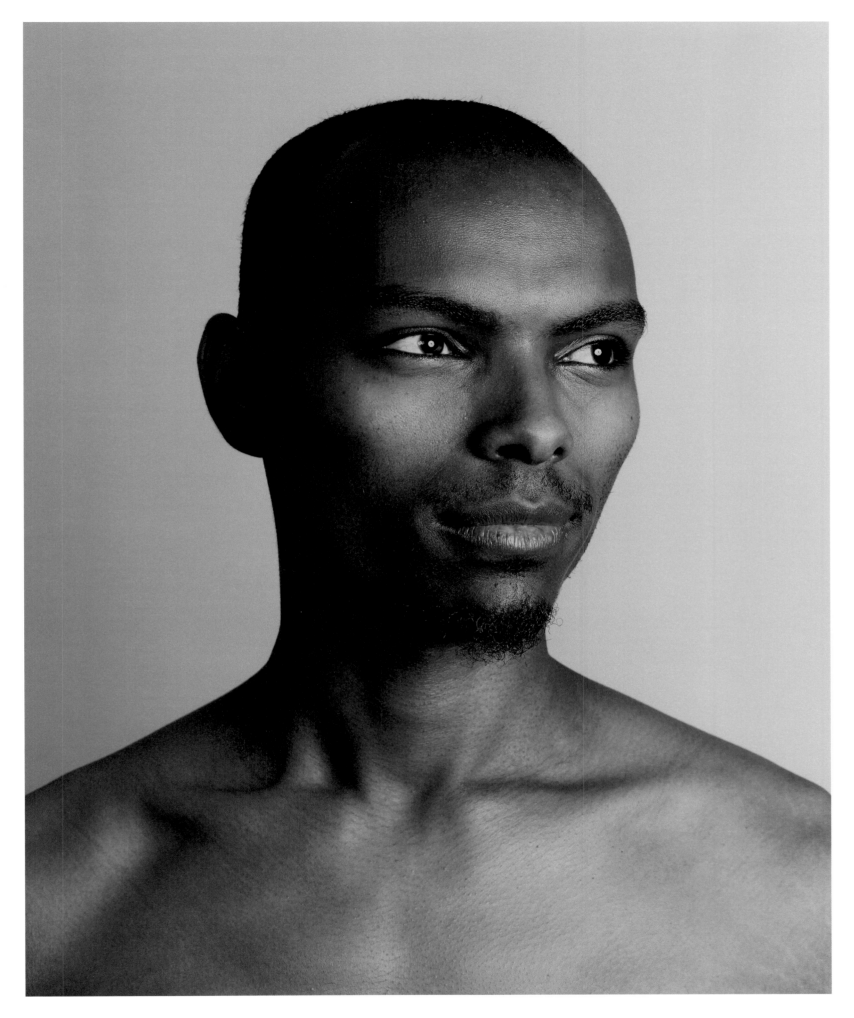

Patisserie Chef, Tel Aviv, Israel

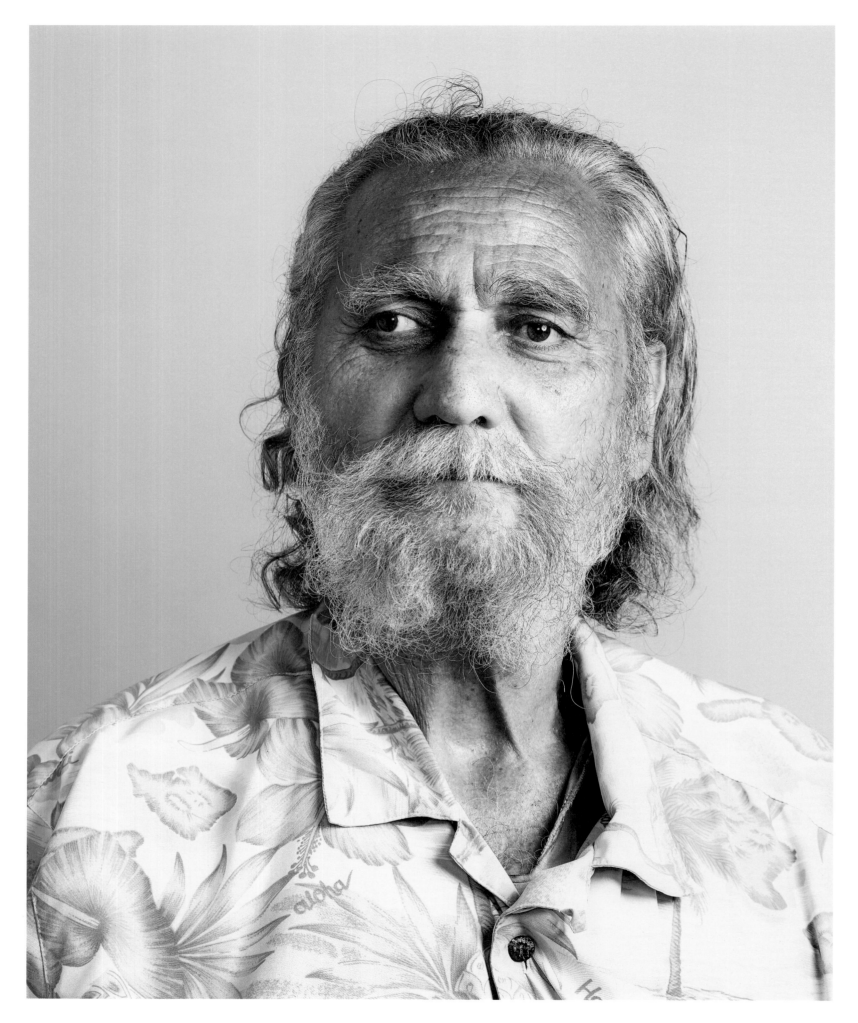

Aloha, Tel Aviv, Israel

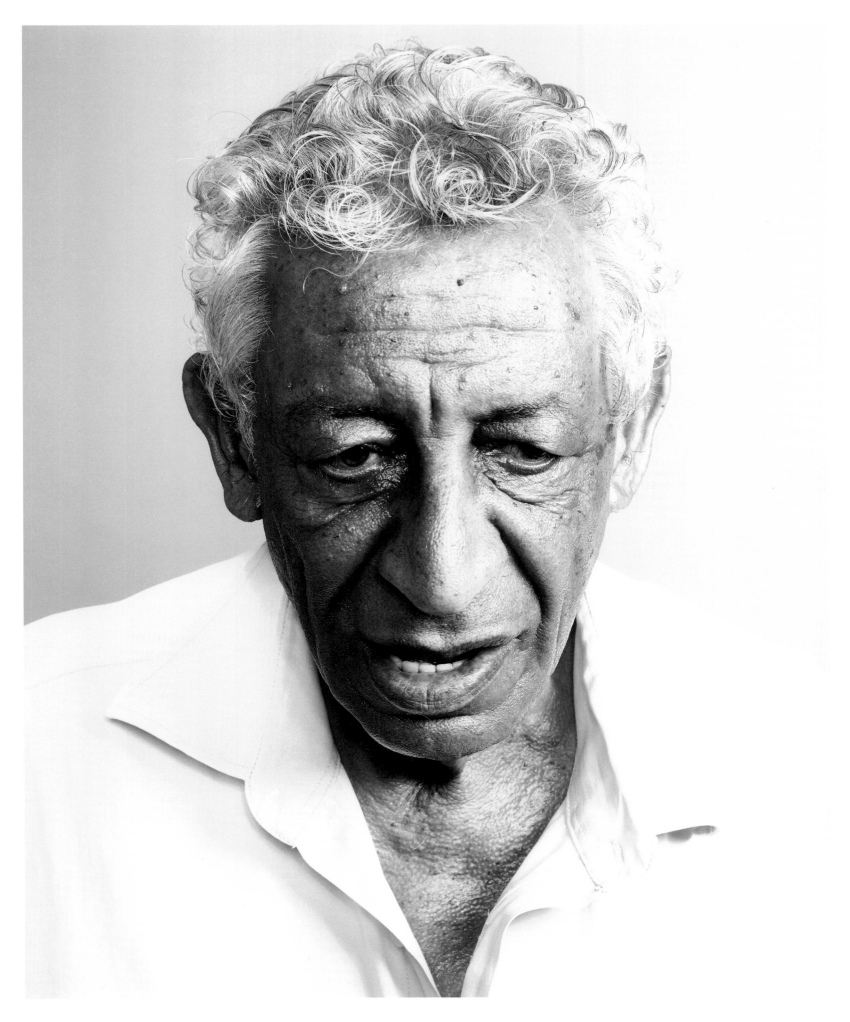

Grieving Father, Tel Aviv, Israel

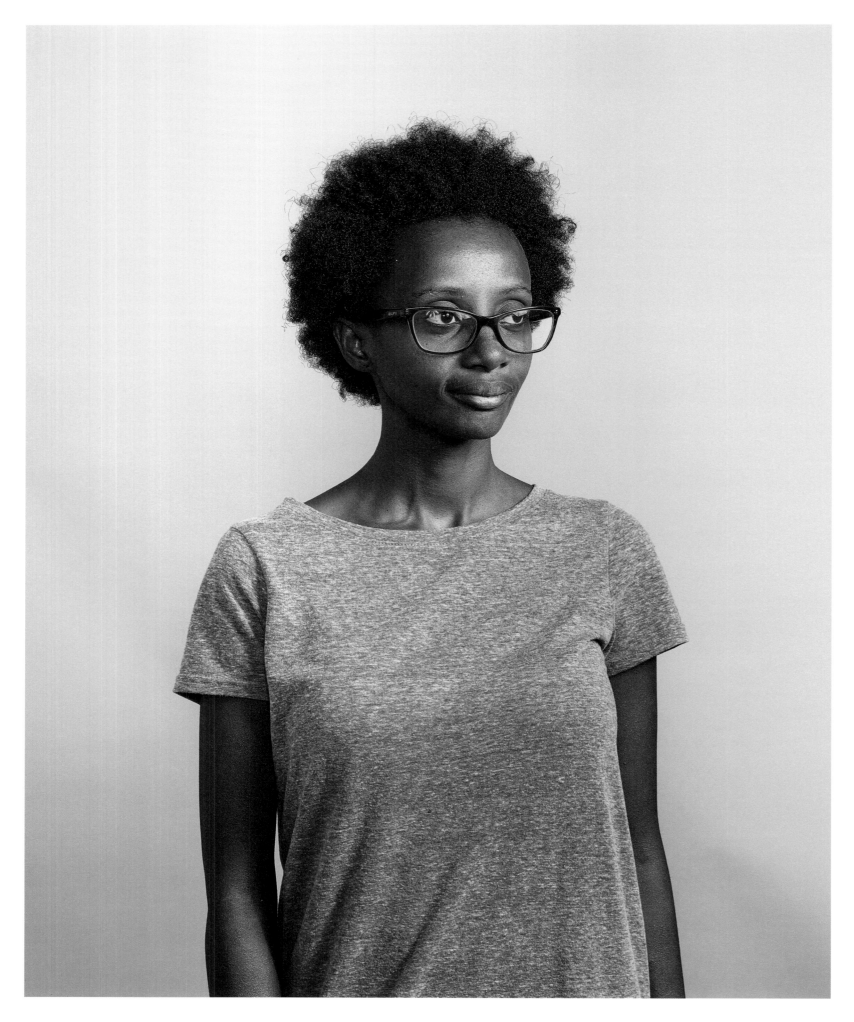

Psychology Student, Tel Aviv, Israel

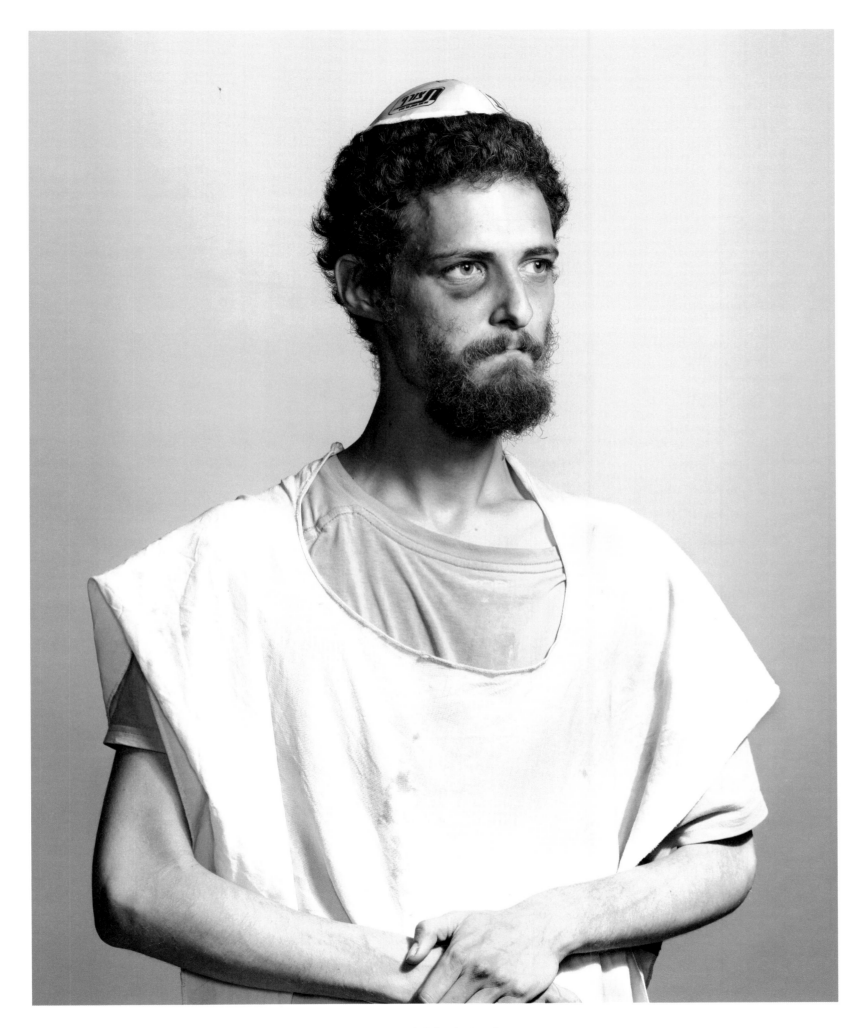

Mugged, Tel Aviv, Israel

Lenore Mizrachi-Cohen is a fourth-generation Syrian Jew, living in New York. She is an artist using traditional calligraphy. The words on the paper say "turn", she said, as in "make a change".

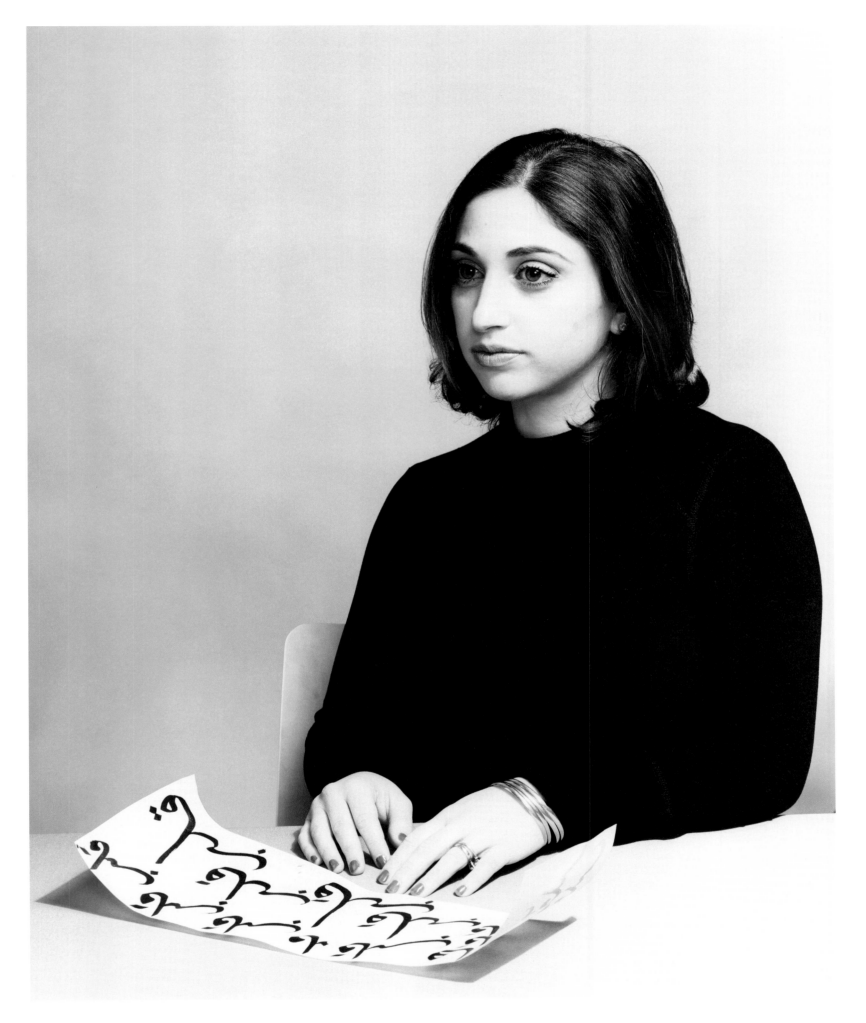

Turn, Brooklyn, USA

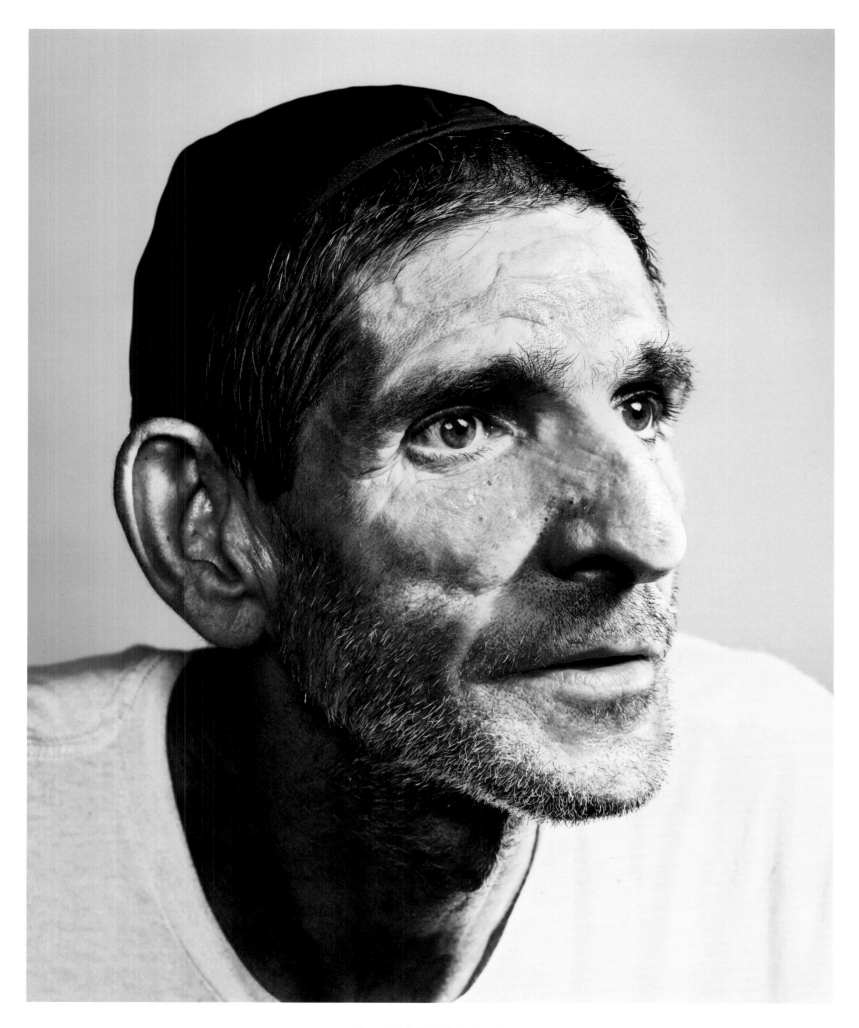

Drug Addict, Tel Aviv, Israel

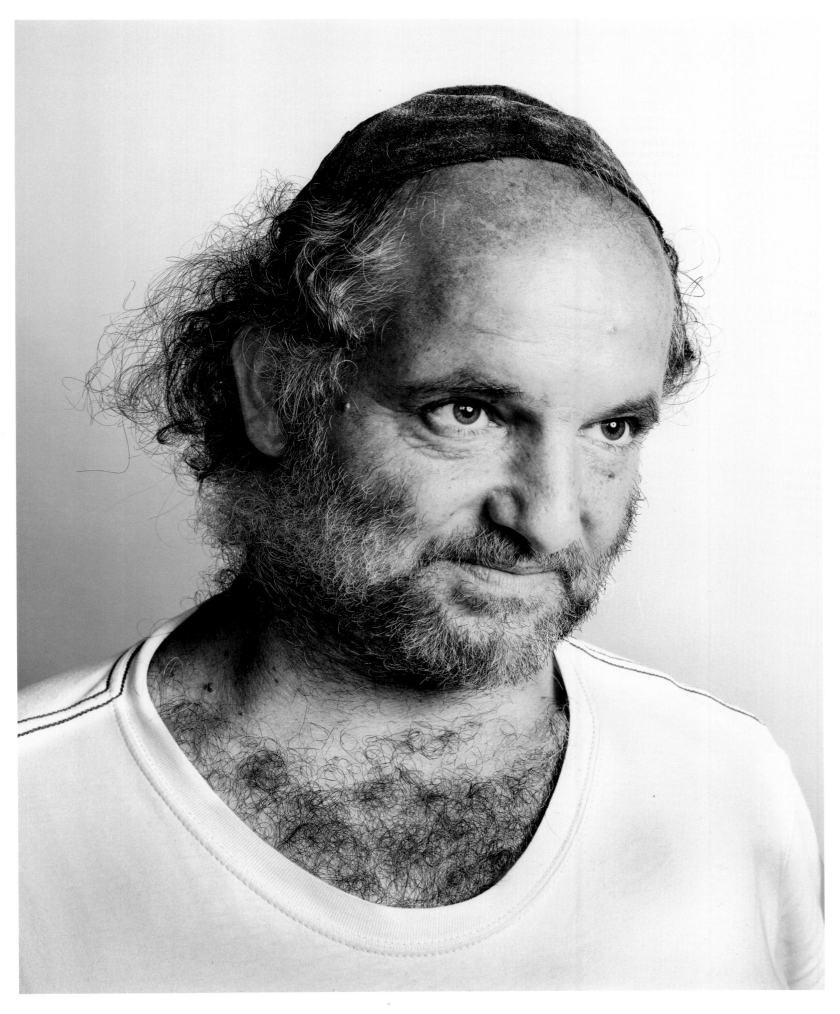

Refuse Collector, Tel Aviv, Israel

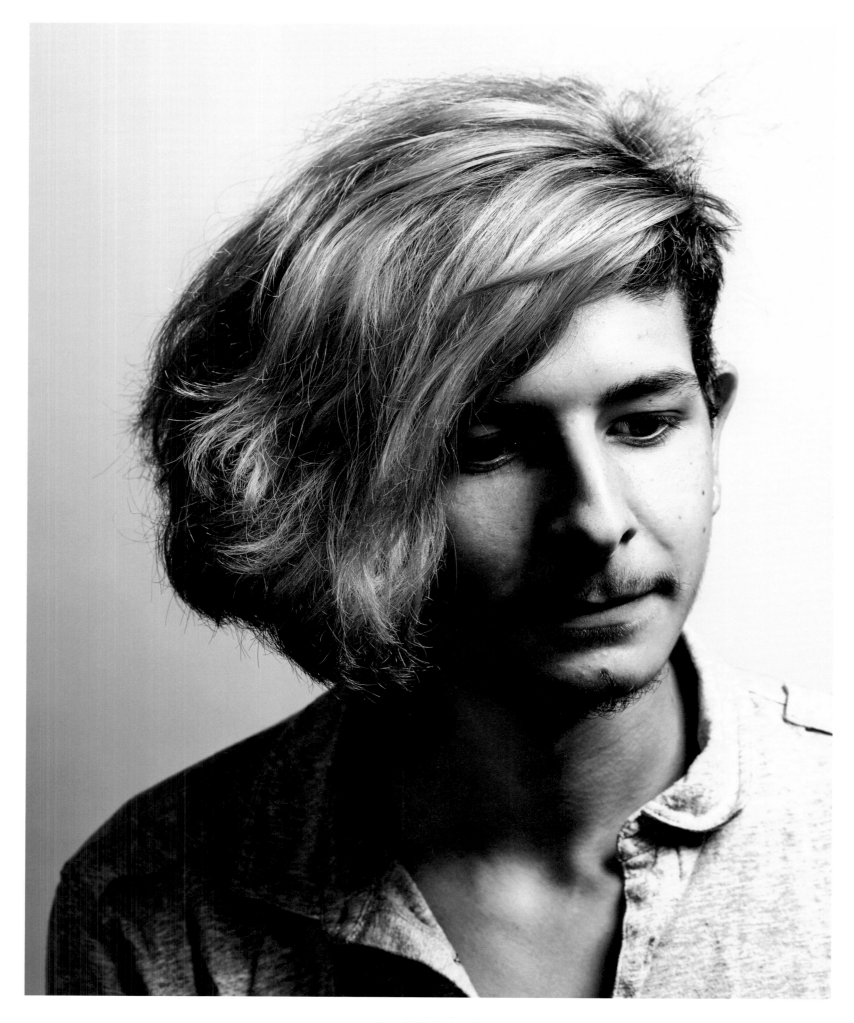

Boy, Tel Aviv, Israel

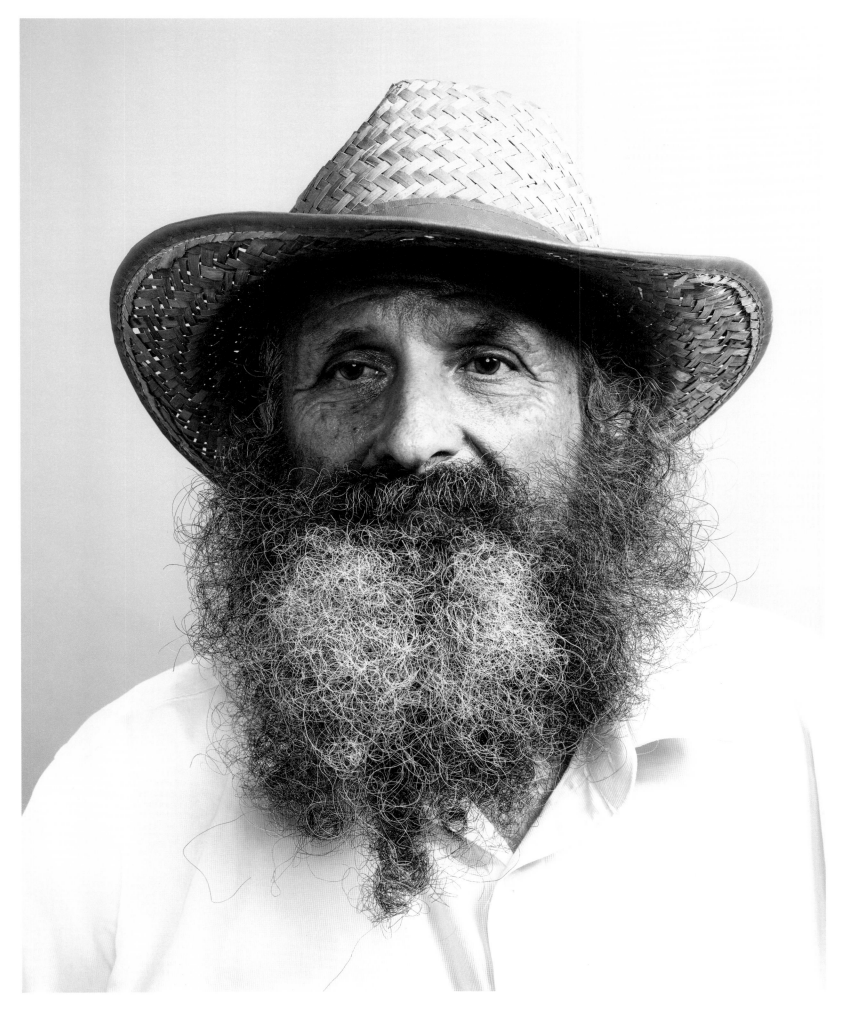

Follower of Jung, Tel Aviv, Israel

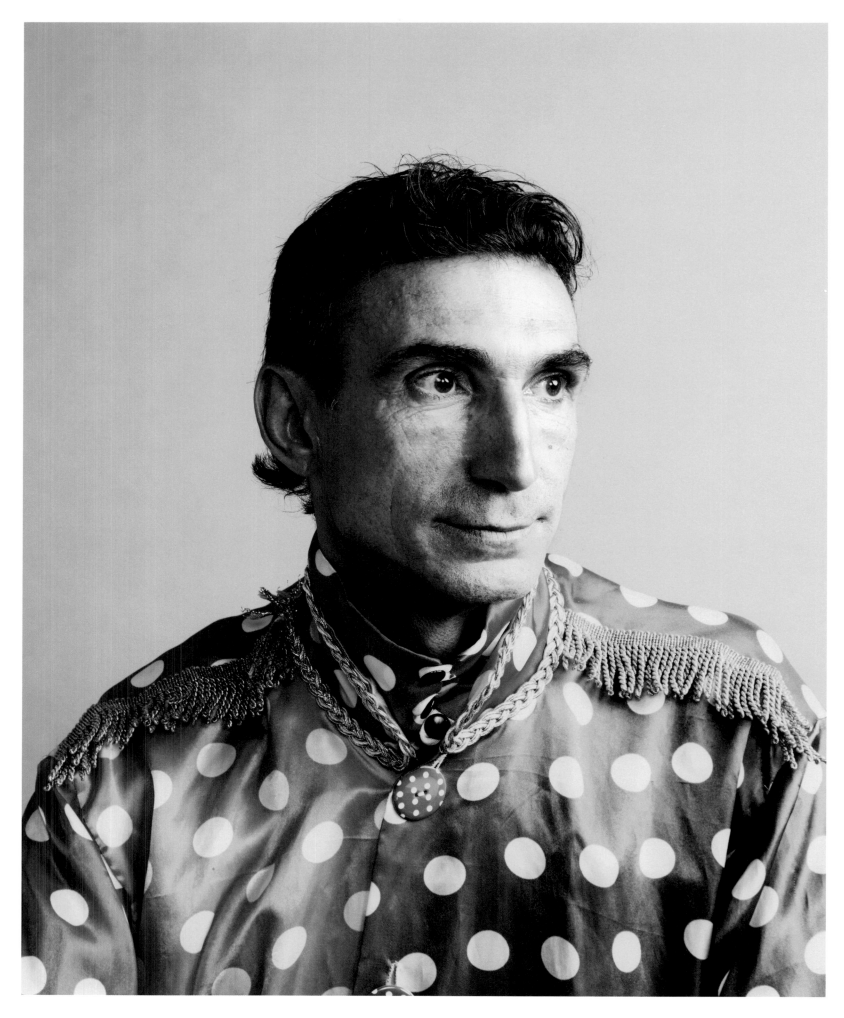

Clown II, Tel Aviv, Israel

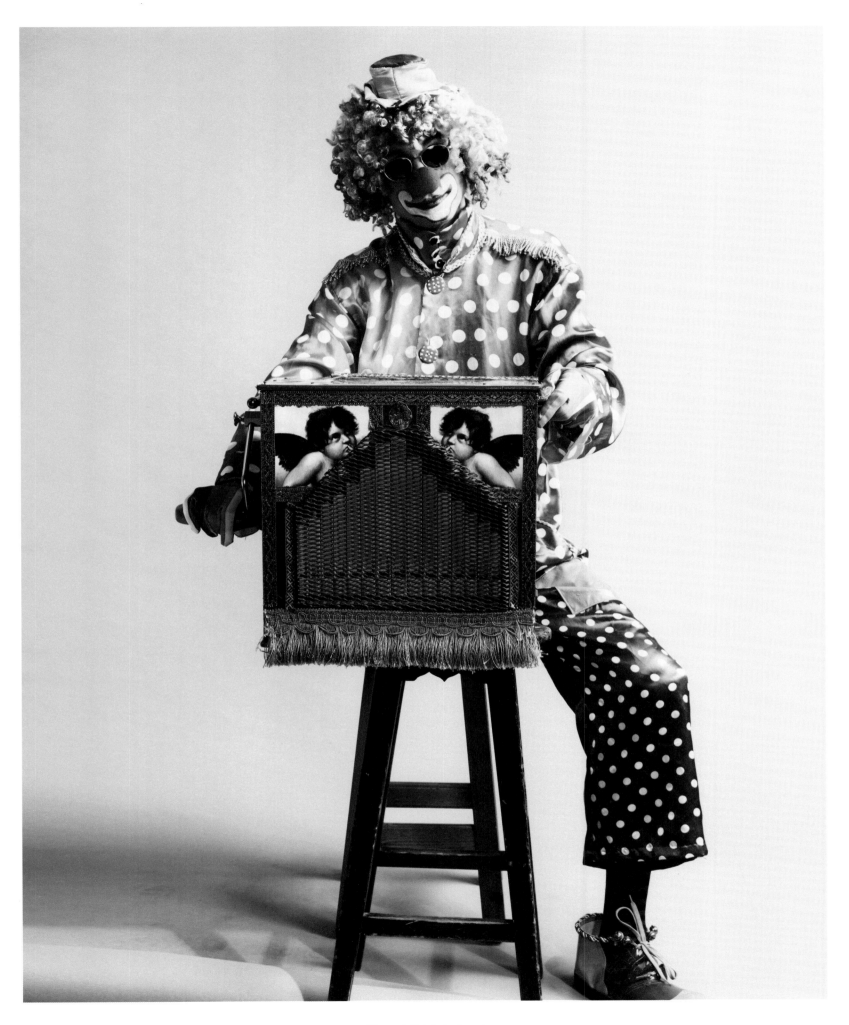

Clown I, Tel Aviv, Israel

Oran Almog, was a victim of the Maxim restaurant
bombing in Haifa in 2003. He lost two of his grandparents,
his father, his brother and his cousin. He was blinded by
the blast. Oran was ten at the time.

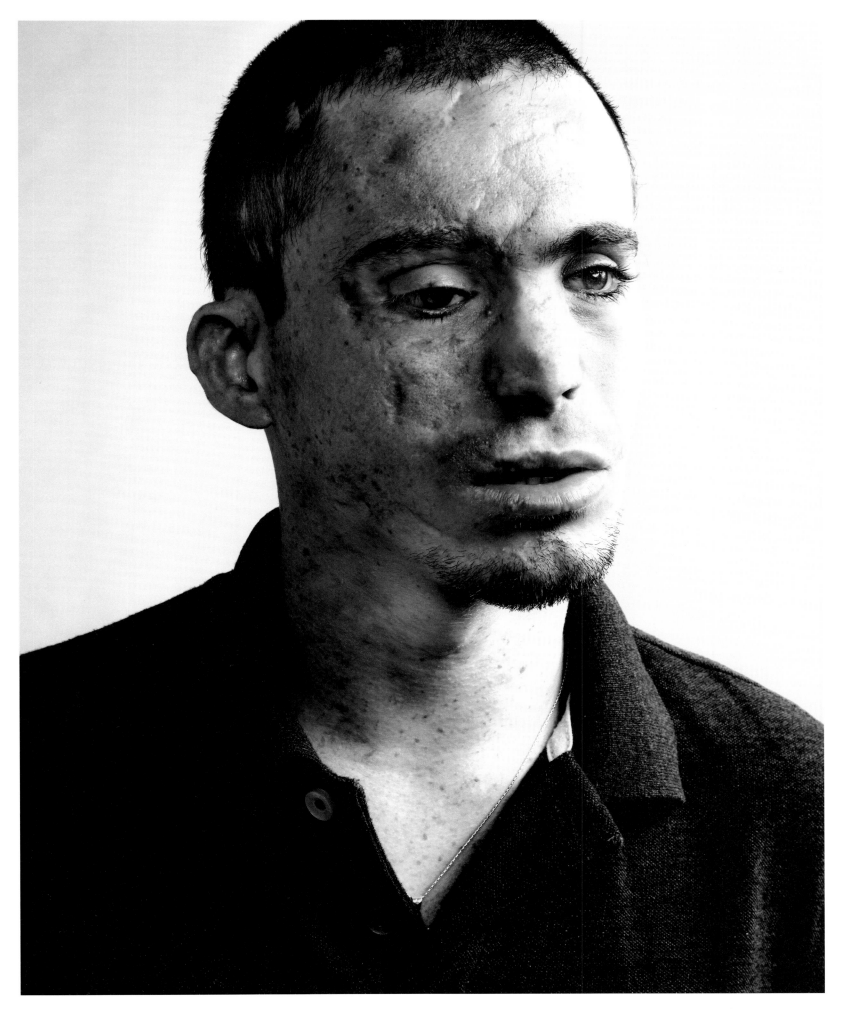

Victim of a Terrorist Attack, Tel Aviv, Israel

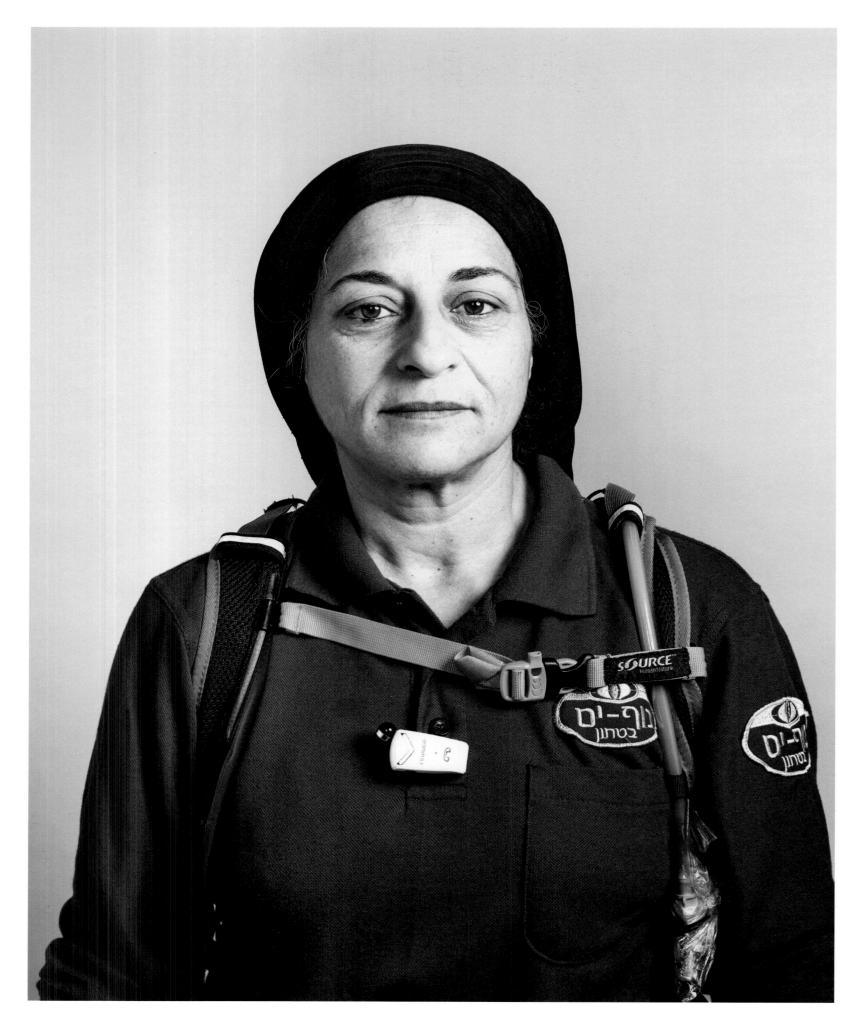

Security Guard, Tel Aviv, Israel

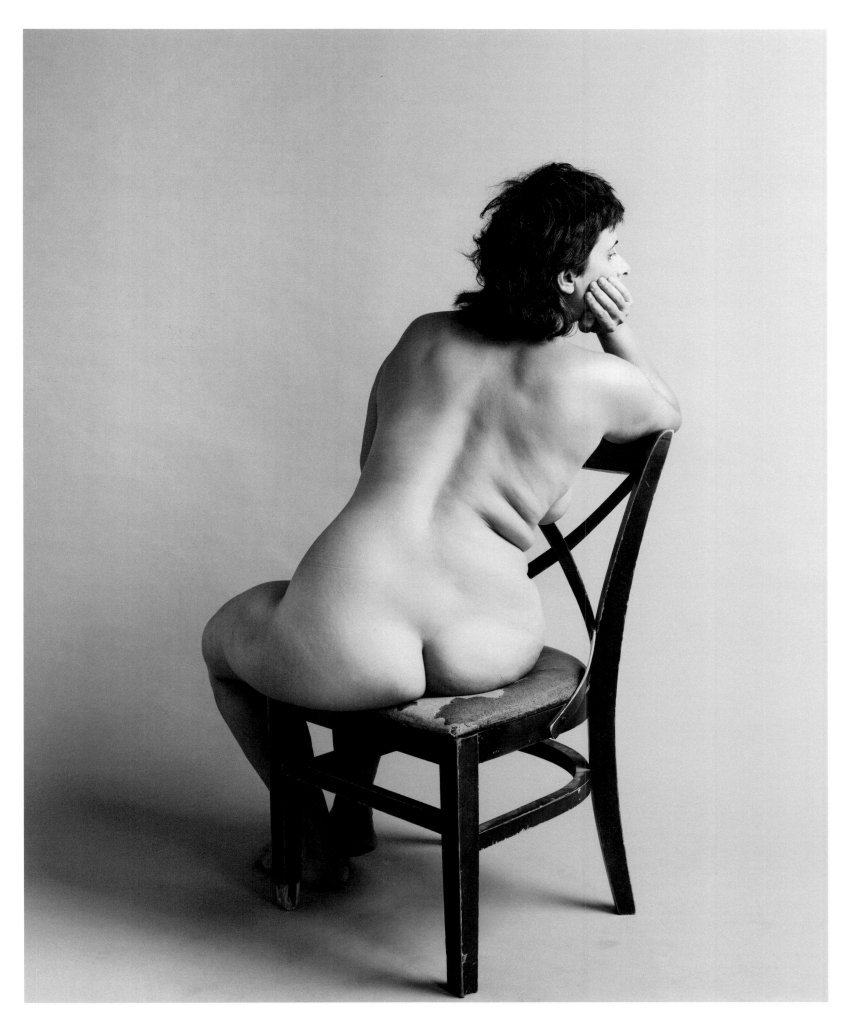

Life Model, Tel Aviv, Israel

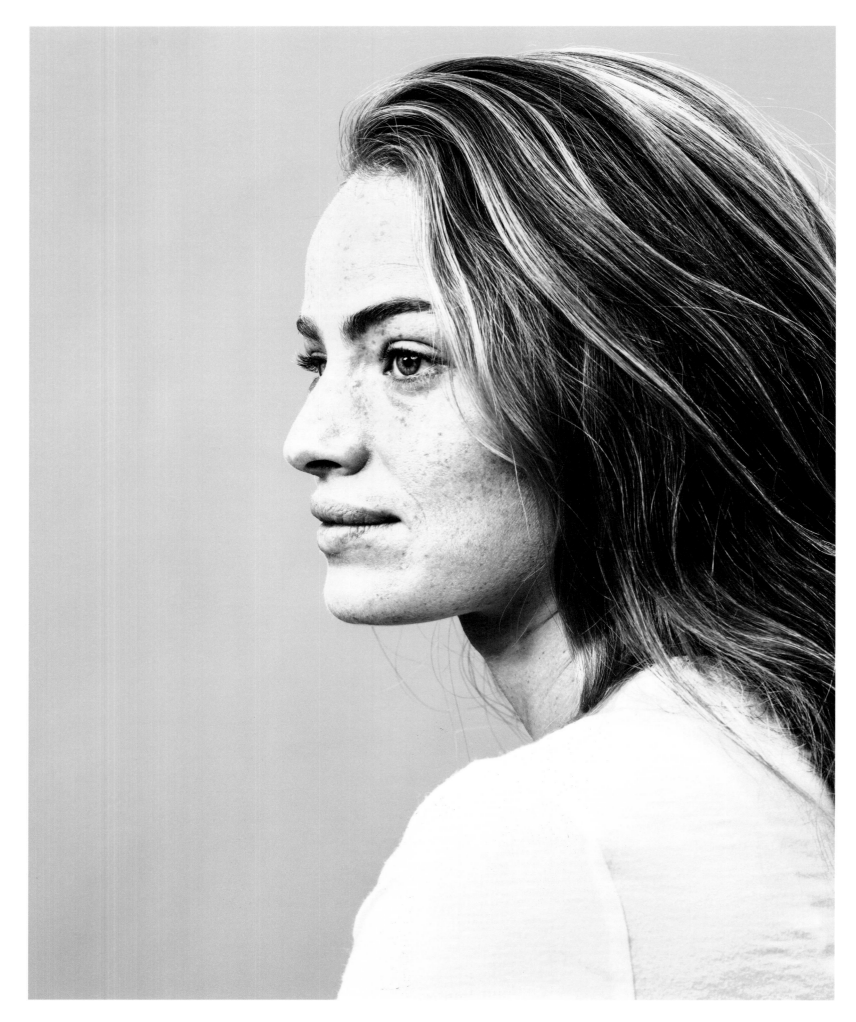

Model, Tel Aviv, Israel

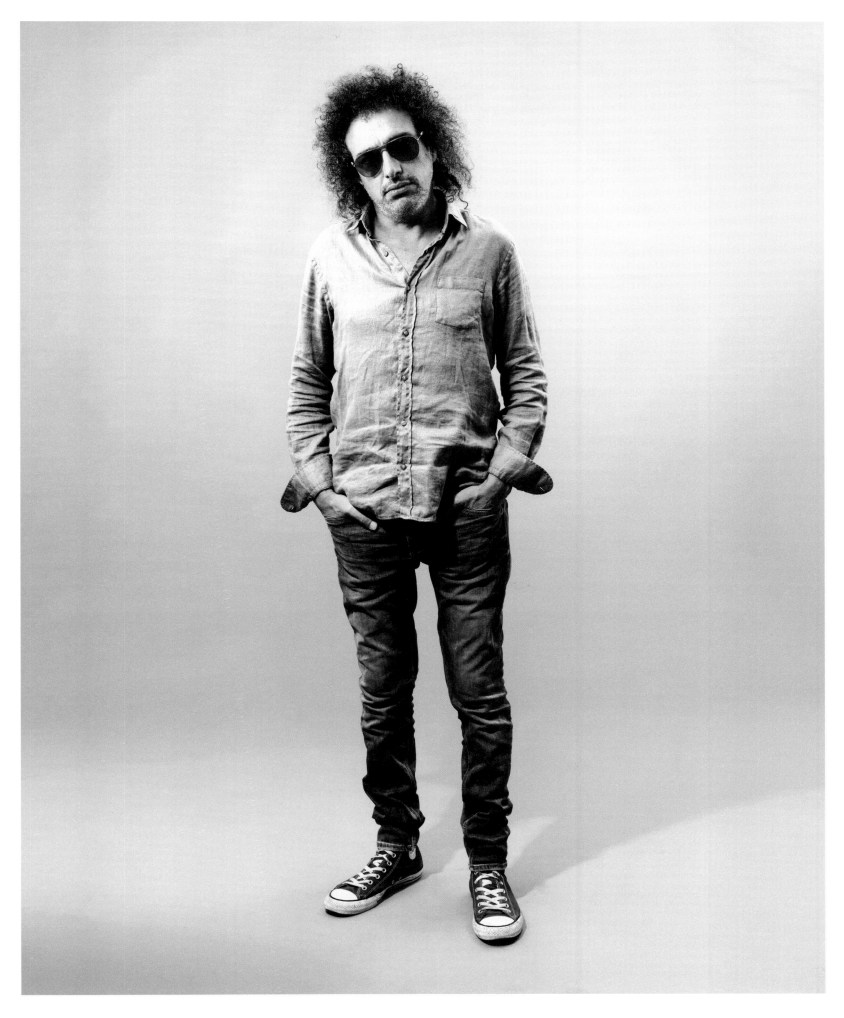

Journalist, Tel Aviv, Israel

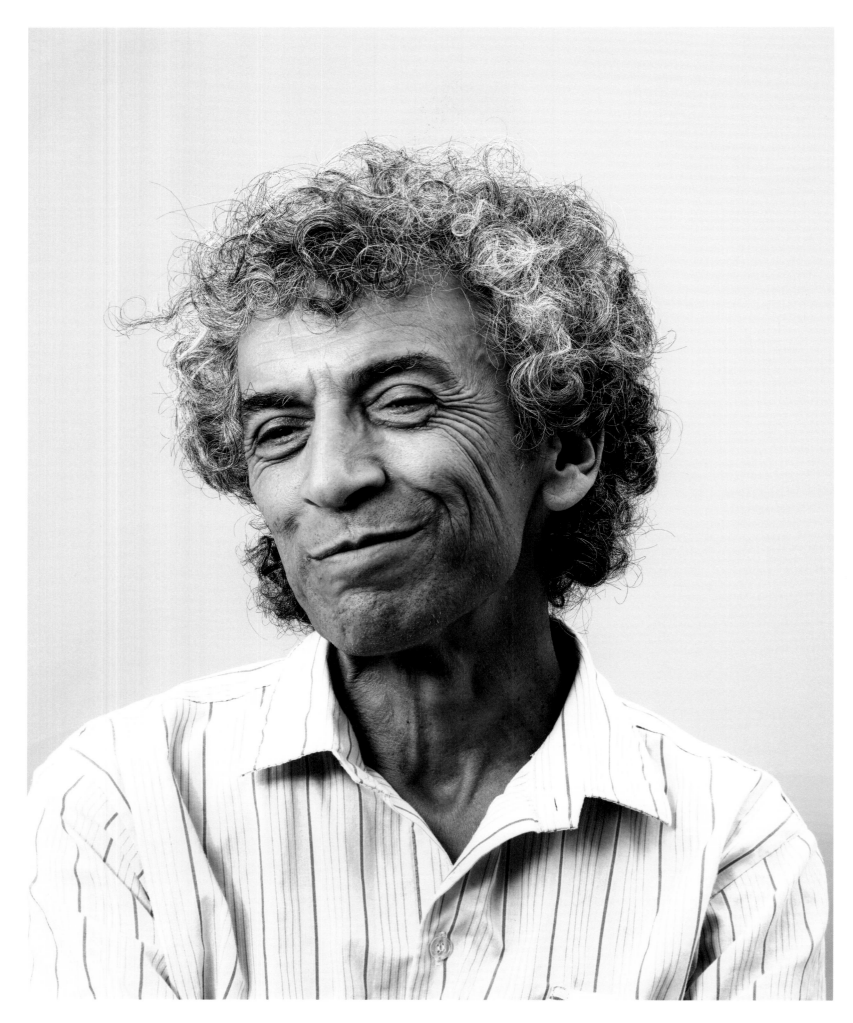

Physicist, Tel Aviv, Israel

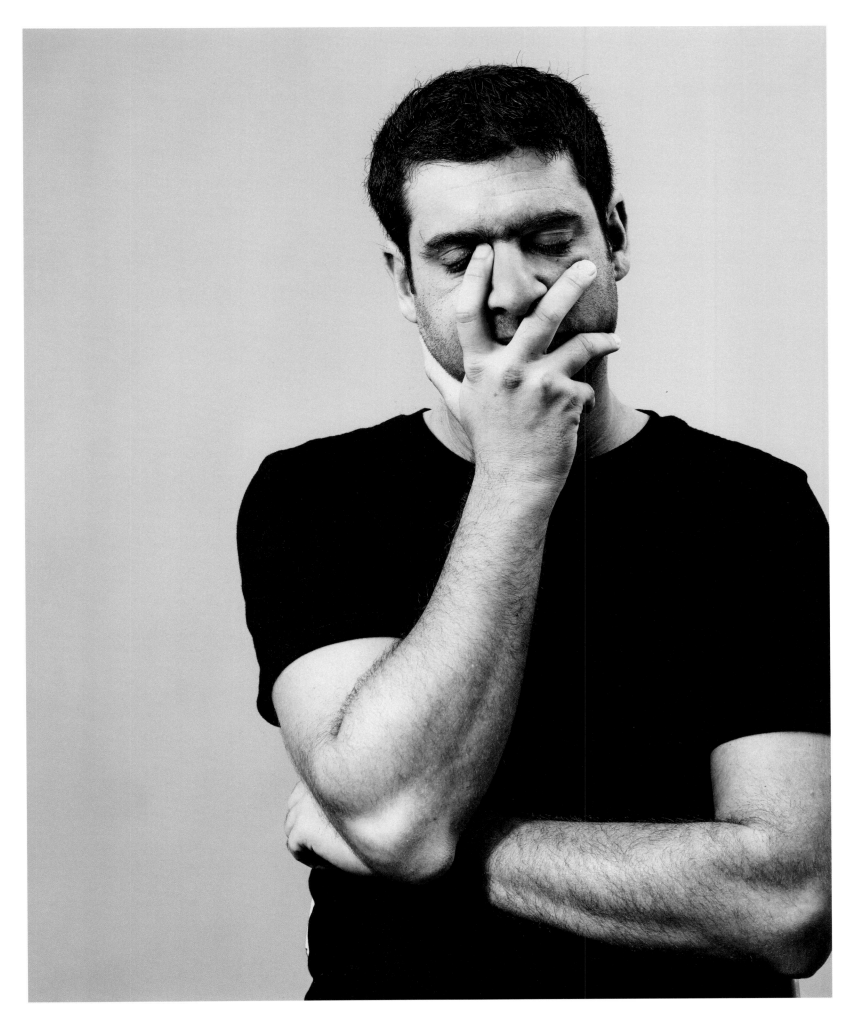

Marine Biologist, Tel Aviv, Israel

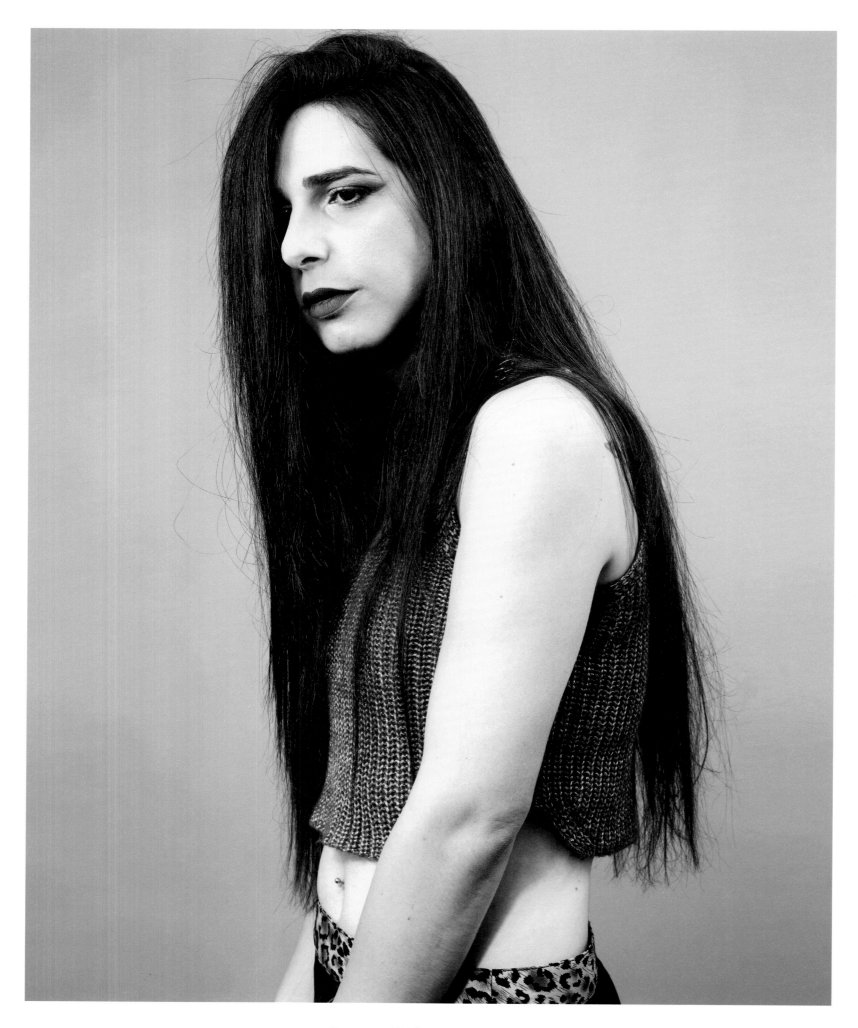

Transsexual Waitress, Tel Aviv, Israel

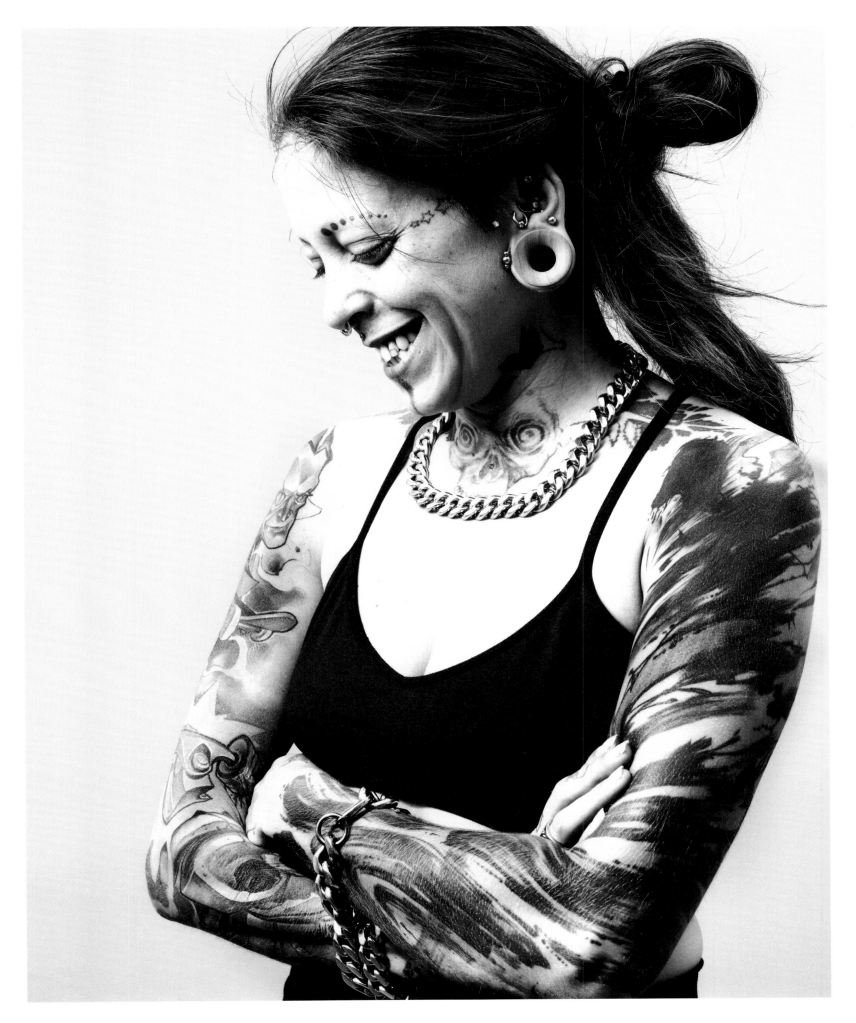

Tattoo Girl, Tel Aviv, Israel

Tehila arrived at the studio with a friend. She had been
raped by her father and had spent time as a sex worker. We
struck a deal that I would call the portrait 'Recovered'.
She was coquettish in front of the camera, and I was uneasy
when she said she wanted to take off her top. However,
she assured me that she wanted to, and that her life story
was written on her body.

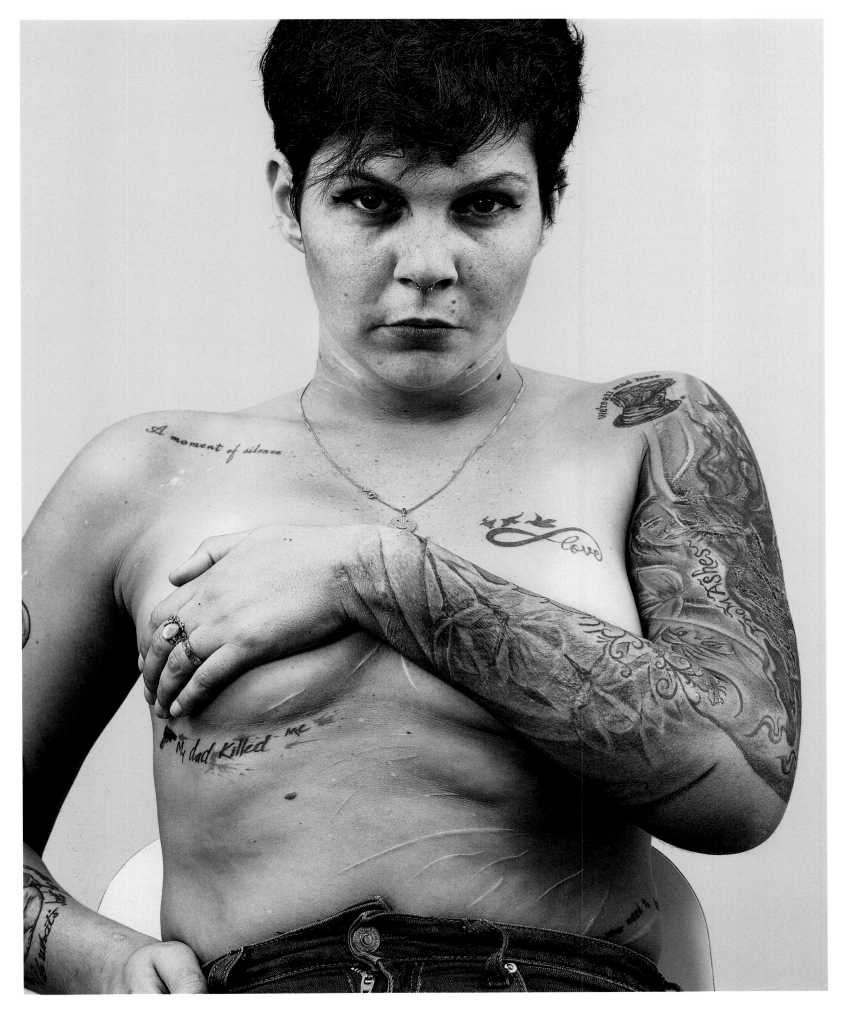

Rape Victim, Recovered, Tel Aviv, Israel

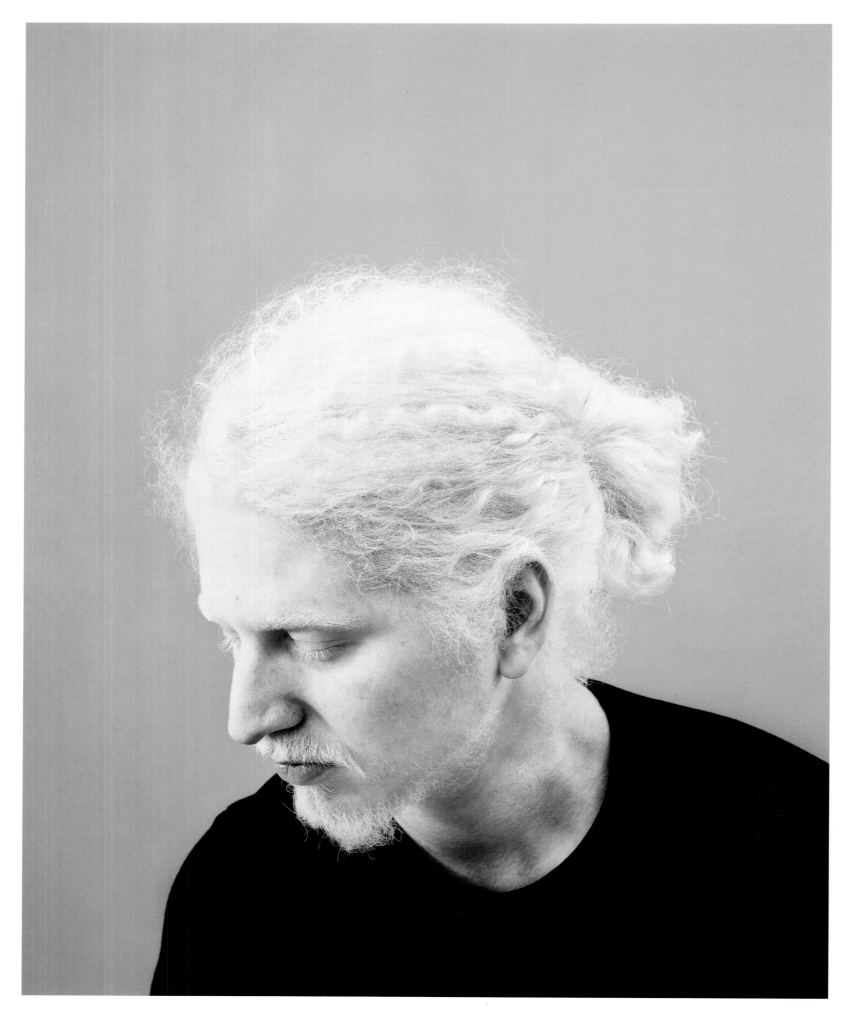

Musician, Tel Aviv, Israel

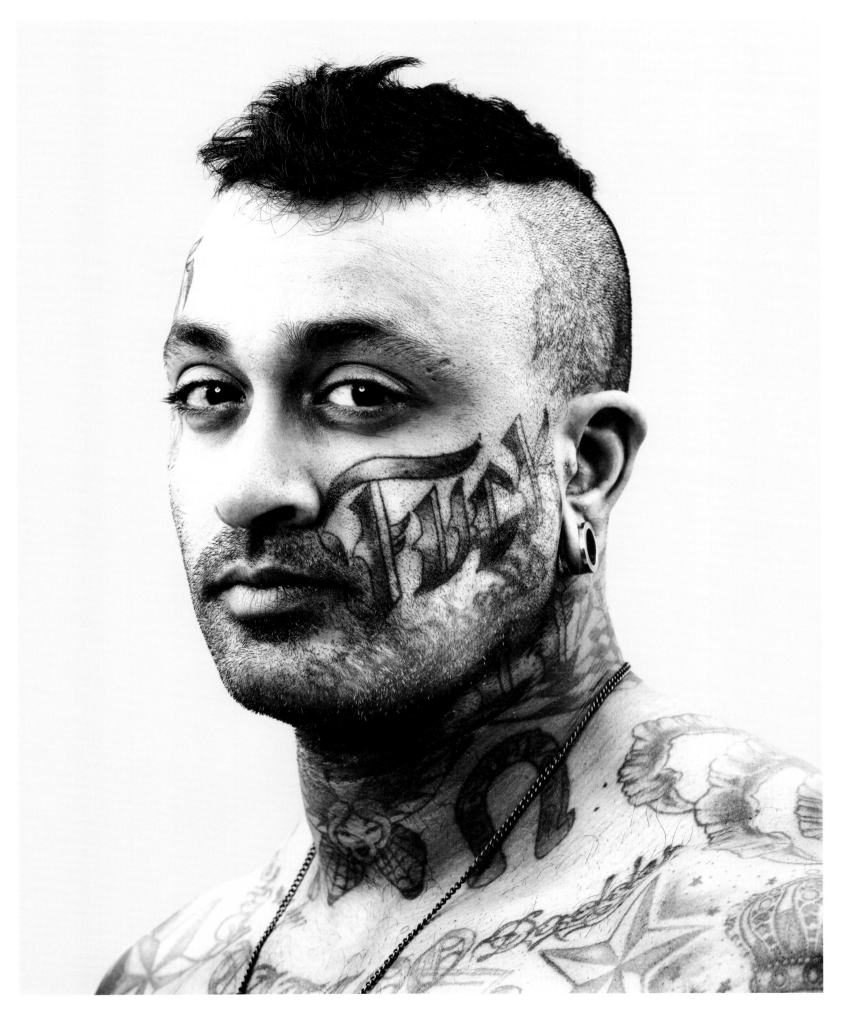

Fuck, Tel Aviv, Israel

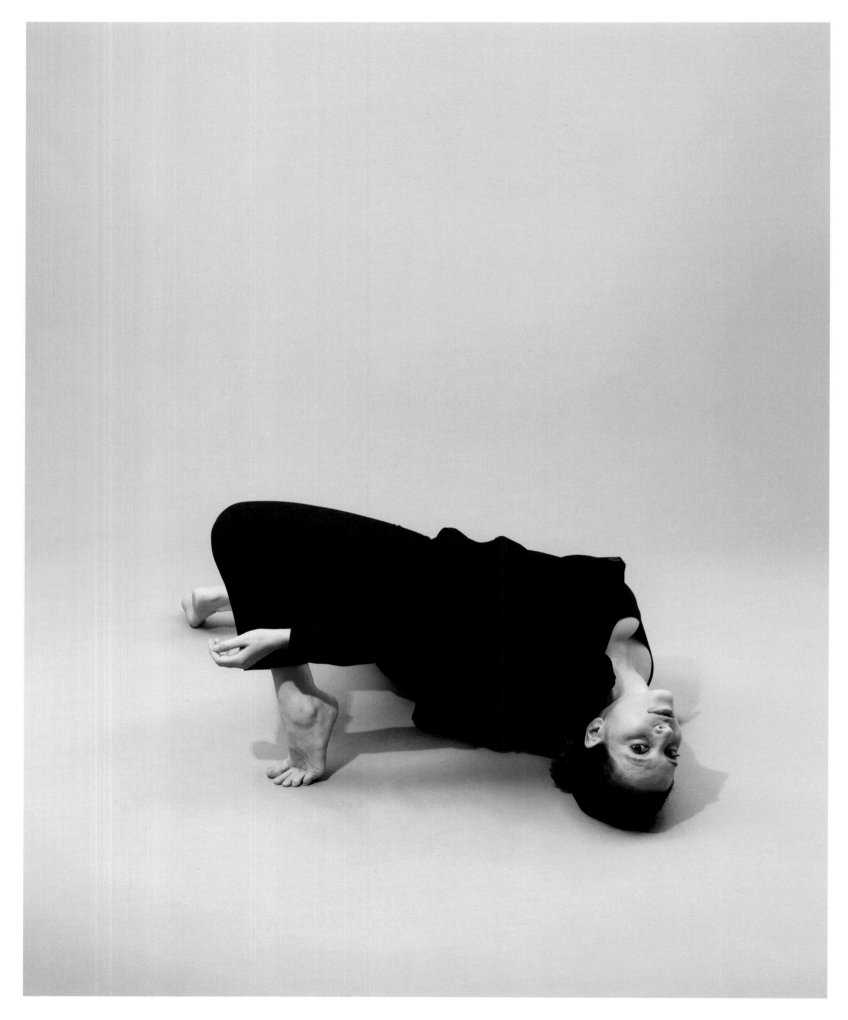

Choreographer, Tel Aviv, Israel

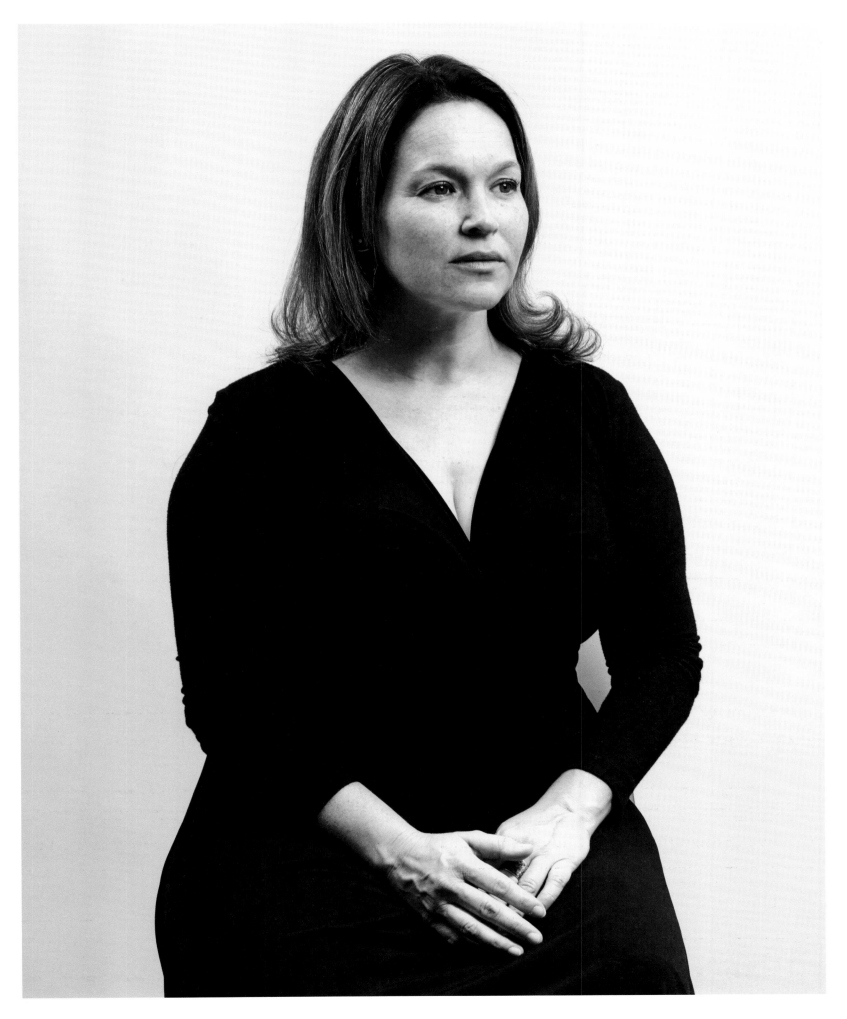

Archaeologist, Tel Aviv, Israel

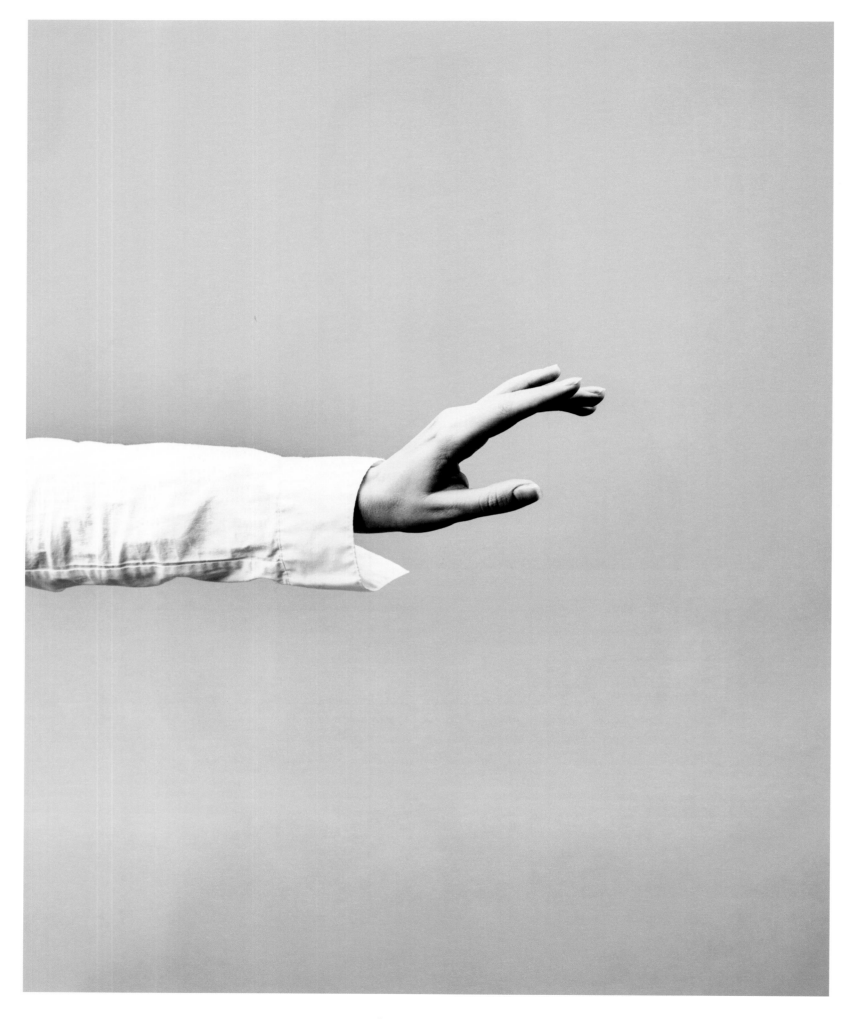

Hand Model, Tel Aviv, Israel

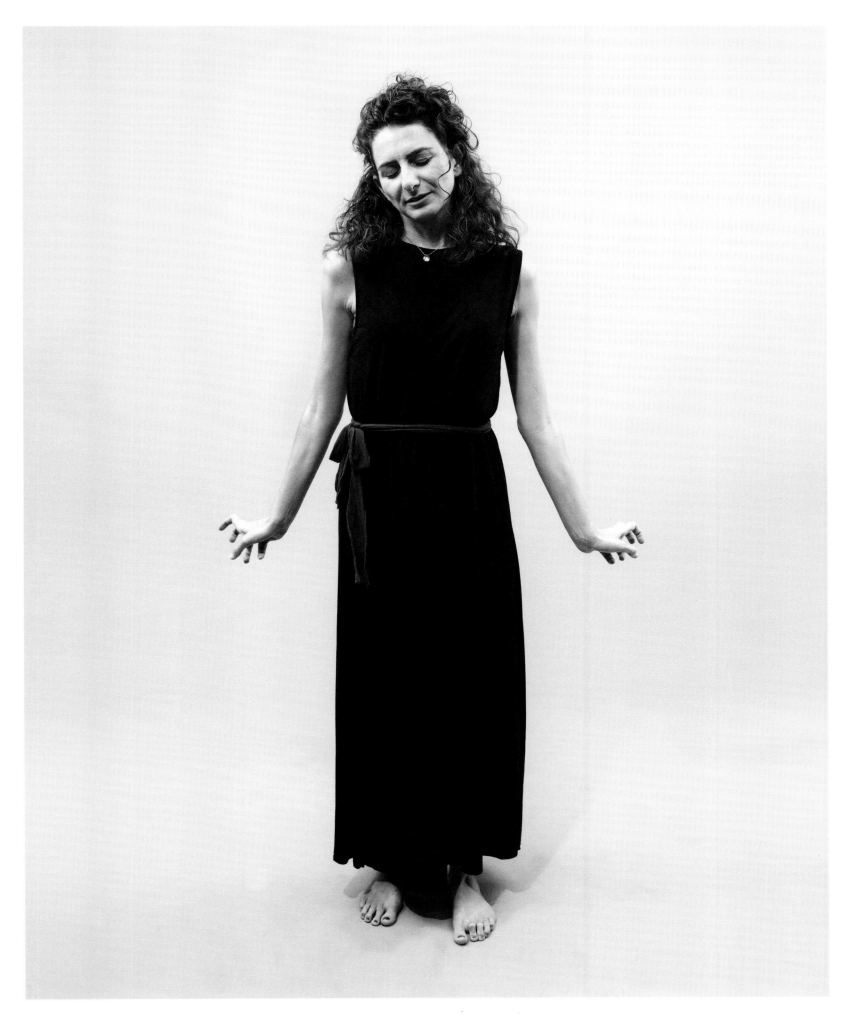

Therapist, Tel Aviv, Israel

This quote is from the opening line of Shep Gordon's film, *Supermensch*. "I drove into Los Angeles, and there was the Hollywood Landmark Hotel. A girl pulled me over and she said she was Janis Joplin. She introduced me to Jimi Hendrix. Jimi Hendrix said 'are you Jewish?', I said 'yes', he said '... then you should be a manager'."

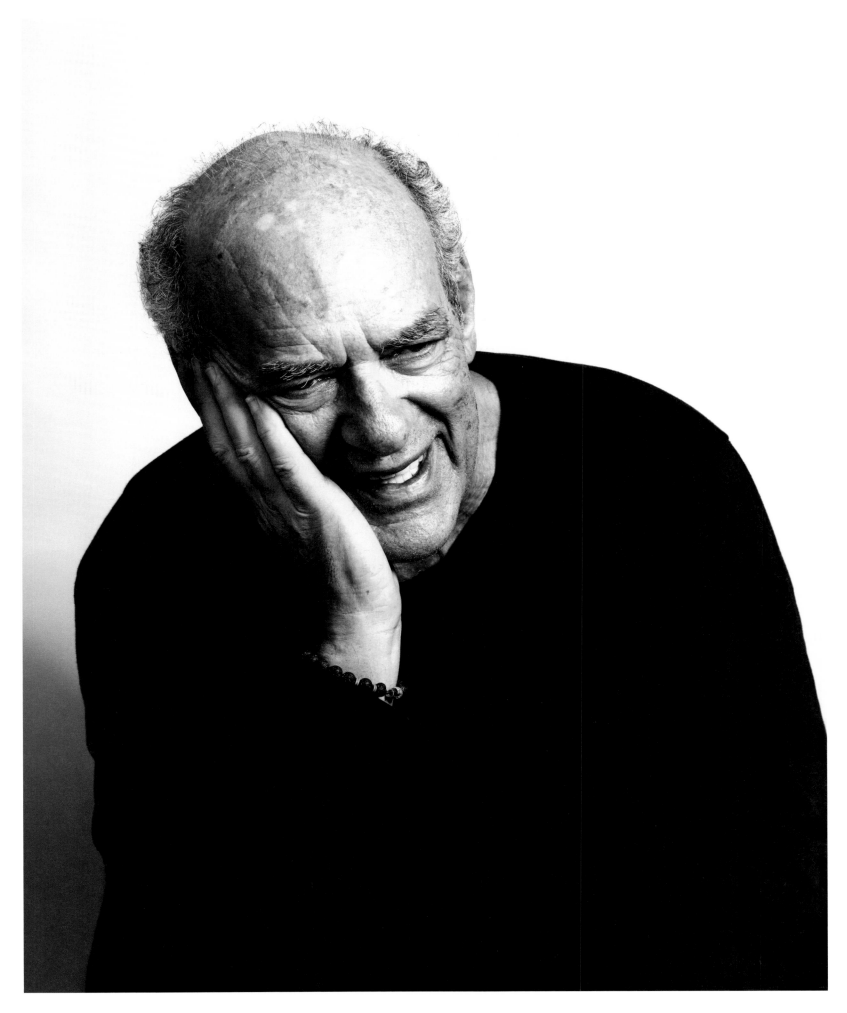

Manager, London, England

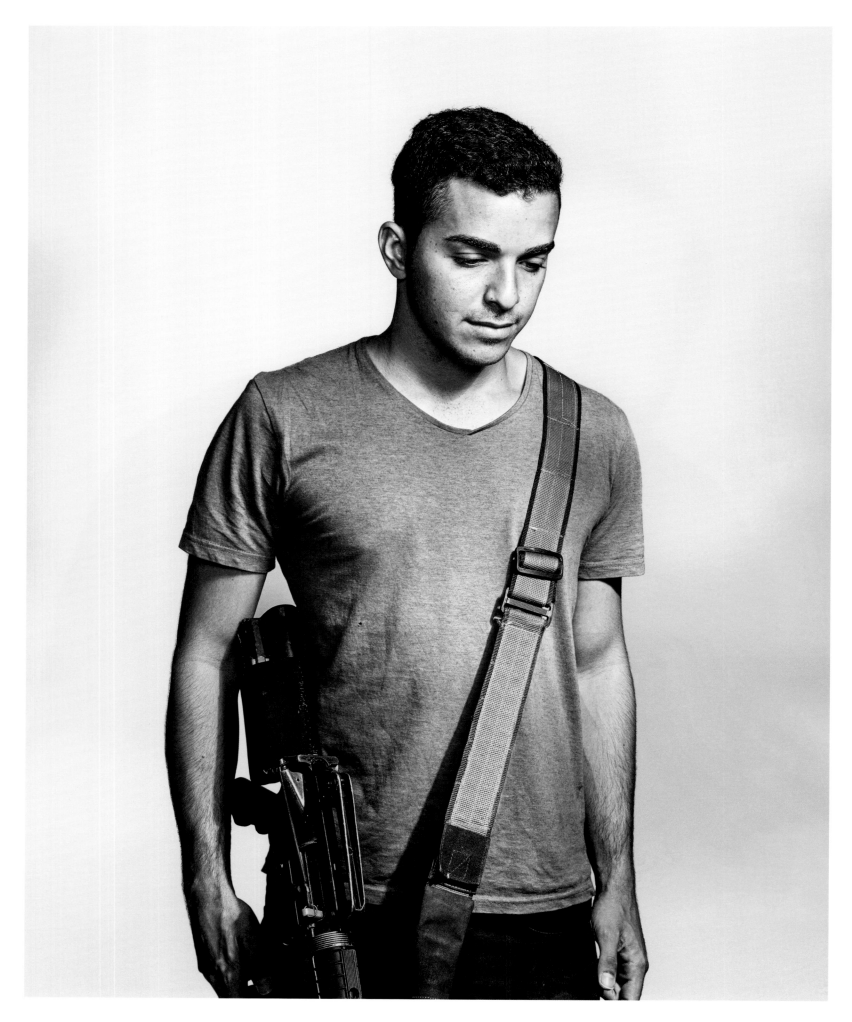

Off-duty, Tel Aviv, Israel

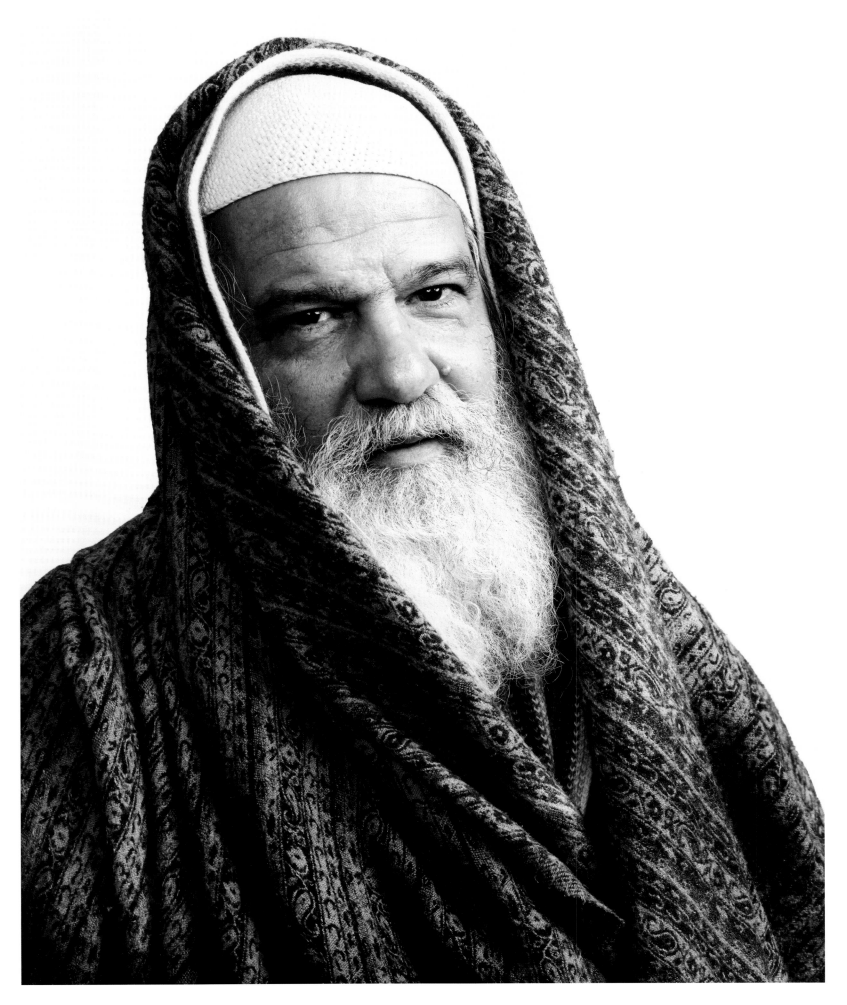

Potter, Uman, Ukraine

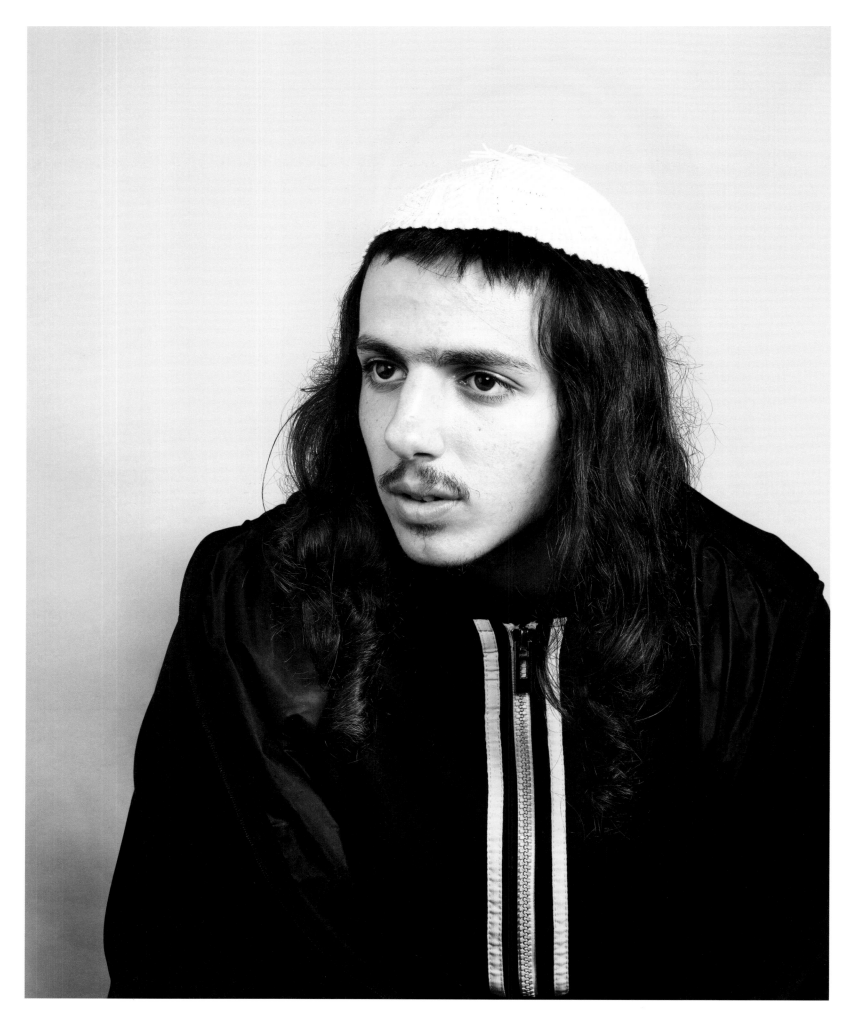

Boy in a Track Top, Uman, Ukraine

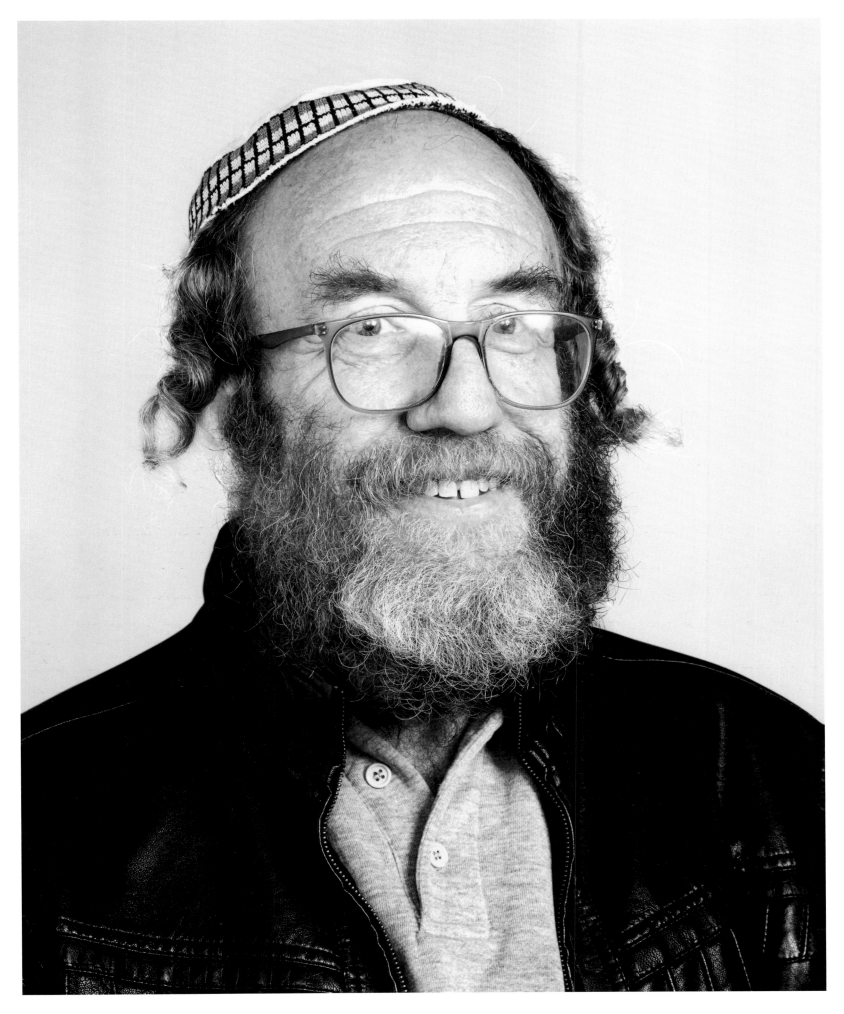

Man with Glasses, Uman, Ukraine

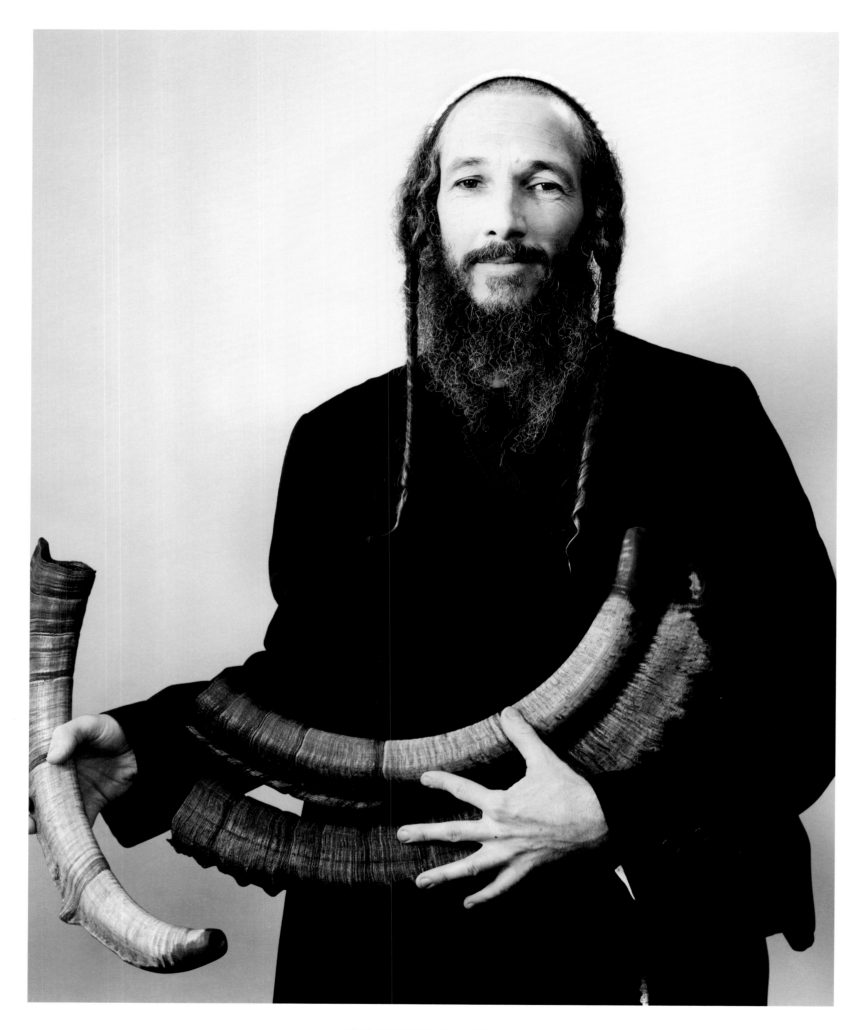

Shofar Salesman, Uman, Ukraine

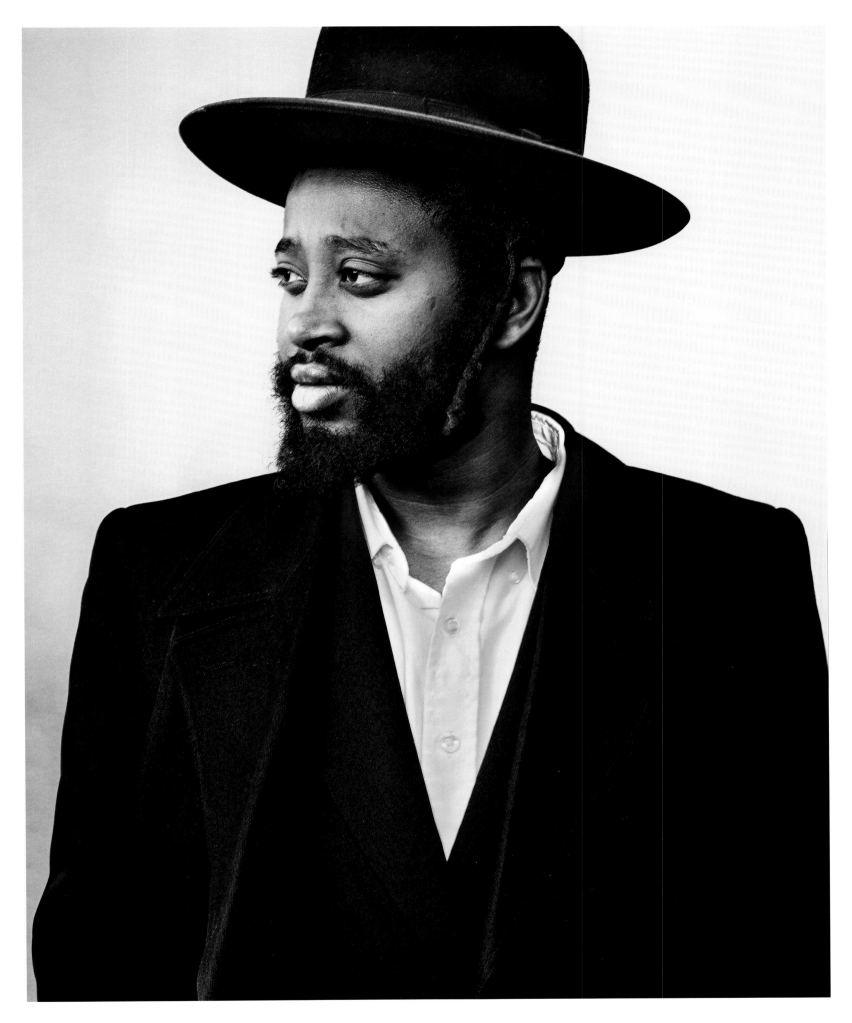

Religious Man I, Uman, Ukraine

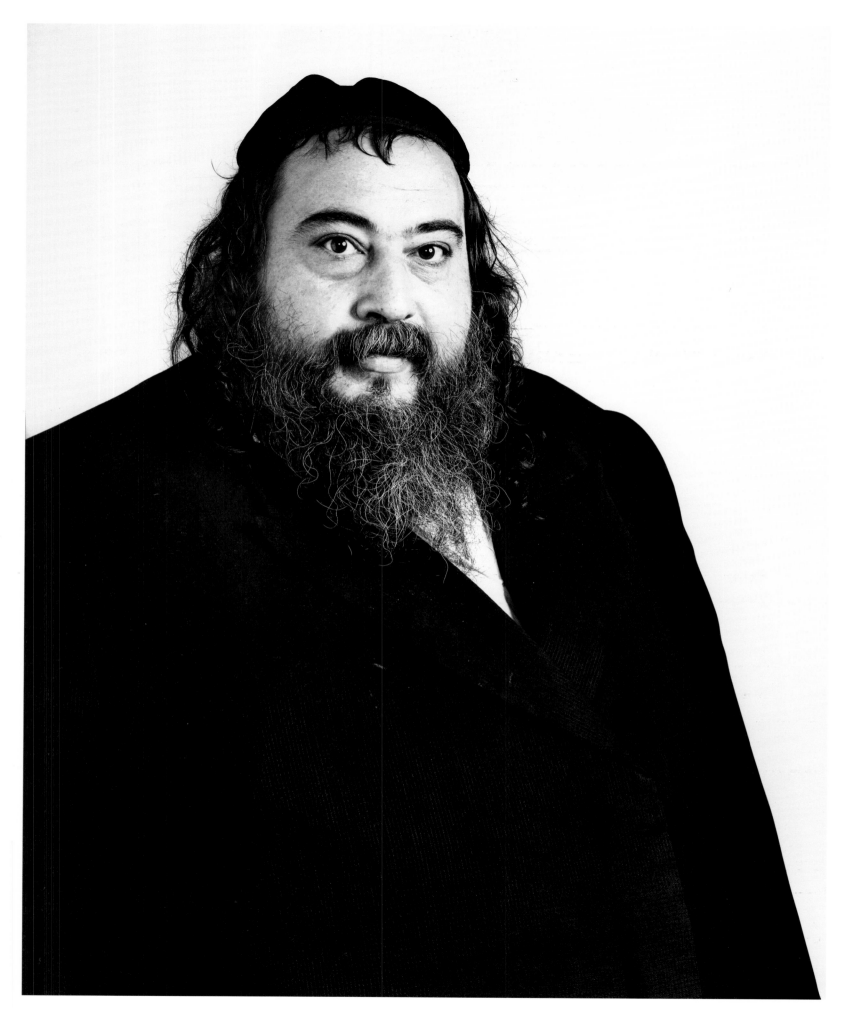

Tall Man, Uman, Ukraine

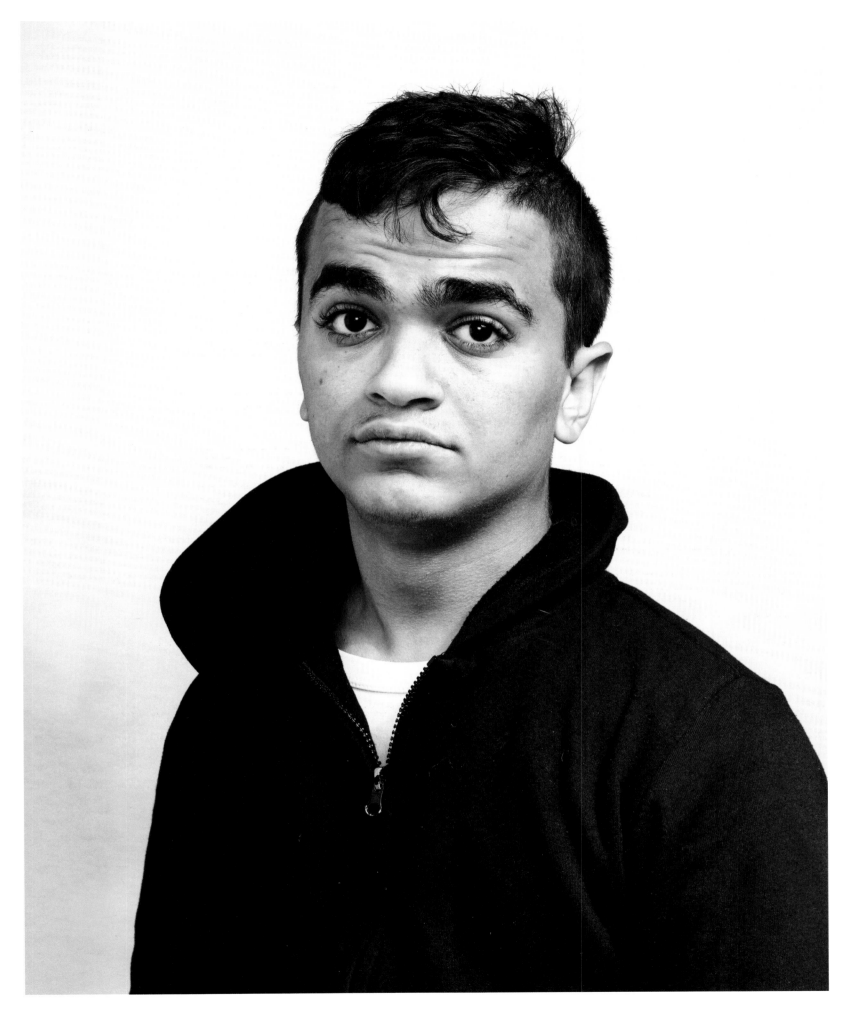

Short Man, Uman, Ukraine

This young man set up a table not far from where we were photographing. He sold sweets to passers-by, until his table was empty. Then he packed up and went home.

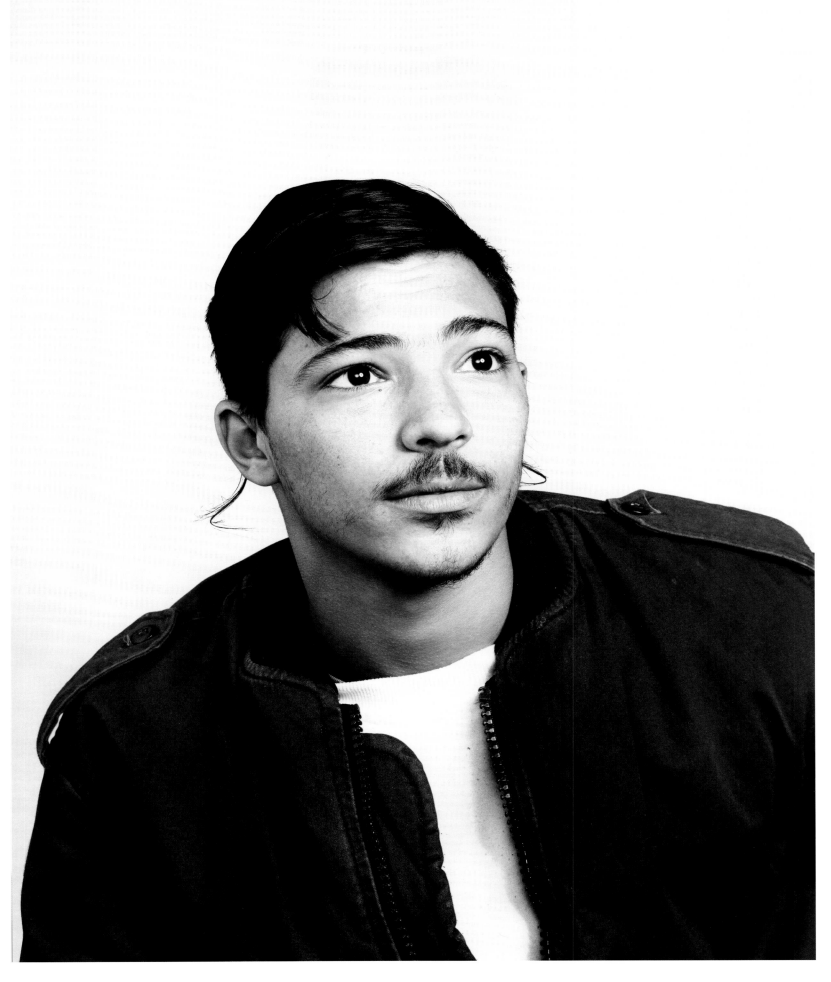

Entrepreneur, Uman, Ukraine

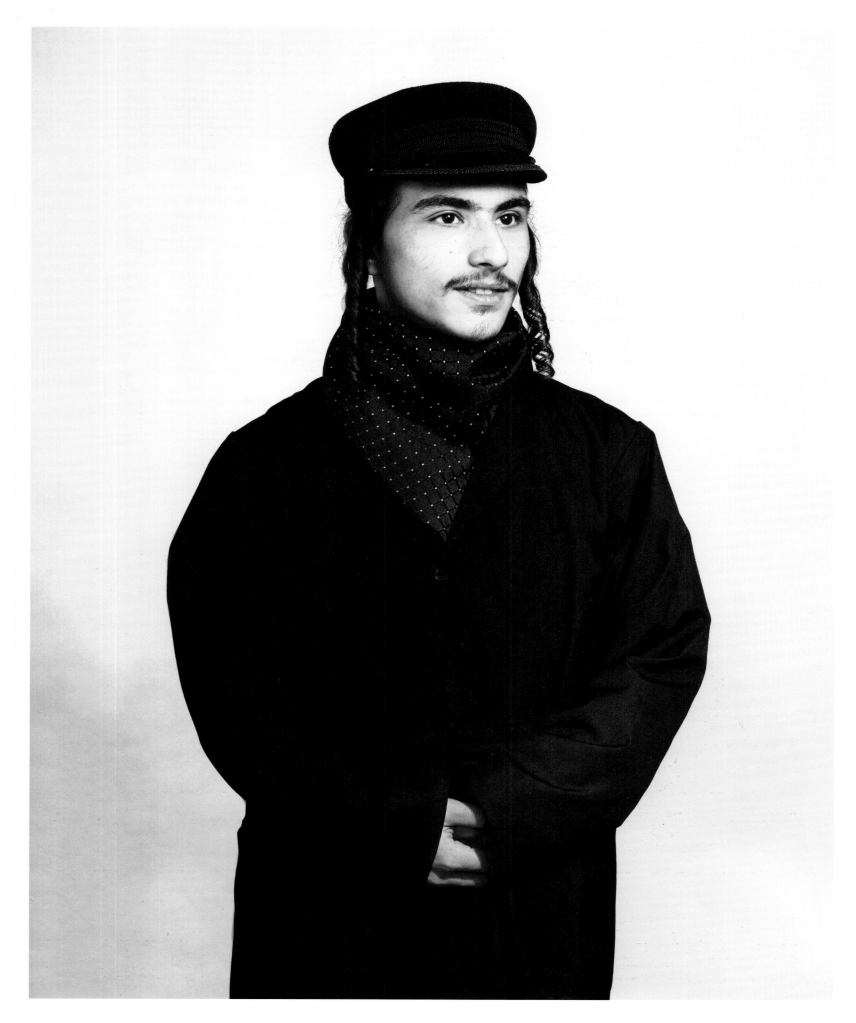

Religious Man II, Uman, Ukraine

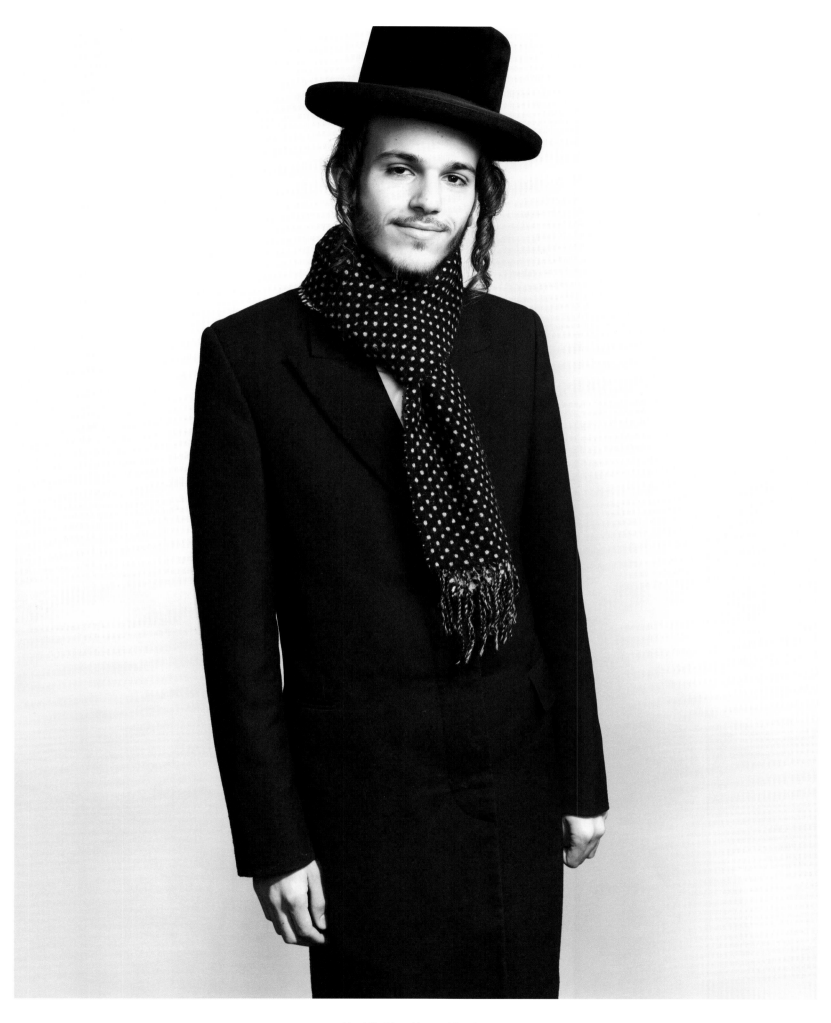

Hasidic Man, Uman, Ukraine

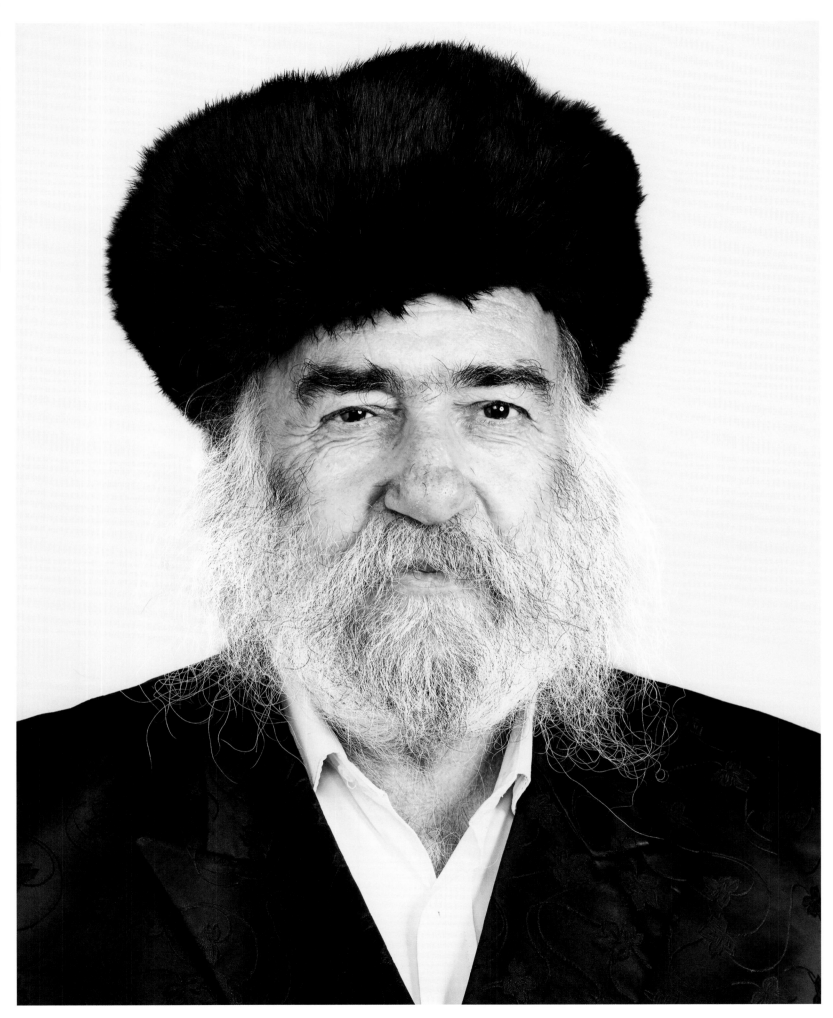

Philanthropic Man (Feeds the Hungry), Uman, Ukraine

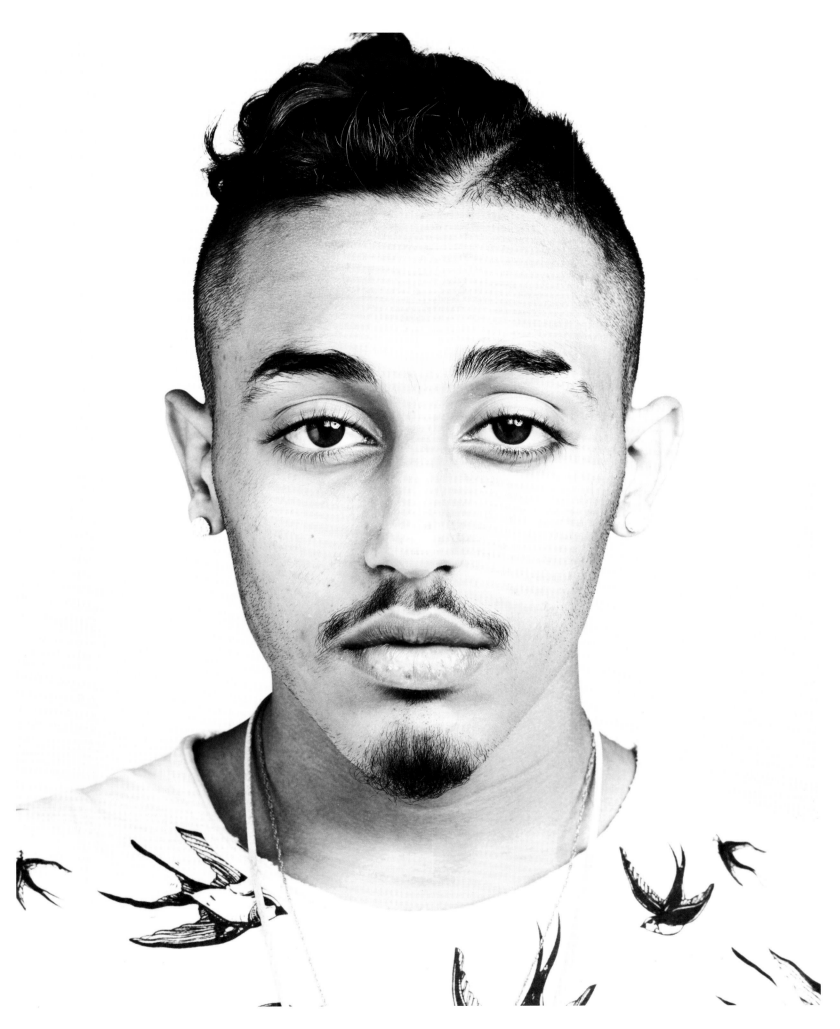

Boy with Swallows, Uman, Ukraine

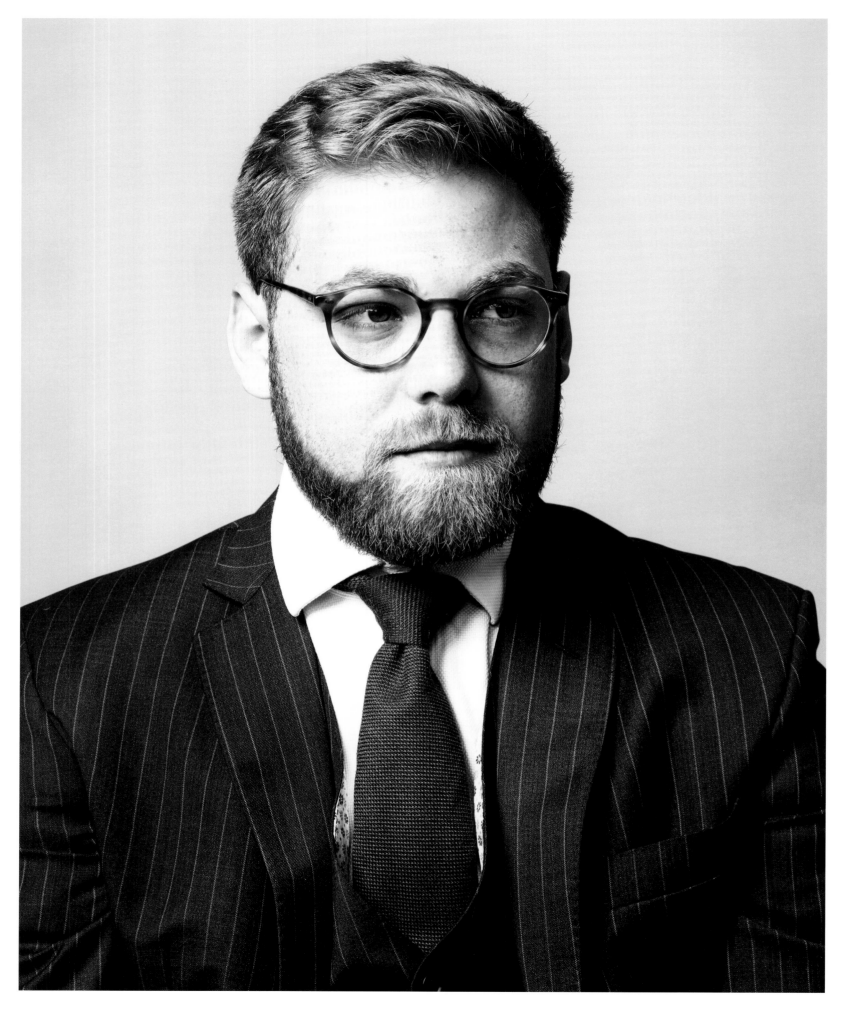

Student Union Leader, Vienna, Austria

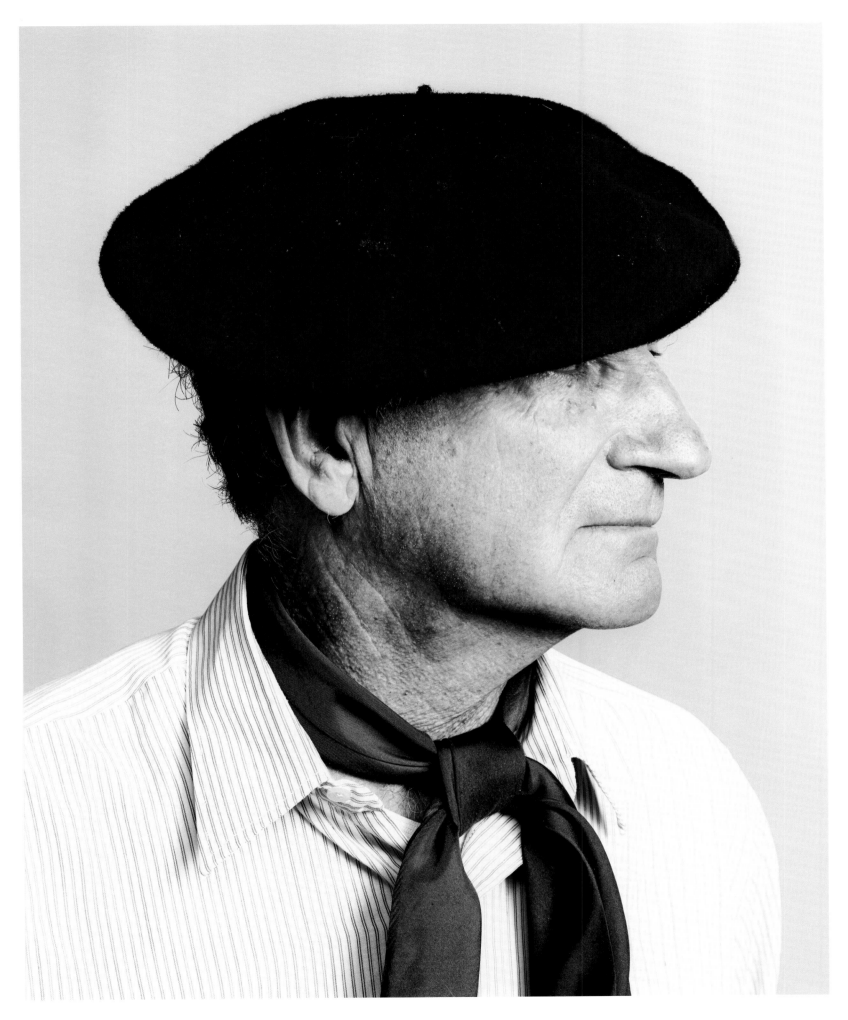

Butcher, Villa Clara, Argentina

When Hannah walked into the room it lit up, she has a delightful personality. She didn't want to highlight her disability in the title of the portrait, so instead I decided to title it 'Good Friend'. It was obvious that she was.

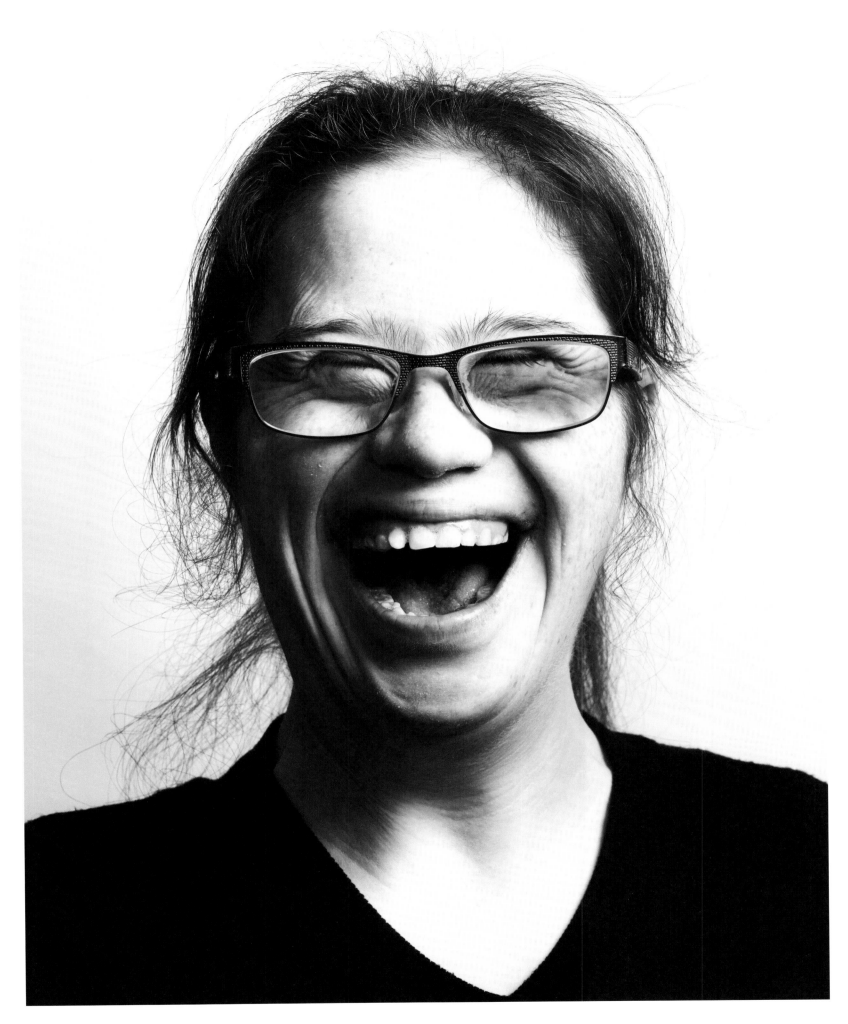

Good Friend, Manchester, England

BEHIND THE SCENES

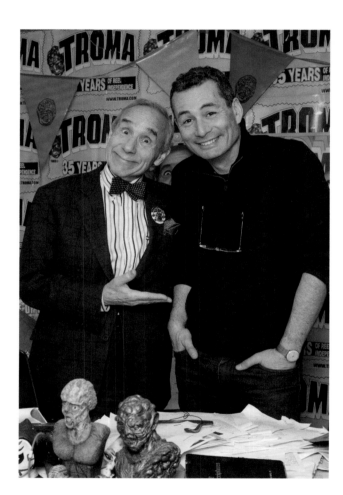

Lloyd, me, and busts of his creation,
Toxic Avenger.
© Saul Sudin

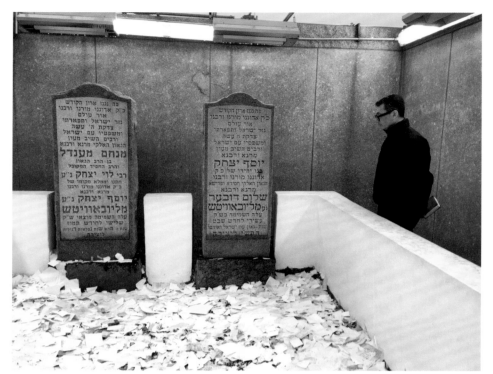

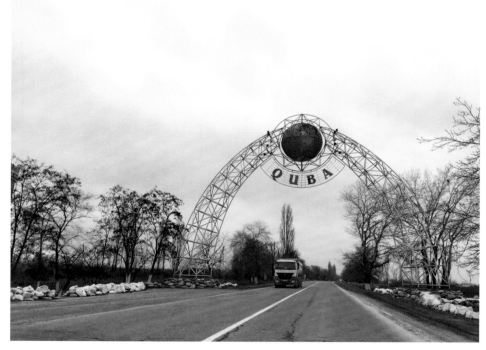

The Ohel in Brooklyn, NY. The grave
of Grand Rebbe Menachem
Schneerson. He was the last Lubavitch
Rebbe. You can write a note and leave it
graveside.
© Yisroel Lew

Entering Quba, a town in Azerbaijan in
the Caucasus mountains two and
a half hours north of Baku and home to
the largest population of Mountain
Jews, originally descended from ancient
Persia.
© John Offenbach

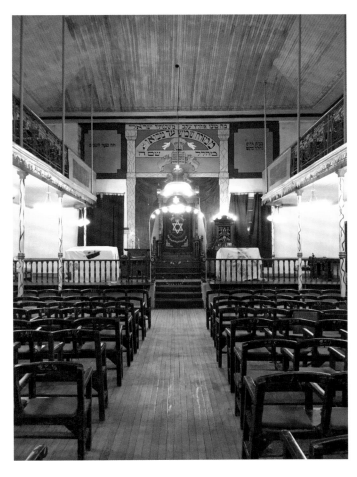

In Basavilbaso, Argentina, this colourful
synagogue was designed and built
by a theatre set-designer who was not
Jewish. Much of it is not quite
traditional, yet it struck me as beautiful.
© John Offenbach

In Barbados in the Caribbean
the recently refurbished Niche Israel
Synagogue originally built in 1654
is recognised as one of the oldest in the
western hemisphere. A number of graves
in its cemetery have a skull and
crossbones depicted on headstones,
the traditional sign for pirates.
© Bridgetown Synagogue Historic
District

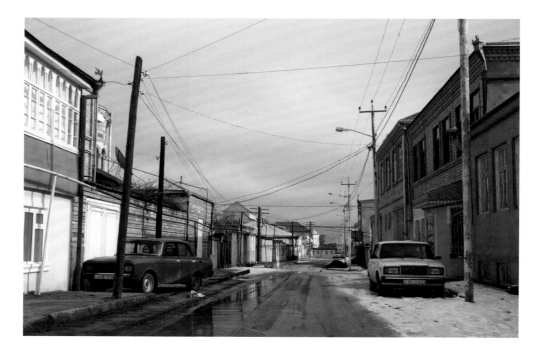

Main Street in Quba, Azerbaijan.
Evidence of former Soviet Union
influence.
© John Offenbach

Backgammon players in Quba.
As in many outlying Jewish towns
I visited, young people have left to
find careers elsewhere. Here the
remaining population play
backgammon and drink lemon tea.
© John Offenbach

On the floor of a community centre in
Kaifeng, the ten commandments written
out in Chinese have been left
abandoned between a filing cabinet
and a water fountain.
© John Offenbach

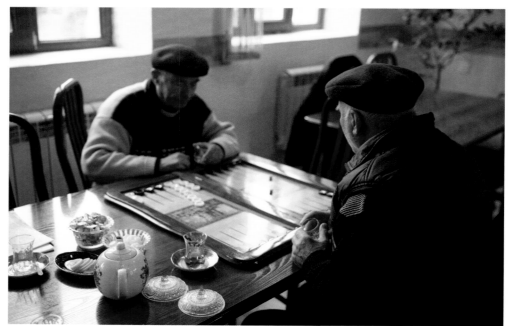

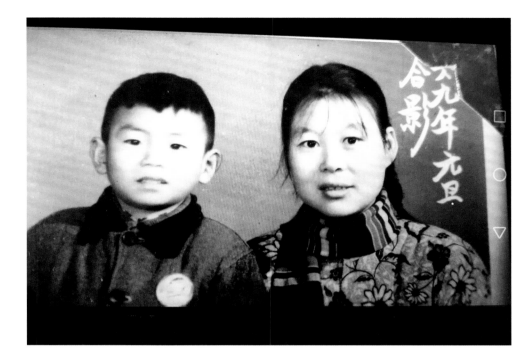

Li Xiu Rong (page 57) from her youth. She recalls seeing the word 'Jew' as a child, entered in her 'Hukou' state registration booklet. In her twenties on trips to Shanghai, she would buy books and read up on Judaism.
© John Offenbach

In Ethiopia, some locals believe Jews turn into hyenas at night and cause malady. This Jewish house has its mezuzah, which is traditionally outside, placed inside the front door and out of plain sight.
© John Offenbach

A beautiful prayer book from the Magen David Synagogue in Mumbai, India. Written in Hebrew on one side and Marathi on the other. A calligrapher's delight.
© John Offenbach

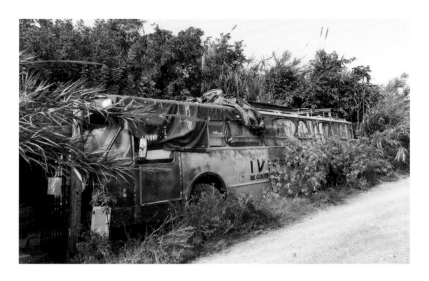

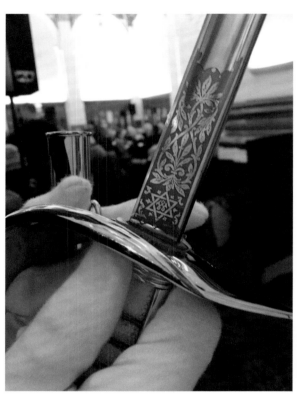

A ceremonial sword with a Star of
David etched into its blade, for Jewish
officers in the British Armed Forces.
© John Offenbach

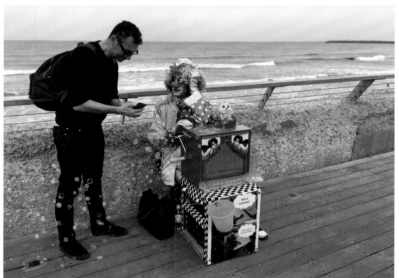

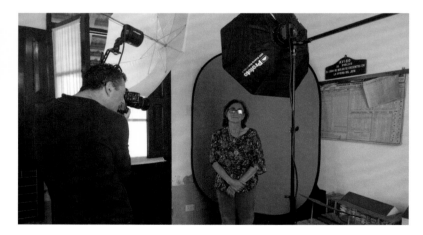

An old bus on the outskirts of Tel Aviv.
It was cheap accommodation for me
when I began the project, and
subsequently became the headquarters
of the project on return visits to Israel.
© John Offenbach

Coming across a clown at the beach
in Tel Aviv, I asked if he would sit
for a portrait. He is the only person who
appears in the book twice. Once
in make-up and then again without
(pages 112 and 113).
© Ilan Bass

A train station waiting room doubles
as a photography studio in Basavilbaso,
Argentina.
© Marcelo Emilio Melchior

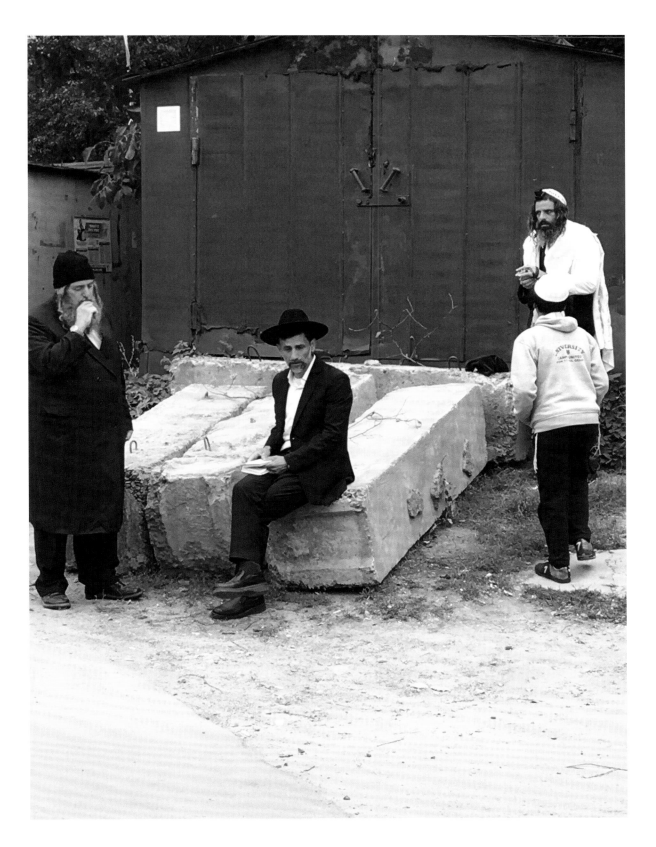

Time out between services
in Uman, Ukraine.
© John Offenbach

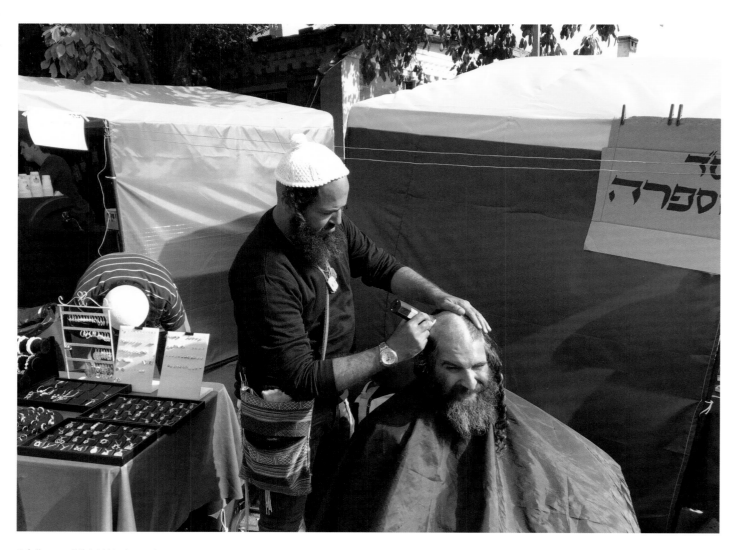

A follower of Rabbi Nachman has
a quick trim in the streets of Uman. The
opposite of 'short back and sides'.
© John Offenbach

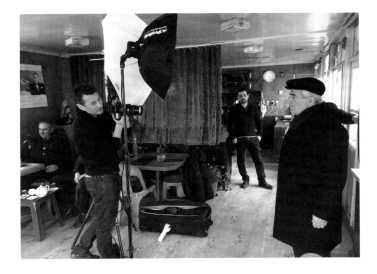

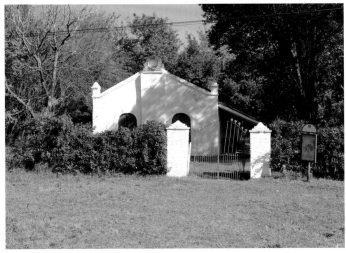

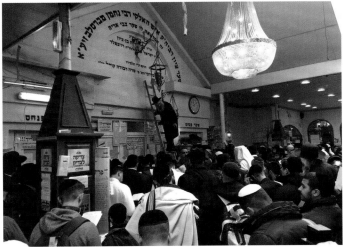

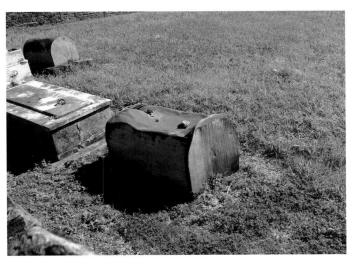

Shooting in an old cafe with some
locals in Quba, Azerbaijan.
© Elchin Mamedov

The small synagogue and burial site
of Rabbi Nachman in Uman, Ukraine. He
was a controversial figure even
during his lifetime in the late 18th
century. Thousands of his
contemporaries travelled with him
eventually ending at this site,
where an infamous pogrom took place.
Pilgrimages to his grave site have
increased in number over the years and
since the end of Soviet rule have
attracted annual visitors in the tens of
thousands from around the world.
© John Offenbach

A small rural synagogue in Basavilbaso
in the region of Entre Rios, Argentina.
In 1891 a German philanthropist, Baron
Maurice de Hirsch facilitated the
mass emigration from Russia of Jews
and resettled them with land (and
a small number of livestock) purchased
here. The émigrés had to learn very
quickly the art of being a cowboy. The
local cemetery is evidence of the
hardship suffered.
© John Offenbach

In a Jewish cemetery in Basavilbaso,
Argentina, from the turn of the
20th century, a child's grave, probably
from a family without the money for
a proper burial or headstone.
© John Offenbach

A Glossary

Bar / Bat Mitzvah

A male / female coming of age ritual involving reading a passage from the Torah, usually at the age of thirteen.

Gefilte Fish

A traditional dish made from a poached mixture of ground deboned fish.

Hasidic Jews

A sub-group of religious orthodox Jews.

Igbo Jews

A group of people practicing a form of Judaism originally from Nigeria.

Kaifeng Jews

A Jewish community from Kaifeng in the Henan province of China.

Mensch

A person of integrity or honour.

Mezuzah

A piece of handwritten parchment inside a decorative casing placed on the doorpost of Jewish homes.

Mohel

A person trained in the practice of circumcision.

Schlock

Something of cheap or inferior quality.

Sheitel

A wig worn by some orthodox Jewish women.

Shochet

A person authorised to slaughter certain mammals and birds for food according to kosher laws.

Shtreimel

A fur hat worn by religious men.

Sofer / Soferet

A male / female scribe trained in traditional Hebrew calligraphy authorised to transcribe the Torah, tefillin and mezuzot.

Tallit

A traditional prayer shawl worn by men.

Thank You

I would like to thank the following people for their very generous help and assistance in making this book:

Alastair Addison, Lior Avitan, Felicity Barsky, Ilan Bass, John Battsek, Demeke Besufkad, Esty Bruck, Toby Cohen, David Cohen, Kevin Davis, Alan Edwards, Abel Evelson, Rabbi Ariel Friedlander, Mark George, Lizzie Gillett, Josh Glancy, Robert Goldstone, Melissa Grunberger, Kieran Jay, Ralphy Jhirad, Jacky Kadoch, Rabbi Menachem Katz, Sinnora Kolatkar, Rotem Malenky, Elchin Mamedov, Ido Martziano, Marcelo Emilio Melchior, Sophie Molins, Irene Orleansky, Wen Xia Peng, Yossi Rapoport, Harvey Rosenblatt, Linda Rosenblatt, Anthony Rosenfelder, Katharine Round, Ruth Saleh, Alex Schneideman, Shneor Segal, Elke Reva Sudin, Saul Sudin, Jessie Wang, Peter Weber, Uli Weber, Pablo Wydra.

Dr. Devorah Baum, for your lyrical and insightful foreword.
Dominik Czechowski, Stephen Fry, and Alan Yentob, for your generous endorsements.
Maya Jacobs-Wallfisch, for your guidance.
Rabbi Yisroel Lew, for your extensive and far-reaching connections.
Massimiliano Pagani at Skira editore, for your confidence in the project.

To Nick Leslau, a very special thank you for your unwavering support, without which this project would have remained just an idea.

To my parents Gary and Geraldine, my wife Jackie and my children George, Alice and Joe for your love and encouragement.

Finally to everyone who agreed to take the time and sit for a portrait, my deepest gratitude.

"A portrait is worth a dozen biographies.
It is the candlelight by which we view history."

Thomas Carlyle, Philosopher
(1795–1881)